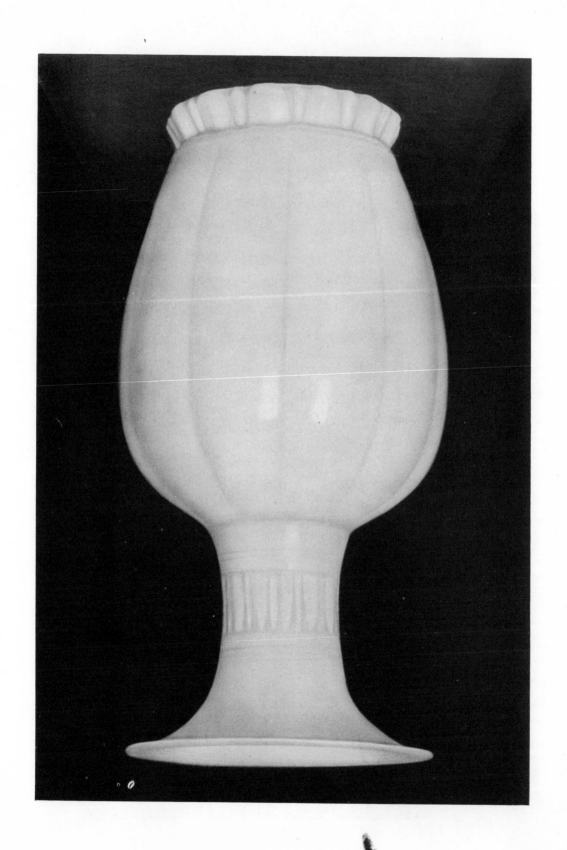

THE ART OF THE
Chinese Potter

AN ILLUSTRATED SURVEY

R. L. Hobson and A. L. Hetherington

DOVER PUBLICATIONS, INC.

NEW YORK

FRONTISPIECE: Vase with ovoid body moulded in ten lobes, tall slender neck with flaring mouth, and low foot cut in a leaf and tongue pattern. On the neck is a carved band of stiff leaves alternately wide and narrow between wheel-made rings: three concentric rings inside the mouth. Porcelain with thick, white bubbly glaze with a faint tinge of blue which is accentuated where the glaze runs thick in the hollows of the form. The base is unglazed for the most part and discloses a biscuit of rather granular type which has burnt a reddish brown: there are the marks of a ring of supports. The form of this beautiful vase was borrowed by the Corean potters for their celadon. Ju type. Sung dynasty. H. 10". *In the possession of Mr. H. J. Oppenheim.*

Published in Canada by General Publishing Company, Ltd., 30 Lesmill Road, Don Mills, Toronto, Ontario.

Published in the United Kingdom by Constable and Company, Ltd., 10 Orange Street, London WC2H 7EG.

This Dover edition, first published in 1982, is an unabridged republication of the work originally published in a limited edition of 1500 copies by Benn Ltd., London, in 1923 (500 of the copies were for the U.S. and bore the Alfred A. Knopf imprint) under the title *The Art of the Chinese Potter from the Han Dynasty to the end of the Ming illustrated in a series of 192 examples selected, described and with an introduction by* [Hobson & Hetherington].

In the present edition the following plates, originally in color, are reproduced in black and white: frontispiece, 1, 11, 39, 40, 42, 51, 62, 64, 67, 69, 76, 79, 94, 95, 96, 136, 139. The 35 remaining color plates, while retaining their original plate numbers, have been grouped in a separate 32-page color section that follows page 12. The captions of all the plates, which originally appeared on tissues preceding the plates, have been reset and appear below the respective pictures; in the captions the plate numbers have been changed from Roman to Arabic (as they were even in the original List of Illustrations).

Manufactured in the United States of America
Dover Publications, Inc.
180 Varick Street
New York, N.Y. 10014

Library of Congress Cataloging in Publication Data

Hobson, R. L. (Robert Lockhart), 1872-1941.
 The art of the Chinese potter.

 Reprint. Originally published: The art of the Chinese potter from the Han dynasty to the end of the Ming. London : E. Benn, 1923.
 1. Pottery, Chinese. I. Hetherington, A. L. (Arthur Lonsdale), 1881-1960. II. Title.
NK4165.H65 1982 738'0951 81-19474
ISBN 0-486-24291-9 AACR2

PREFACE

Many students and collectors of Chinese pottery and porcelain find greater help from examination of good illustrations of the wares which delight them than they gain from reading detailed descriptions. So far as the later wares of China are concerned, and by that term we mean the examples produced after the close of the Ming dynasty in the middle of the 17th century, several volumes of plates have been produced. But apart from the illustrations accompanying the descriptive accounts of the pre-Ming and Ming wares, there is a dearth of informative reproductions of the work of the earlier potters.

The object of this volume is to furnish the collector with a series of representations of some of the finest examples which are known to exist in this country. The description of each specimen has been carefully made so that with the plate before him, the collector may realise as far as possible the main characteristics exhibited by it. Care has been taken to select examples which have not been well illustrated in accessible works, for it is tiresome to be confronted with notable pieces which are already familiar. But this course has involved the exclusion of a number of magnificent specimens which would naturally find a place in this volume. On the other hand, there are fortunately in this country a number of private collections of first-rate importance from which it has been our privilege to draw. To all who have placed their cabinets at our disposal we tender our sincerest thanks; as the ownership is indicated in each instance it is unnecessary to particularise further the collections used.

The most famous album of fine examples of Chinese porcelain was that compiled by Hsiang Yüan-p'ien in the 16th century. He added to the interest of his specimens by describing in many cases the circumstances under which he or his friends acquired them. We have been tempted to do the same, for an account of some of the adventures experienced by our friends in the pursuit and capture of their treasures would be entertaining. But we have refrained from doing so because we might deprive those collectors of some of their best stories, and thereby return evil for good.

By way of introduction a short account is included of the main features which mark the growth of the art of the Chinese potter during the periods concerned, and a brief description is furnished

v

of some of the famous kilns which were operating at different times in China. Any more detailed account of the wares would be out of place, and for this other works should be consulted. At the same time attention has been paid to certain recent theories which have not as yet received public examination.

In a work of this description success mainly depends upon the artistic appreciation and experience of those responsible for the photography and colour guides from which the blocks are produced. We desire to express our thanks to the artists for the care and skill they so unremittingly bestowed upon the task.

<div style="text-align: right">R. L. H.
A. L. H.</div>

June, 1923.

NOTE: In the List of Illustrations that follows, all those plates showing the indication "(colour)" will be found in a separate color section following page 12 (in the Introduction). Within this color section the plates retain their original numbering and appear in proper numerical order, with the exception of No. 125, which appears on the same page as No. 115, and No. 148, which appears on the same page as No. 130.

LIST OF ILLUSTRATIONS

LIST OF ILLUSTRATIONS

LIST OF ILLUSTRATIONS

LIST OF ILLUSTRATIONS

LIST OF ILLUSTRATIONS

LIST OF ILLUSTRATIONS

LIST OF ILLUSTRATIONS

LIST OF ILLUSTRATIONS

LIST OF ILLUSTRATIONS

LIST OF ILLUSTRATIONS

LIST OF ILLUSTRATIONS

LIST OF ILLUSTRATIONS

LIST OF ILLUSTRATIONS

xix

LIST OF ILLUSTRATIONS

DYNASTIC DATES

Han dynasty, B.C. 206–220 A.D.
Northern Wei dynasty, 386–532
T'ang dynasty, 618–906
Sung dynasty, 960–1279
Yüan dynasty, 1280–1367
Ming dynasty, 1368–1644

REIGNING PERIODS OF CHIEF MING EMPERORS

Hung Wu, 1368–1398
Yung Lo, 1403–1424
Hsüan Tê, 1426–1435
Ch'êng Hua, 1465–1487
Hung Chih, 1488–1505
Chêng Tê, 1506–1521
Chia Ching, 1522–1566
Lung Ch'ing, 1567–1572
Wan Li, 1573–1619

AN INTRODUCTION

There is only one manufactured material which has been identified so closely with a nation in the eyes of the English-speaking races that the name applied to it is that of the country of its origin. China is the name given not only to that vast empire of the East inhabited by the Chinese, but to the product for which that empire is most famous in Western estimation. The children of this country become familiar with the word *china* as signifying the cup or plate from which they eat long before they learn that there is a country of that name.

China is the term used popularly to denote pottery, earthenware, and porcelain; and vessels were made from all these materials by the Chinese in different ages.

But while the Chinese have been regarded as the master potters of the world, and their art has been the inspiration of their fellow-craftsmen elsewhere, it is interesting to note that their skill was obtained comparatively late in the world's history. Egypt, Persia, and Greece were certainly in the field before the Chinese, who derived much of their knowledge, especially in regard to glazes, from contact with the West. The patience and industry for which they are noted soon placed the Chinese ahead of all their rivals, and their supremacy was hardly challenged before the 19th century.

Prior to the 2nd century before the Christian era, the potter's art in China was limited to fashioning vessels of utility in pottery, and it is generally believed that glaze was first employed during the Han dynasty (B.C. 206–221 A.D.). Recently[1] some criticism of this theory has been put forward, and the counter-suggestion has been made that the introduction of glaze dates from about the 5th or 6th centuries.

This is not an appropriate occasion to enter upon a full discussion of the arguments advanced which in any case are of a negative character. It is sufficient to say that they have not shaken our faith in the Han attribution of the earliest lead-glazed wares. The reference made below to the finds at Samarra of fine porcelain with high-fired felspathic glazes affords definite proof of the existence of wares of this kind as export products in the T'ang dynasty. Before examples could have been available for export to Mesopotamia, manufacture on an extensive scale and for a considerable

[1] *Chinesische Frühkeramik*, by Dr. O. Rücker Emden.

3

time must have been proceeding in China; and it is not unreasonable to assume that true porcelain was being made in the early part of the T'ang dynasty.

By post-dating the earliest examples of lead glazes on pottery bodies to a period shortly before the establishment of the T'ang dynasty we would have to accept the idea of a very rapid development of potting technique within a short space of time. It is difficult to believe this to have been possible, having regard to the scientific knowledge possessed in China at that period.

But the Han potter made no very ambitious attempts at artistic productions, although, as we hold, he knew how to glaze his vessels. The pottery was utilitarian, and the specimens with which we are familiar are those made for burial with the dead. It was a custom in China to put into the tomb replicas of vessels and objects used in everyday life for the service of the dead in a better land. Thus we find models of farmyards, granary towers, well-heads, and cooking stoves, as well as jars, ewers, dishes, and cups from which the spirits of the departed might eat and drink. Plate I shows a fine example of a typical Han wine-jar, and Plate III a model of a well-head. The decomposition of the glaze on these wares has given an adventitious beauty to them; the lead silicate glazes have become iridescent, and a beautiful silvery sheen is generally seen on part or the whole of the object.

The next great epoch in Chinese history was the T'ang dynasty (618–906 A.D.), and by this time ceramic art had reached a very high standard of excellence. Further evidence of contact with the West is seen in the models of men and animals made in pottery at that time. The fine figures of Bactrian horses and camels show how these animals had become common objects in China by importation, and many of the human figures indicate types of faces which are certainly not Chinese. Plates X, XIV, and XVII illustrate these facts.

It is natural, too, that Buddhist influence should be seen in many of the figures dating from the T'ang dynasty. Introduced into China perhaps as early as the 1st century A.D., Buddhism occupied varying degrees of importance in the life of the people; different ruling houses adopted attitudes of friendliness or opposition to its tenets, but the religion never took deep root in the life of the people. In later times it became very depraved. But still Buddhism

has exercised a decided influence on the ceramic art of the early potters, and evidence of its power is seen in the figures of the Lokapala or Guardians of the Four Quarters found in the grave equipment of T'ang notables. Figures of Lohan or apostles of Buddha are to be found dating from the same period, and the great Lohan in the British Museum is a very fine example not only of the magnificent potting of the period but of Buddhistic art. Plates VIII and IX represent further specimens of the figures of this epoch.

But the T'ang potters by no means confined their attention to the production of pottery figures. While the collector will most frequently meet with these, he will find, if he is fortunate, beautiful vases, ewers, bowls, and dishes, all of which show much distinction and many evidences of Western influence. In their execution the potter employed a wide range of technique. Skilful use of slips[1] of different colours was made, and these were contrasted with the bodies on which they were superimposed. At the same time bold designs, generally of a floral character, were executed by incising the paste with a sharp point.

Simpler effects were created in the wine-jars and vases which owe their beauty to their graceful shapes and to the single coloured glazes washed over them. These glazes—generally soft lead-silicate glazes—are thin in their application and hardly ever continue to the base of the vessel, stopping short of the foot in an uneven line.

It must not, however, be overlooked that although the soft lead-silicate glazes predominate in the T'ang wares, high-fired felspathic glazes were also in use. The view has long been held that the T'ang potter probably was master of the secret of the manufacture of true porcelain; but there was no definite proof available until the recent excavations[2] at Samarra on the Tigris established the fact. This town flourished between 830–883 A.D., and in its buried remains fragments of Chinese porcelain with high-fired felspathic glazes have been found. The finds included both white glazed specimens and fragments of celadon ware, showing that in the second half of the T'ang dynasty the Chinese potter had reached

[1] Slip is the term used to denote a liquid clay mixture.
[2] See Sarre, *Die Kleinfunde von Samarra, Der Islam, Zeitschrift für Geschichte und Kultur des Islamischen Orients.* Band V, heft 2/3:

a degree of certainty in his production of true porcelain sufficient to ensure an export trade as far afield as Mesopotamia. The white wares are very similar to the Ting yao and allied wares of the Sung dynasty; while the celadons are like those known as " Northern Chinese." Plates XXIX and XXX show examples of early white ware possessing characteristics similar to the Samarra fragments with their gummy white glaze.

Usually, however, the T'ang body is of a white pipe-clay consistency, but is sometimes hard enough to resist the knife.

During the last few years increasing evidence of the maturity of the potter's art in the T'ang dynasty has been forthcoming. Though the sensuous appeal of some of the later Sung glazes is lacking, the T'ang pottery excels in graceful outlines and nobility of form. There is nothing small about the T'ang ceramic art, and as knowledge of this period grows we shall doubtless have greater reason to admire and appreciate it.

Apparently ceramic factories existed up and down the length and breadth of China wherever suitable clay deposits occurred, but our knowledge to date does not permit us to identify the wares made at the few factories which we know to have been operative at the period; still less can we differentiate the productions of the many minor centres of which history has told us nothing. Thus it is that we have to rest content at present with assigning wares to such an extensive period of time as the 7th to the 10th centuries, with no attempt at all at saying whether particular specimens were made in the north, south, east, or west. To the archæologist this is vexing no doubt, and will have to be remedied by scientific excavation, but to the art lover it is sufficient to see and admire such fine productions, for instance, as those represented on Plates IX, XIX, and XXI. The men who made the objects there depicted had nothing to learn, so far, at all events, as artistic sense is concerned.

In the Sung dynasty (960–1279 A.D.) further developments were made. Greater refinement of the materials used for the body of the ware became general, and a wide range of glaze colours was developed. The lead-silicate glazes were abandoned generally in favour of the high-fired felspathic glazes which could be applied much more thickly; as a consequence a depth of glaze and a heightened colour effect were achieved. These thick glazes are

fairly typical of the Sung period, though we shall have occasion to note one or two instances in which these felspathic glazes are thinly applied. Simple shapes continued to be fashioned as a rule, but the style and technique of the decoration was more ambitious. With few exceptions the glazes of the period are monochrome.

We have much more knowledge of the factories operating during the Sung period than we have of the T'ang centres of production, and a brief account of the principal ones will help to explain the many examples of Sung workmanship displayed in this album.

One of the most striking of the Sung wares is the Chün yao made at Chün Chou in the province of Honan. While the ancient Chinese writers do not speak in high terms of the products of this centre and give them but slight commendation compared with the eulogies showered upon certain other contemporary wares described below, fine specimens command considerable attention to-day and are much sought after by present-day connoisseurs both in the East and the West. The body varies from a hard porcellanous stoneware to a softer and more sandy type ; the two varieties are distinguished by the Chinese by the terms *tz'ŭ t'ai* (porcelain body) and *sha t'ai* (sandy body) respectively.

The glaze is thick and felspathic, showing as a rule a bluish tone which is due to opalescence. In the " soft " Chüns, the *sha t'ai* of the Chinese, the blue is generally more pronounced and the colour is due to copper. In many of the most striking specimens there are one or more splashes of red or purple, and in rarer cases splashes of green or green bordered with red. The red colour is also due to copper, but in a different condition.

The vessels of this factory which are usually met with are bowls, globular vases, or saucers. These were no doubt made for utilitarian purposes. At the date of manufacture this ware was evidently not held in high esteem, and was not adapted to the delicate and dainty forms required by the scholar and art connoisseur.

A more gorgeous glaze achieved by the Chün Chou factories is that generally displayed on bulb-bowls and flower-pots which were probably supplied for Imperial use. The colour varies from a series of greys through deep purples to a crushed strawberry red. Inside the bowls the glaze is either a blue colour or *clair de lune*. Pieces of this description which belong to the porcellanous stoneware group usually have numerals, 1–10, incised on their bases,

apparently to denote their size. The bases of the vessels are generally washed over with brownish green glaze, and on the circumference of the base will be found a circle of spur marks where the vessels rested on clay " spurs " during the firing.

A characteristic of this type of Chün ware, to which importance is attached by collectors, is the presence of marks in the glaze which look like shaky V's or Y's; these are known by the Chinese as " earthworm " marks from their resemblance to the tracks of tiny worms.

Important examples of these different varieties of Chün yao will be seen on Plates XXXIII, XXXV, and XLI, and Plate XXXIV shows the bottom of a bulb-bowl with its potting characteristics.

In the Yüan dynasty and in the Ming dynasty the traditions were continued, though in the latter period the town was called Yü Chou instead of Chün Chou. In the Yüan dynasty a less gorgeous type of glaze appears to have been made, and the wares generally are of a rougher order; the distinction is sufficiently marked for the term Yüan tz'ŭ to be applied to the Mongol products. In the Ming dynasty the ware appears to have gone out of fashion, and the number of accredited specimens of that period is limited, according to present knowledge.

Closely allied to the Chün yao is a more refined ware called Kuan yao. Kuan means Imperial or official, and is the term applied to the products of the Imperial factories established first at K'ai-fêng Fu in Honan, and later on to those of the Imperially supported kilns at Hang Chou after the transfer of the Sung court to the South. Of this ware the early Chinese writers speak in eulogistic terms, but beyond displaying finer technique both in body and glaze, it presents features very similar to those of the better examples of Chün yao, in fact it is difficult to say where the Chün succession ends and the Kuan family begins. Specimens of what may be ascribed to the Imperial potters of K'ai-fêng Fu or Hang Chou are illustrated on Plates XXXVII and XXXVIII.

While the Kuan yao may perhaps be regarded as the aristocratic members of the Chün family, there are relatives of less distinguished appearance. We refer to the rather similar kind of ware produced at factories in Kwangtung in the neighbourhood of Canton and that made in the Ming period and later at Yi-hsing, a town not far removed from Shanghai.

Round Canton, glazed stoneware has been made from very early times, but it was probably during the latter part of the Ming dynasty and after that most of the Kwangtung ware which we see was made. The most common type of glaze met with is a dark blue or purple one with white opalescence variegating it, but there are specimens with a greyish colour which approximates fairly closely to some of the Chün effects. The body is a good deal darker in colour, so that no great difficulty should be experienced in detecting these Southern products.

The Yi-hsing wares are potted on a hard reddish stoneware body and some of the variegated glaze effects are pleasing; the glaze generally is a soft one which does not bind too well with the body and consequently shows signs of chipping off.

In marked contrast to the gaily coloured Chün wares is the white simplicity of the Ting yao. This ware was made at Ting Chou in the province of Chihli during the early part of the Sung dynasty; but after the incursions of the Chin Tartars had forced the Sung emperor to retreat south of the Yangtze to set up his capital at Hang Chou, the Ting Chou potters migrated south also and the majority of them appear to have established themselves at or near Ching-tê Chên which was later to become the ceramic metropolis of the Empire. But no doubt many of these potters, and those from subsidiary factories employing the same kind of technique, moved to other centres.

In any case, we know of a wide series of wares closely related to the Ting yao proper, but showing differences which point to several centres of origin. The difficulty of distinguishing the ware made in the north at Ting Chou and that produced in the south later was one which puzzled the ancient connoisseur, for we are told that those who can distinguish between the two " have no reason for shame."

The Ting ware consists of a fine white body with an orange or reddish translucency when potted thinly enough to allow light to pass through it. The glaze is a creamy or ivory white. Incised or moulded designs often ornament the plates and bowls which constitute the majority of specimens seen to-day, and the drawing is distinguished by its boldness and its artistic feeling.

The Ting ware is divided into three classes, the white Ting or *pai ting*, the flour-coloured Ting or *fên ting*, and the earthy Ting

9

or *t'u ting*. The first named is the rarest and is the most lustrous in its glaze. The last named is found in a greater variety of shapes, but the quality of its creamy crackled glaze is inferior, and translucency is rarely observed in the body.

One of the characteristics which has for centuries been associated with the Ting ware is the presence of " tear drops " in the glaze. These marks are due to local aggregations of the glaze where it has been arrested in its flow over the surface of the vessel. Pieces were often, but not invariably, fired on their mouth-rims which are frequently found bound in copper to hide the unglazed portion.

There are numerous Sung specimens of the Ting type which do not conform with the general features displayed by the Ting yao proper, and with present knowledge it is impossible to classify these more narrowly. Probably there was a number of factories employing similar technique, especially during the latter part of the Sung dynasty, after the main centre at Ting Chou became disorganised. One of the allied classes of white ware has been called Kiangnan Ting, which implies that it was produced at factories in Kiangnan, i.e. in the two provinces of Kiangsu and Anhwei. The features of this type of ware are a creamy glaze and a close crackle. The effect has not inappropriately been likened to pigskin or to an ostrich's egg.

The Ting glaze effect is also obtained by placing on the body a thin white slip and superimposing upon that a transparent film of glaze. The result is to produce a fine white surface with a " softness " very similar to that exhibited by the Ting glaze. Many of the specimens so glazed probably come from the factories of Tz'ŭ Chou which will be mentioned later, and of other districts in southern Chihli.[1]

During the Ming dynasty the traditions were continued, but the body of the ware was made of finer porcelain, and a more " glassy " surface is found. Many of the Ming reproductions, however, are very hard indeed to distinguish from Sung specimens, especially the imitative wares made towards the end of the Ming dynasty in the reigns of Chia Ching and Wan Li.

In the estimation of a very large number of collectors the early celadons hold the highest place. The green, blue-green, and green-grey tones displayed by the celadon wares never weary the

[1] Kulühsien and Kichownan have been named in this connection.

eye and always harmonise with an artistic colour-scheme. Hence their universal popularity not only to-day, but in bygone ages ; specimens of celadon ware have been found in all parts of the world —Java, Sumatra, the Philippines, Borneo, India, Persia, Arabia, Egypt, and Zanzibar.

In Sung days the most important centre of celadon production was a place called Lung Ch'üan, in the province of Chekiang, where there were two brothers by name Chang. The elder brother potted vessels the glaze of which was crackled and which go by the name of Ko ware ; accredited specimens of this ware are scarce. But specimens of the art of the younger brother and of his school are not difficult to find ; we know of a number of wasters dug up on the old kiln-site which enable us to recognise the ancient descriptions recorded in Chinese literature.

The body is a grey porcellanous material which often exhibits a red colour at the foot-rim where it has been exposed to the fire. The glaze varies in colour from a definite green through shades of blue-green to a dove-like grey ; in all cases there is a softness of colour due to the fact that the glaze is not transparent. In the later Ming celadons a more " glassy " appearance is noticeable though the same range of colour tones is found.

The most prized celadon colour is an opaque blue-green or blue-grey which sometimes goes by the name *Kinuta*, a term applied to it by the Japanese and derived from a famous mallet-shaped[1] vase with a glaze of this colour.

Some of the most beautiful of the Sung specimens owe their charm entirely to shape and glaze effect, but others are decorated by ornament in relief or by incised designs.

A curious effect is found in the so-called *tobi seiji*, or spotted celadon, where irregular blotches of dark brown are set in the green glaze. A fine example is seen on Plate LXXII.

The celadons which have been found the world over usually consist of heavy plates and dishes or large vases and bowls ; these went in former days by the title *martabani* ware. The name is derived from the Gulf of Martaban on the shores of which lies the town of Moulmein in Burma. The ware was largely re-exported from this centre. In India these heavy plates are often called *ghori* ware ; a name derived from the town of Ghoor on the Persian-

[1] *Kinuta* means mallet or hammer.

Afghanistan frontier, and the seat of government of the Ghori Emperors of India. They are also called poison plates, from the tradition that they possessed the property of neutralising the effect, or disclosing the presence, of any poison that might be contained in food placed on them.

A great many of these heavy celadon dishes and plates date from Yüan and Ming times when world trade with China was widely developed. A characteristic feature is the broad unglazed ring, often red in colour, found on the bottom of the dish marking the place where the specimen was supported during firing.

A branch of the celadon family is found in the family called " Northern Chinese," a term embracing a group of wares the precise provenance of which is not at present known. The colour of the glaze is an olive green of different shades, and the ware is usually distinguished by a dark brown body and bold incised decoration. Wares of this type were made as early as the 9th century as has been noted on a previous page.

Perhaps the ceramic factory with the longest continuous history in the world is that of Tz'ŭ Chou in Chihli. Crockery Town, to give an English rendering of the Chinese name, is said to have commenced its ceramic existence in the Sui dynasty (589–618 A.D.), and it is still a flourishing manufacturing centre ; thirteen hundred years is a span of time of no mean order, a record in comparison with which only Ching-tê Chên can compete ; and the wares produced from its kilns appear to have been of a similar character throughout its life.

We have no definite examples of pre-Sung date to which we can point, but specimens of Sung origin are easily found. The body is a grey stoneware tending towards a reddish brown colour, and the glaze varies in colour from white to black. The commonest examples are dishes, vases, and jars covered with a white or creamy glaze on which bold designs are painted in brown or black. The white glaze effect is achieved by means of a white slip with a transparent glaze superimposed. Another variety consists of black glaze with or without a design in brown upon it. This black glaze may or may not exhibit " hares fur " markings which are such a feature in the *temmoku* glazes described later.

The Tz'ŭ Chou potter varied his effects by means of an incising tool, and we often find specimens in which the unfired glaze has

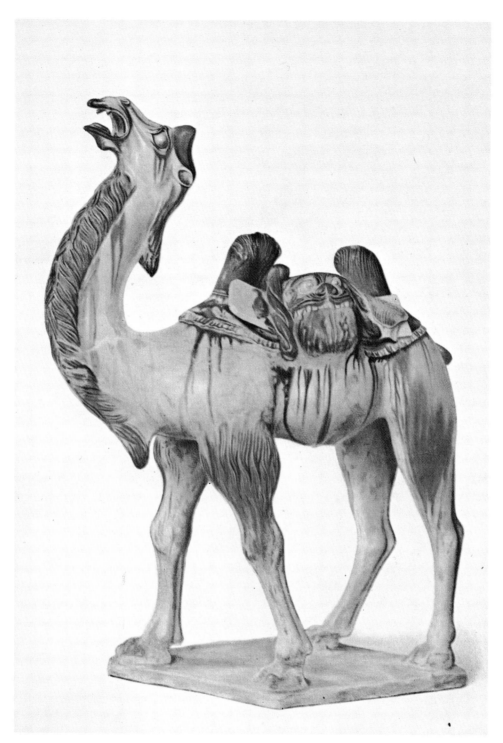

PLATE 10. Model of a Bactrian camel with head in air. Soft white ware with colourless glaze minutely crazed and mottled with yellow and green. The camel is loaded with its pack, the covering of which is in the shape of an animal's head. In front of the pack is slung what appears to be a rolled and twisted blanket. A board passes beneath the pack and blanket at the side of the animal; at its front end a ewer is suspended and at its other end a side of bacon. The modelling of the figure, as of every detail, is superb. The ewer is of special interest on account of its characteristic T'ang shape. The one on Plate 15, though not identical, resembles the pack ewer in general form. This camel is part of the sumptuous furniture of a tomb believed to be that of Liu T'ing-hsün who died in the year 728 A.D. T'ang dynasty. H. 33.1″. *In the possession of Mr. George Eumorfopoulos.*

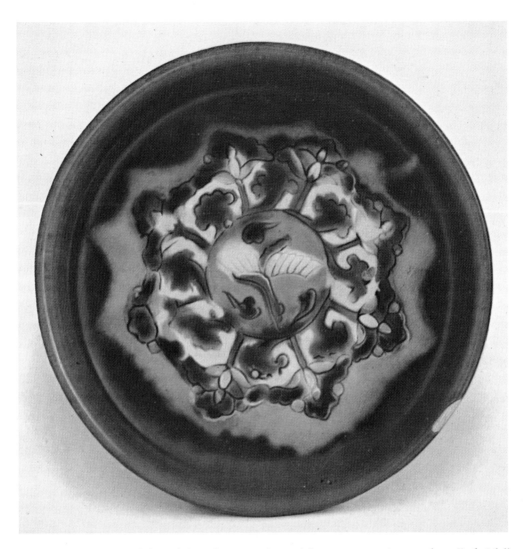

PLATE 13. Circular dish with low slanting sides and flat centre, resting on three "cabriole" legs. Soft white pottery with incised designs glazed white and yellow in a blue ground. The glaze is soft looking and, as usual, finely crazed. In the centre is the design of a mirror of "water-chestnut" form enclosing a medallion with a flying crane. Dishes of this form have been found in tombs with a number of small cups set out on them. T'ang dynasty. D. 11.5". *In the possession of Mr. George Eumorfopoulos.*

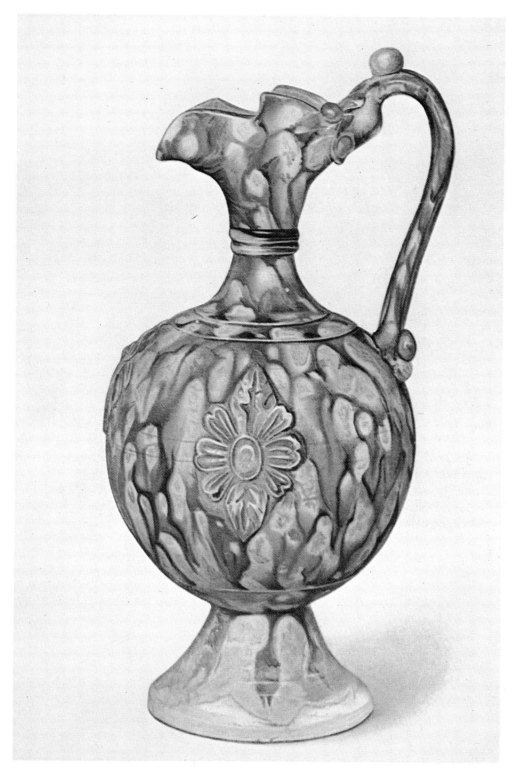

PLATE 15. Ewer with globular body, contracted neck, and three-lobed mouth, hollow bell-shaped foot, and high handle with double rib and a stud at either end. Hard white pottery with applied ornaments of rosette and palmette design on the sides, and a colourless glaze mottled with green and yellow. The handle, though ending in a palmette instead of a serpent's head, is evidently of serpentine derivation, and this combines with the general form of the vessel to suggest Hellenistic influences. They have, as a consequence, obvious affinities with certain Italian wares of the Renaissance. T'ang dynasty. H. 10.6″. *In the possession of Mr. George Eumorfopoulos.*

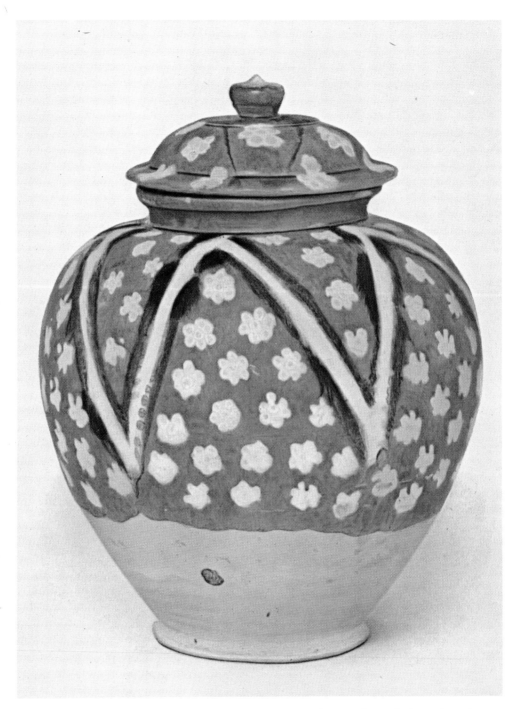

PLATE 20. Jar with ovoid body, short, slightly spreading neck, and dome-shaped cover
with knob; flat base with bevelled edge. Light buff ware with a wash of white slip and
designs reserved in white in a green ground, a band of chevron pattern with scattered plum
blossoms between. The chevrons are bordered with blue lines broken by dabs of yellow.
The glaze, as usual, is transparent and almost colourless in itself, and the colour is applied
locally on the body of the ware: the glaze stops some distance above the base. T'ang dynasty.
H. 10.5". *In the possession of Mr. George Eumorfopoulos.*

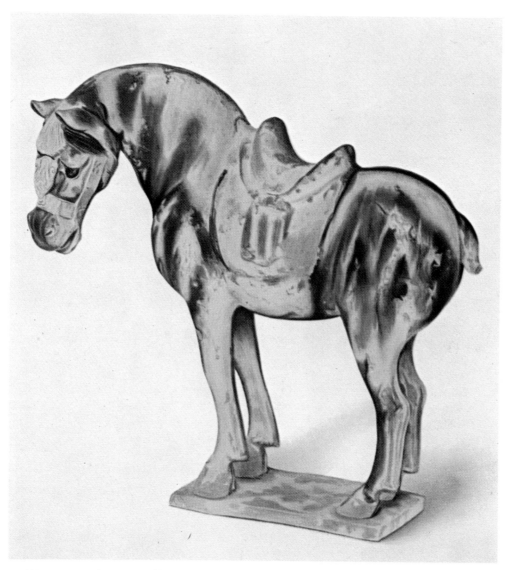

PLATE 22. Model of a saddled horse standing on a flat rectangular base; soft white pottery with transparent, almost colourless, glaze splashed with blue. The plum blossom ornaments on the head-harness and the palmette-shaped pad on the nose are characteristic T'ang decorations. The delightful modelling of the animal needs no comment. T'ang dynasty. H. 11.5″. *In the possession of Mr. George Eumorfopoulos.*

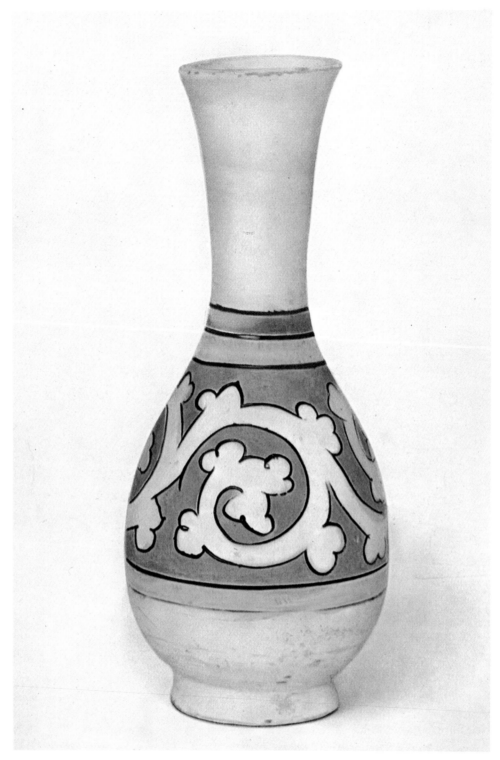

PLATE 24. Bottle with slender pear-shaped body and tall neck expanding slightly towards the mouth; hollow foot. Grey pottery body with dressing of white slip and incised ornament, and a transparent glaze locally coloured, viz. a broad belt with foliage scroll, white in a green ground, bordered with yellow. The glaze on the neck is a beautiful pearly white and of great depth and solidity; it stops below the decorated part. The resemblance of the design to the Gothic scrolls such as appear on European mediæval textiles and on the pavement tiles from Chertsey Abbey and elsewhere, is interesting though probably fortuitous. T'ang dynasty. H. 8.5". *In the possession of Mr. George Eumorfopoulos.*

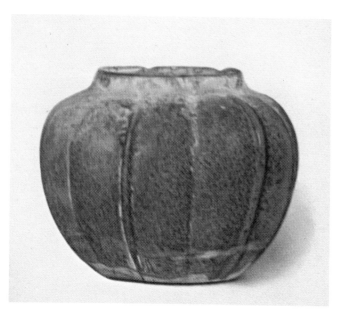

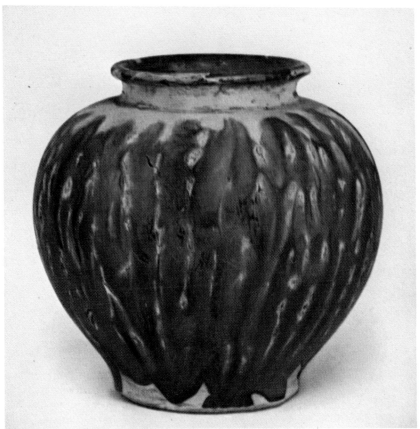

PLATE 26. Fig. 1. Water-pot of melon shape, of reddish buff pottery with yellow glaze inside and mottled aubergine purple outside. The glazes are encrusted in places, especially in crevices, with iridescence which can only have been formed by prolonged chemical action under conditions such as would obtain during burial. Though this aubergine colour is very rare on T'ang pottery, there is reason to think that the piece belongs to that period. T'ang dynasty. H. 2.75". *In the possession of Mr. A. L. Hetherington.* Fig. 2. Vase with ovoid body, low contracted neck with slightly spreading lip, and flat base with bevelled edge. Soft white pottery with pale straw-coloured glaze liberally splashed with blue. The glaze as usual is minutely crazed. T'ang dynasty. H. 4.9". *In the Victoria and Albert Museum.*

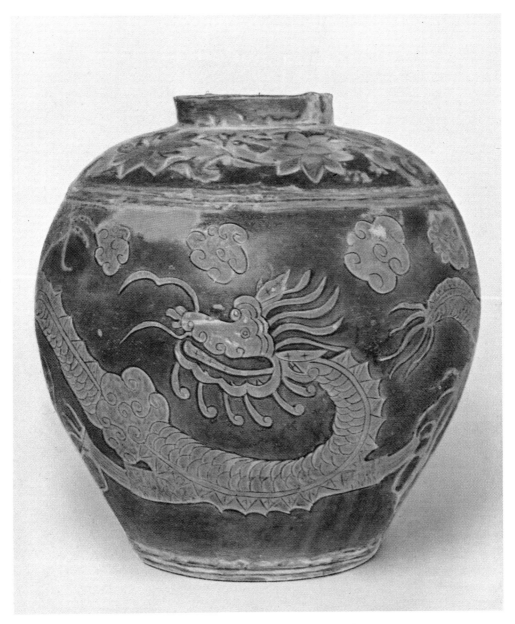

PLATE 28. Vase of rounded oval form with short straight neck and narrow mouth; a band of wheel rings on the shoulder and above the base, which is flat. Red earthenware with white slip covering which has been scraped away so as to leave the ornament in white relief in the red ground. Much of this ornament has in turn been coloured green, and the whole is covered with a transparent glaze of faintly yellowish tint. The final effect is a white and mottled green design in an orange-red ground. The glaze has scaled off in parts. The design consists of a large and boldly etched dragon among cloud-scrolls, and on the shoulder a border of running lotus pattern. This is an early example of the graffiato technique; the colour-scheme is unusual, but closely resembles that of a remarkable figure in the British Museum which was found in Szechwan in the tomb of a dignitary who died in 839 A.D. T'ang dynasty. H. 15.5". *In the possession of Mr. George Eumorfopoulos.*

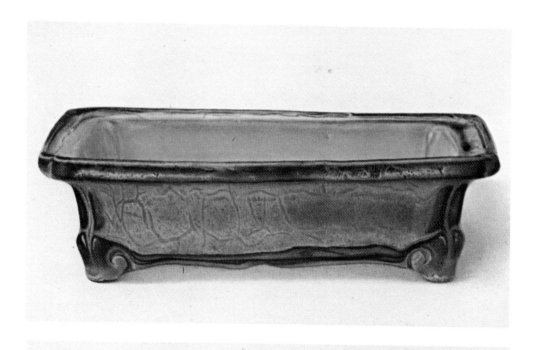

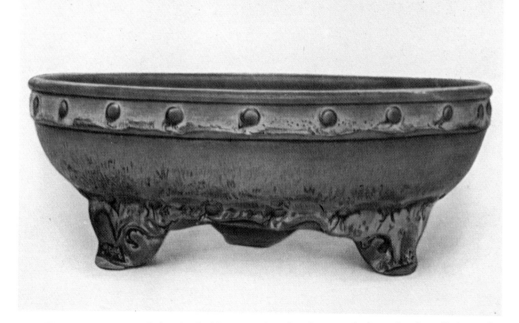

PLATE 33. Fig. 1. Bulb-bowl of oblong rectangular form with four cloud-scroll feet. Grey porcellanous ware with purplish opalescent glaze on the outside showing prominent "earth-worm" marks (see p. 8). The inside has a *clair de lune* glaze with the body showing through where the glaze is thin. The base is washed over with a greenish brown glaze, and has the usual ring of spur-marks and the numeral *shih* (ten) incised. Chün ware. Sung dynasaty. L. 7.1″. *In the possession of Mr. F. N. Schiller.* Fig. 2. Bulb-bowl, circular, with three cloud-scroll feet; of shallow bowl-shape with grooved band below the lip outside and a row of studs. Grey porcellanous ware of fine grain with thick opalescent glaze, mottled grey inside with prominent "earth-worm" marks; on the outside the glaze which runs in thick welts on the lower part is purple streaked and splashed with flocculent grey. The characteristics of the base will be seen on the next plate. With regard to the form, the *Po wu yao lan* remarks "of these (Chün) wares, the sword-grass bowls and their saucers alone are refined." It would appear that the flower-pots, such as that of Plate 35, are the sword-grass bowls, and that shallow bowls like the present one were originally used as saucers or stands for the flower-pots. They would, and indeed did, also serve separately as bowls for growing bulbs. Chün ware. Sung dynasty. D. 9.5″. *In the possession of Mr. George Eumorfopoulos.*

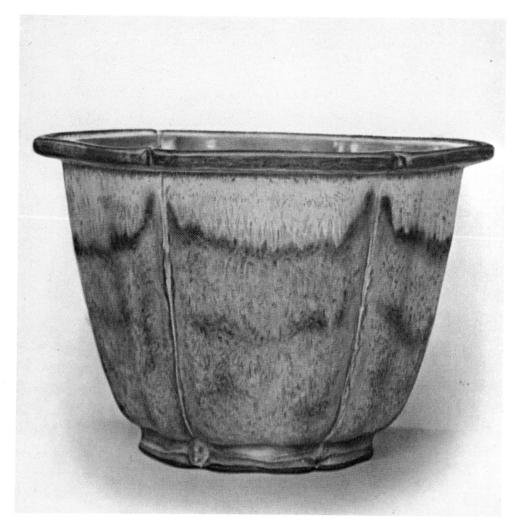

PLATE 35. Hexagonal flower-pot with narrow flat rim. Grey porcellanous ware with thick opalescent glaze, of purplish lavender colour flecked with grey inside, and of purple colour, verging on crimson, and heavily splashed and flecked with grey on the outside. Olive-brown glaze under the base, and the numeral *liu* (six) incised. There is besides an inscription incised during previous ownership—*Chien fu kung. Chu shih hsia shan yung* "Chien-fu palace. For use on the artificial hill of rockery and bamboos"; the latter doubtless refers to a pavilion in the pleasure grounds of the palace. For a note on the incised numerals found on this type of ware, see Plate 34. Chün ware. Sung dynasty. H. 6.5″. *In the possession of Messrs. G., R. and C. Benson.*

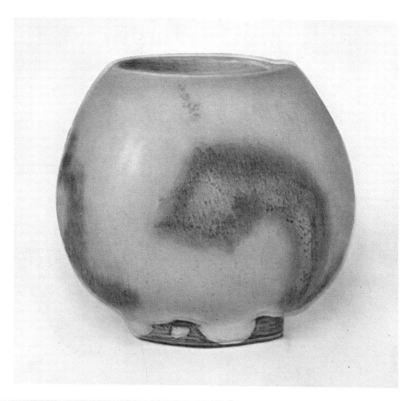

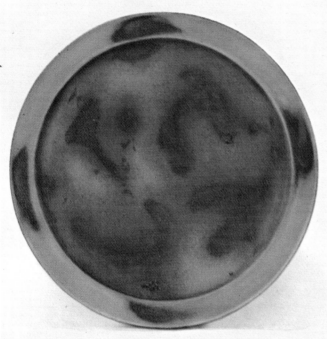

(ABOVE) PLATE 37. Water pot in the shape of a lotus bud with slightly contracted mouth. Greyish white porcellanous ware burnt brown at the exposed edge of the base. Thick, pitted opalescent glaze of pale blue colour with three S-shaped patches of purple. The glaze is thin at the lip, but has formed thickly in the lower part and there is a patch of it under the base. The purple markings on this piece are symmetrical and evidently were produced intentionally. Kuan ware. Sung dynasty. H. 3.5". *In the possession of the Misses Alexander.*

(BELOW) PLATE 38. Plate with flat bottom and narrow, flat foot-rim. Greyish white porcellanous ware burnt red on the raw edge of the foot-rim. Thick opalescent glaze of bluish colour with patches and suffusions of purple frosted with green. The base is glazed. Plates of this typical Sung form sometimes have a ring of spur-marks on the base recalling those of the Chün ware bulb-bowls. This particular specimen is a fine example of the gorgeous effect produced by the skilful use of copper in different conditions. Kuan ware. Sung dynasty. D. 7.4". *In the possession of the Misses Alexander.*

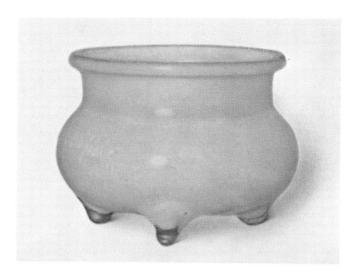

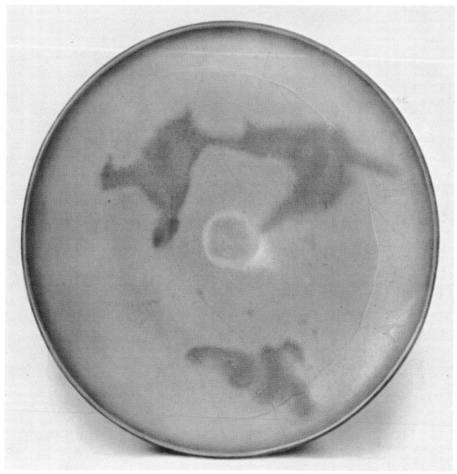

PLATE 41. Fig. 1. Incense vase on three small feet; depressed globular body and straight neck with expanded mouth-rim. Grey porcellanous ware with thick, smooth, opalescent glaze of pale lavender-grey colour with blushes of purple. Chün ware. Sung dynasty. D. 3.4″. *In the possession of Mr. H. J. Oppenheim.* Fig. 2. Shallow bowl with wide mouth and small foot. Grey porcellanous ware (burnt red on the unglazed base) with thick opalescent glaze of lavender-grey colour with splashes of purple on the interior. The glaze has run thick at the mouth and the colour has faded into a brownish edge, but it has correspondingly thick-ened round the base where it stops in an irregular line. Chün ware. Sung dynasty. D. 5.25″. *In the possession of Mr. H. J. Oppenheim.*

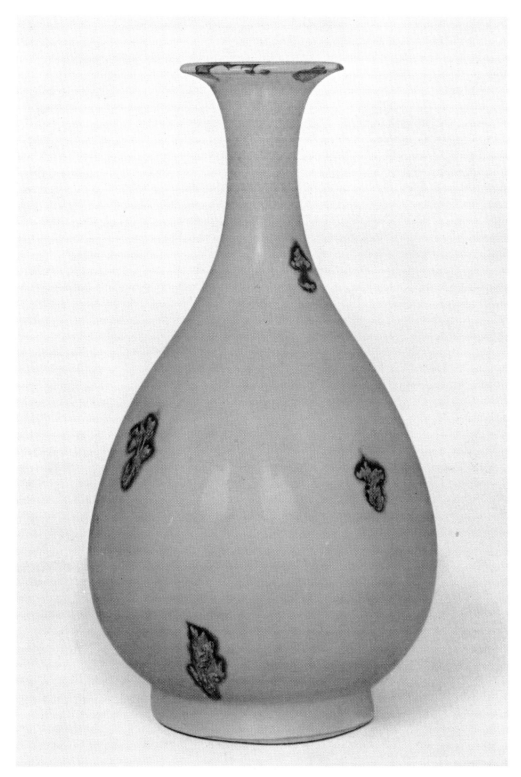

PLATE 72. Bottle, with pear-shaped body, slender neck, and spreading lip. Grey por-
cellanous ware with green celadon glaze and splashes of lustrous brown. This spotted celadon
is known by the Japanese (who prize it greatly) as *tobi seiji* or "buck wheat" celadon. The
spots are formed by dabs of glaze containing ferric oxide; and the type was doubtless at first
the outcome of accidental spotting of the celadon glaze which owes its colour to ferrous oxide.
Lung-ch'üan ware. Sung dynasty. H. 10.75″. *In the possession of Mr. George Eumorfopoulos.*

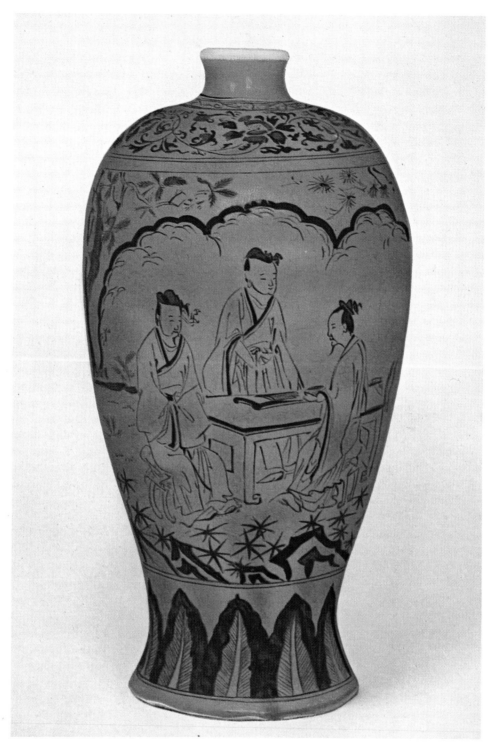

PLATE 83. Vase of baluster form with high shoulders, short neck, and small mouth. Red-
dish stoneware, as seen at the base, which is unglazed, with coating of white slip and designs
finely painted in black under a soft transparent blue glaze. On the body are two panels with
figure subjects in garden landscape. In one, three persons grouped round a table with a musi-
cal instrument, representing Music, which is one of the Four Liberal Accomplishments (see
Plate 116). In the other, Checkers is represented by two players seated at a table; another
figure stands behind, and a fourth approaches with a bundle of wood on his shoulder. This last
is doubtless Wang Chih, the Rip van Winkle of China, who watched a game of chess played
by Immortals in a mountain grotto. One of the players, the story goes, gave him an object like
a date stone to put in his mouth, and he became oblivious to hunger, thirst, and time. When
advised at length to go home, the handle of his woodman's axe had powdered into dust, and
on his return he found all his kith and kin long since dead. On the shoulder, a band of floral
scroll; and stiff leaves above the base. Tz'u Chou type. 14th century. H. 10.25″. *In the posses-
sion of Mr. George Eumorfopoulos.*

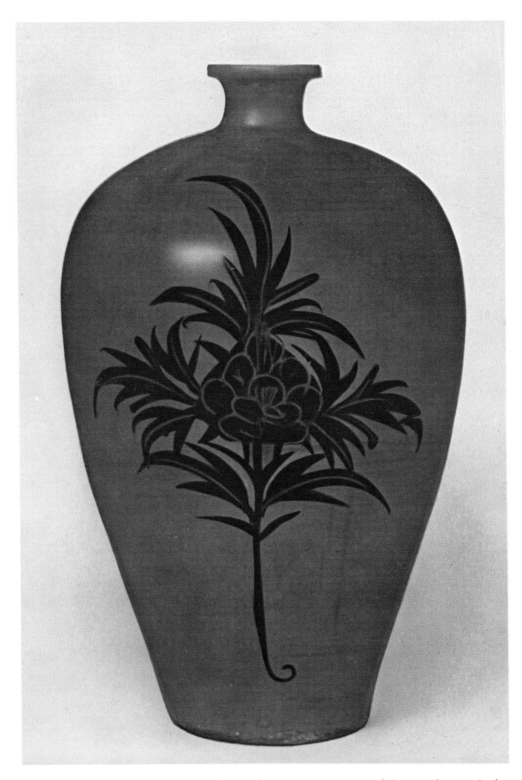

PLATE 85. Vase with ovoid body, short neck, and small mouth slightly spreading at the lip. Buff-grey stoneware with coating of white slip and three groups of boldly painted designs of a flower with fern-like foliage in black under a transparent green glaze. The base is covered with white slip and transparent colourless glaze. The green extends over the foot-rim which bears the marks of five supports. Tz'u Chou type. Sung dynasty. H. 12″. *In the possession of Mr. George Eumorfopoulos.*

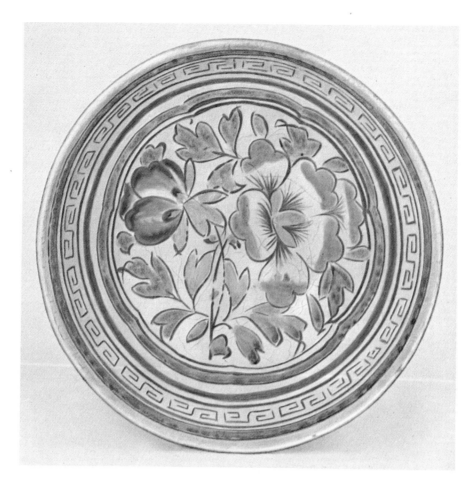

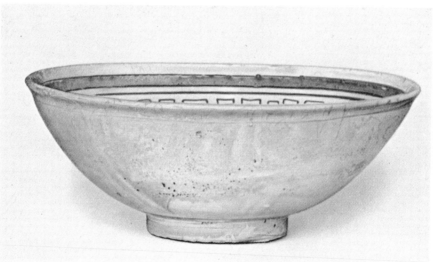

PLATE 92. Bowl with rounded sides and low, narrow foot. Buff-grey stoneware with wash of white slip and a transparent cream-white glaze with a tendency to crackle. Outside, the glaze is thin, and ends in an irregular line short of the base as is seen in the side view of the bowl. Inside it forms with the underlying slip a fine cream-white surface on which a beautiful design is painted in red, green, and yellow enamels. In the centre is a mirror-shaped panel with spray of peony; around this is a band of red key-fret pattern between plain bands of red and green. The designs are outlined in red. A similarly painted bowl, bearing a date equivalent to 1203 A.D., was illustrated in the *Kokka,* November, 1921. The enamels are of great interest on so early a specimen. The red is a rich, tomato colour showing signs of iridescence; the green is a strong leaf-green and the yellow a rather muddy and brownish colour; both the last colours are frosted over to a great extent by decay. The enamels have, as one would expect, clear affinities with those used on Ming porcelain. ? Tz'u Chou ware. Sung dynasty. D. 8.6″. *In the possession of Mr. O. C. Raphael.*

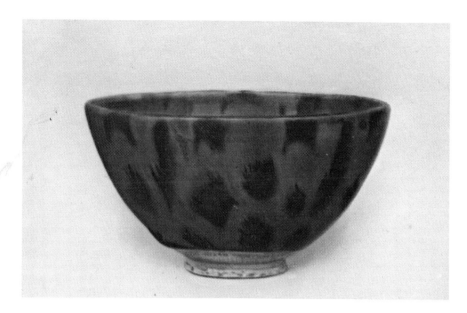

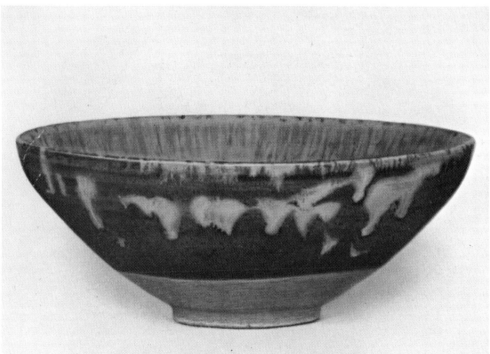

PLATE 100. Fig. 1. Tea-bowl with gently curving sides and narrow foot. Buff stoneware with thick brown glaze streaked with black. The markings on the inside of this choice bowl roughly resemble a chrysanthemum flower, and those outside are of the tortoise-shell type. Honan ware. Sung dynasty. D. 3.12″. *In the possession of Mr. George Eumorfopoulos.* Fig. 2. Bowl with wide mouth slightly contracted at the lip, sloping sides, and narrow foot. Buff stoneware. On the outside the glaze is red-brown with splashes of yellow, of grey tone giving a tortoise-shell appearance. On the inside the yellow splashing is more general, except in three places where the red-brown predominates. These may be attempts at bird designs, but the glaze has run and the detail of the decoration cannot now be distinguished. There is, however, some similarity of technique to that displayed in the bowls on Plate 103. The glaze stops short of the base without any thick roll. Honan ware. Sung dynasty. D. 6.25″. *In the possession of Mr. George Eumorfopoulos.*

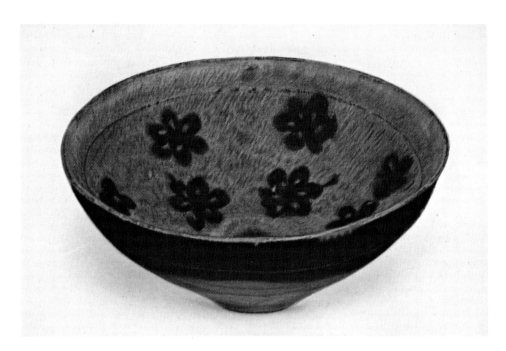

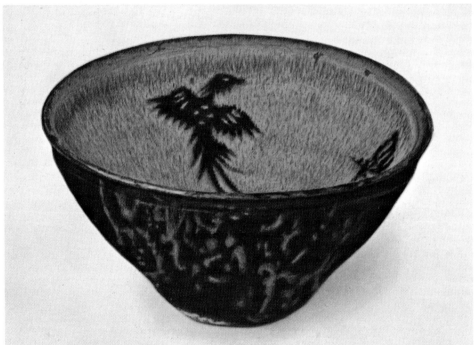

PLATE 103. Fig. 1. Tea-bowl of somewhat shallow nature. Buff stoneware with dark brown temmoku glaze on the outside stopping short of the foot-rim. Inside, the glaze is a flocculent grey with a purplish tone, and in the glaze are drawn a series of plum blossoms in brown-black which give a rosette appearance. This is one of the family of temmoku bowls referred to on p. 15 of the introduction, and said to have been made at Yung-ho Chên in the prefecture of Chi-an in the province of Kiangsi. Sung dynasty. D. 4.6″. *In the possession of Mr. F. N. Schiller.* Fig. 2. Tea-bowl of conical form with mouth lightly channelled on the exterior. Buff stoneware with black temmoku glaze outside reaching practically to the base, and mottled with yellowish grey markings, giving a tortoise-shell appearance. Inside, the glaze is a flocculent grey with a bluish band near the mouth; lower down the glaze is grey, flecked with deep yellow; in this glaze designs are drawn in brown-black, viz. a plum blossom on the bottom and two phœnixes and butterflies on the sides. As in the case of Fig. 1 on this plate, the bowl is reported to have been made in Chi-an Fu in Kiangsi. Sung dynasty. D. 5″. *In the possession of Mr. F. N. Schiller.*

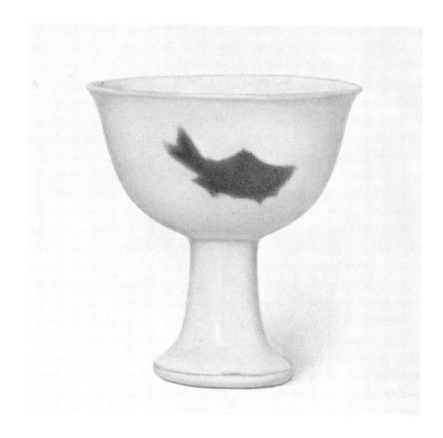

PLATE 108. Fig. 1. Stem cup (*pa pei*), goblet-shaped; fine white porcelain with three fishes in brilliant red under the glaze. The stem is hollow. Mark in blue inside the bowl enclosed by a double ring, *Ta Ming Hsüan Tê nien chih,* made in the Hsüan Tê period of the Great Ming dynasty (i.e. 1426–35 A.D.). This period is famous for its underglaze red derived from copper, and these stem cups with fish are specially mentioned among the triumphs of the time. H. 3.1″. *In the possession of Mr. P. David.* Fig. 2. Dish, saucer shaped. Porcelain, with red glaze inside and out, except for a narrow band at the mouth-rim and the hollow of the base, which are white. Under the base is, faintly incised within a double ring, the mark of the Hsüan Tê period in six characters (1426–35). The red, derived from copper, has developed a brilliant crimson on the sides, though it is rather duller in the middle. It is the *chi hung* or sacrificial red for which the Hsüan Tê period was famous. Cf. *Po wu yao lan,* "bowl, in colour red as the sun, but with white mouth-rim." The paste is fine-grained, and browned at the exposed edge. The white glaze under the base is solid-looking and of bluish tone. D. 8.3″. *In the British Museum.*

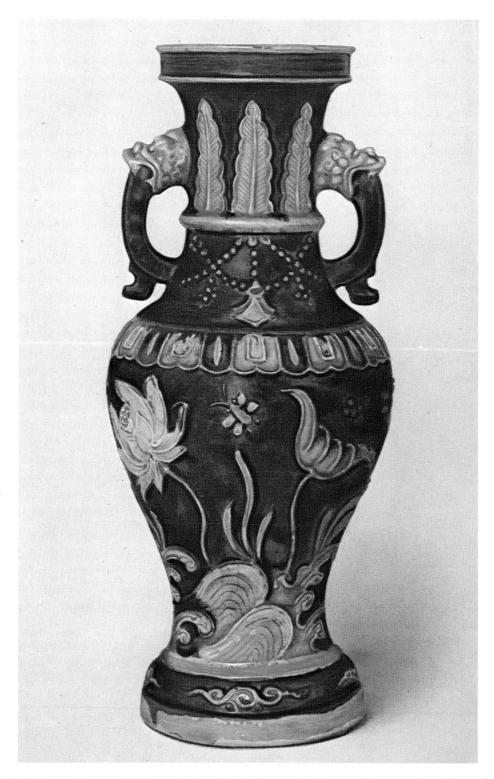

PLATE 110. Vase with baluster body, tall, slender neck with spreading mouth, and spreading base. Two handles on the neck issuing from dragon heads. Porcelain with designs outlined in threads of clay (cloisonné style) and washed in with coloured glazes—turquoise, brownish yellow, and impure white in a dark violet-blue ground. On the sides, lotus plants in waves, and insects; a petal border on the shoulder. On the neck a band of stiff plantain leaves and a band of pendent jewels with a ridge between. Scrolls on the base. The bottom is splashed with green glaze, and shows in the unglazed parts a reddish biscuit. A good example of *san ts'ai* or "three-colour" ware, see p. 17. 15th century. H. 11.5". *In the possession of Mr. H. J. Oppenheim.*

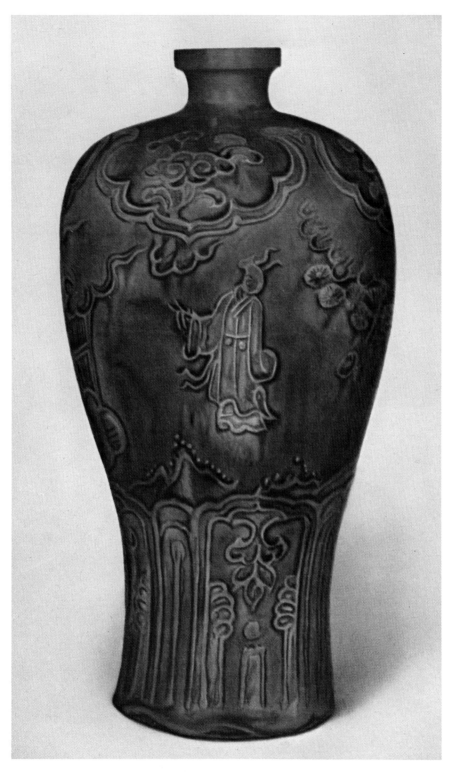

PLATE 112. High-shouldered baluster vase with small mouth (*mei p'ing*). Porcelain with designs lightly outlined in threads of clay and coloured with yellow, white, and aubergine glazes in a deep green ground. The main ornament represents a mountain retreat with pine tree and mists; on one side is a sage, and on the other an attendant with a lute (*chin*). On the shoulders are *ju-i* shaped lappets enclosing sprays of *ling chih* fungus; and above the base, a deep border of false gadroons. The biscuit, where it appears on the partially glazed base, has burnt a deep reddish brown. 15th century. H. 12″. *In the possession of Mr. Anthony de Rothschild.*

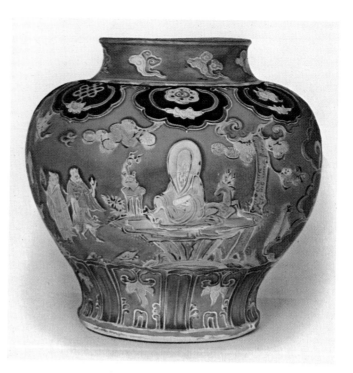

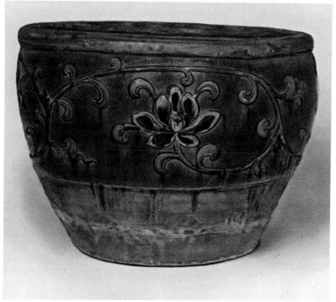

PLATE 115. Wine jar of potiche form with low neck and wide mouth. Porcelain with designs outlined in threads of clay in cloisonné style, and washed in with coloured glazes—aubergine, yellow, dark violet, blue, and white—in a turquoise ground. Green glaze inside. On the body, Shou Lao (God of Longevity), is seattd on a rocky throne with a scroll in his left hand, an incense burner and his familiar, a deer, beside him; a tortoise in front, and a stork flying above are other attendant emblems of longevity. The Eight Immortals approach to pay him court, Li T'ieh-kuai and Ho Hsien Ku, appearing in front. Below is a band of false gadroons, and above ju-i shaped lappets enclosing the Eight Buddhist Emblems (pa chi hsiang), of which the knot, the wheel, and the conch shell are seen in the picture. Propitious cloud-scrolls on the neck. 15th century. H. 13″. In the possession of Messrs. G., R. and C. Benson.

PLATE 125. Fish-bowl, tub-shaped, with rolled rim. Hard reddish pottery with a lotus scroll design, modelled in low relief and washed in with coloured glazes—aubergine and blue—upon a green ground bordered above and below with broad belts of peacock blue. Blue glaze inside. These massive fish-bowls were frequently demanded by the Imperial patrons of Ching-tê Chên, and caused much trouble in their successful production. Those made of porcelain were particularly difficult to fire without damage; sometimes they were as large as 36 inches across and 24 inches high. 16th century. D. 26.5″. In the possession of Messrs. G., R. and C. Benson.

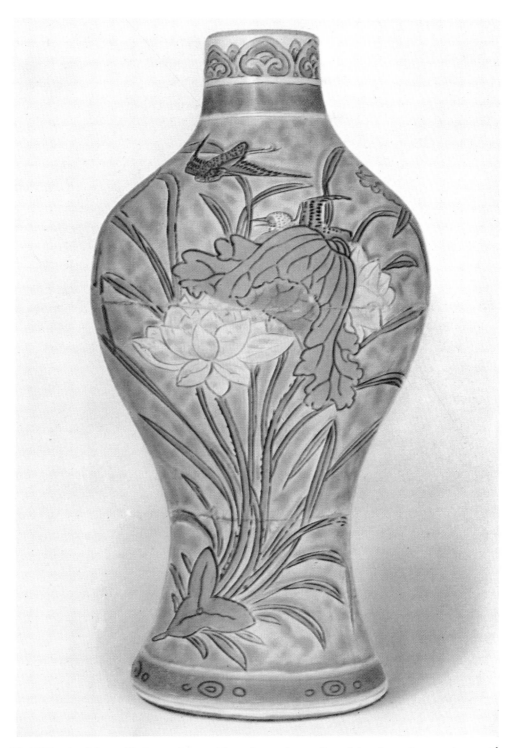

PLATE 117. Vase of baluster form with neck cut down. Porcelain of massive structure with borders in underglaze blue and bold design of lotus plants and egrets outlined in reddish brown and washed in with enamel colours in a mottled turquoise ground; border of *ju-i* pattern on the neck. Other vases of this form and structure are known, with the Ch'êng Hua mark. None of those known in this country appears to have survived without damage to the neck. 15th century H. 16". *In the possession of Mr. T. H. Green.*

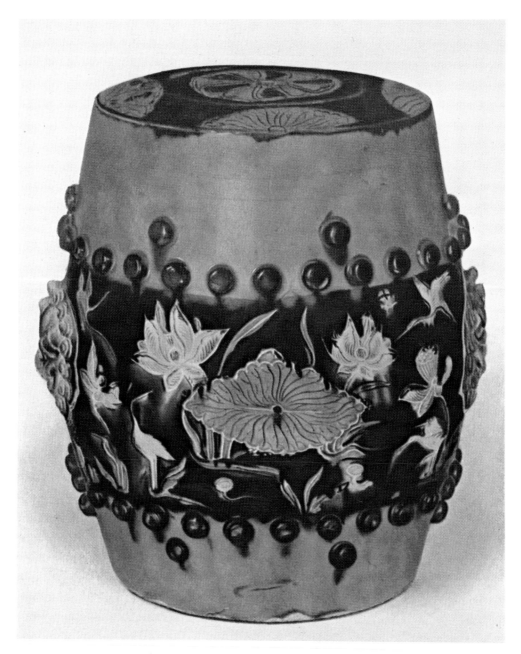

PLATE 119. Barrel-shaped seat with two lion-mask handles. Porcelain, with designs incised and bordered with threads of clay, and washed in with coloured glazes. On the sides, a broad belt with design of lotus plants and egrets in a dark violet-blue ground, between two broad bands of turquoise. The central design is bordered with large studs. On the top, a formal lotus blossom between four lotus leaves incised and glazed in colours in a dark violet blue ground. The *Po wu yao lan* (a late Ming work) alludes to "beautiful barrel-shaped seats . . . gorgeous as cloud-brocades" among the specialities of the Hsüan Tê period. Such things continued to be made throughout the Ming period. About 1500. H. 13″. *In the possession of Messrs. G., R. and C. Benson.*

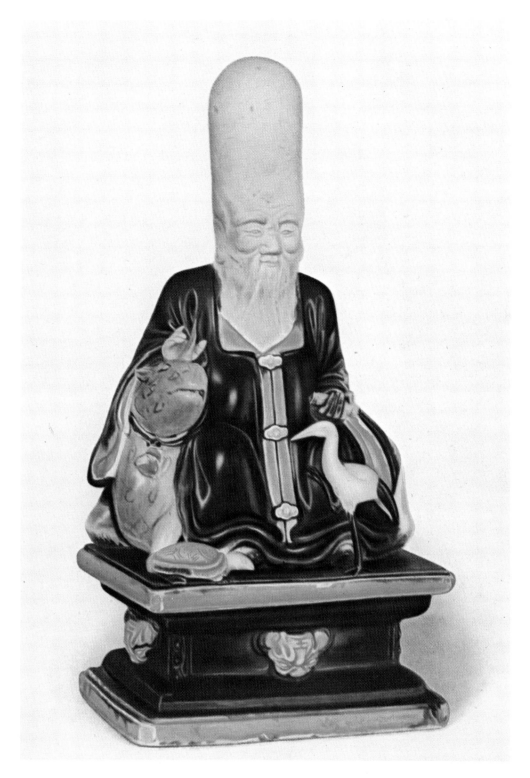

PLATE 121. Figure of Shou Lao, God of Longevity, with elongated forehead, seated on a deer and holding a scroll, with his tortoise and stork before him. Finely modelled in porcelain with coloured glazes—dark violet-blue, turquoise, and yellow; the flesh parts and some other details are in unglazed biscuit. Rectangular pedestal with tiger heads in relief. The deer, tortoise, and stork, all familiars of the God of Longevity, are themselves regarded as emblems of long life. About 1500. H. 10.4″. *In the possession of Mr. Anthony de Rothschild.*

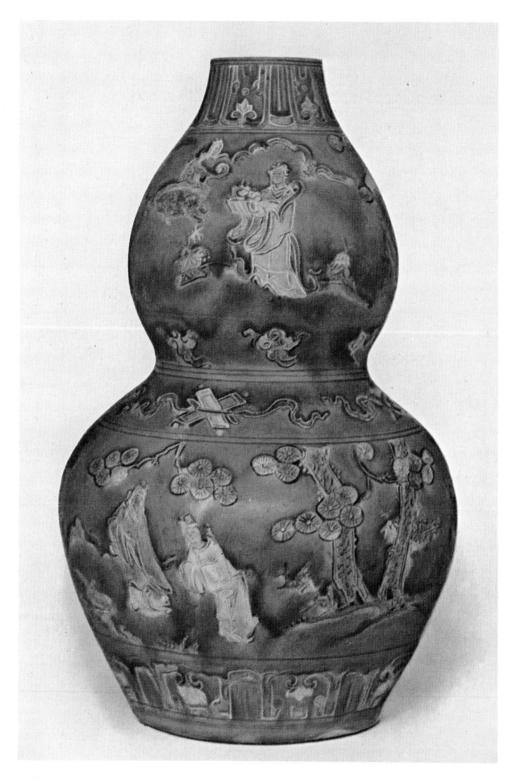

PLATE 123. Vase of double-gourd form. Porcelain with designs outlined in threads of clay (cloisonné style), and washed in with coloured glazes—aubergine, yellow, and white in a turquoise ground. Green glaze inside the mouth. The main designs are set in a mountain landscape with pine trees and mists; on the upper bulb are Shou Lao, God of Longevity, with his deer, and Hsi Wang Mu, Queen Mother of the West; on the lower bulb are the Eight Taoist Immortals (*pa hsien*). At the waist are symbols bound with fillets and *ju-i* cloud-scrolls (propitious clouds); and at the mouth and above the base are borders of false gadroons. The base is unglazed. About 1500. H. 18.75". *In the possession of Mr. George Eumorfopoulos.*

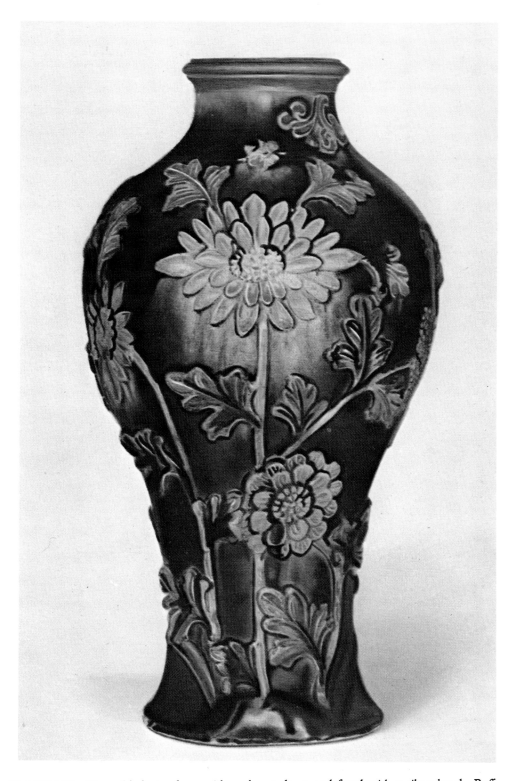

PLATE 127. Vase of baluster form with neck cut down and fitted with a silver band. Buff-white porcellanous stoneware with chrysanthemum designs modelled in relief and washed over with coloured glazes—turquoise and cloudy white—in a ground of violet aubergine with patches of peacock blue. 16th century. H. 14". *In the possession of Messrs. G., R. and C. Benson.*

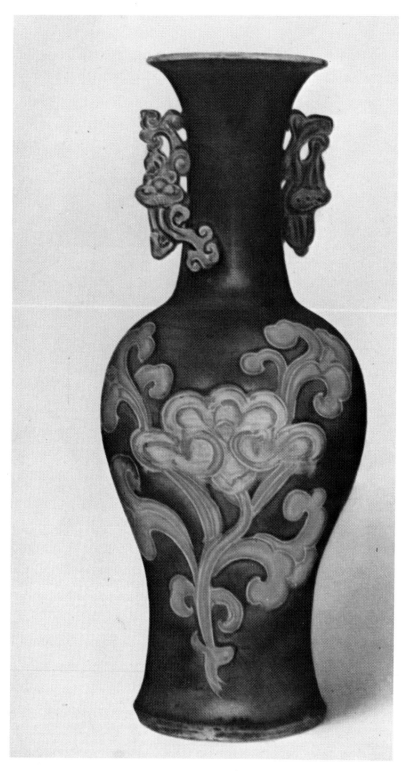

PLATE 129. Vase of beaker shape with baluster body, straight, slender neck with spreading mouth, and two handles modelled in the form of conventional lily sprays. Buff-white porcellanous stoneware with a formal lily design outlined in threads of clay and washed in with turquoise and cloudy white glazes in a ground of dark aubergine, finely dappled. 16th century. H. 18.5". *In the possession of Messrs. G., R. and C. Benson.*

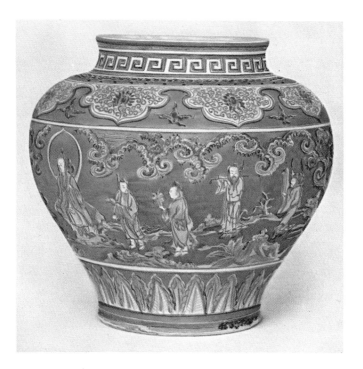

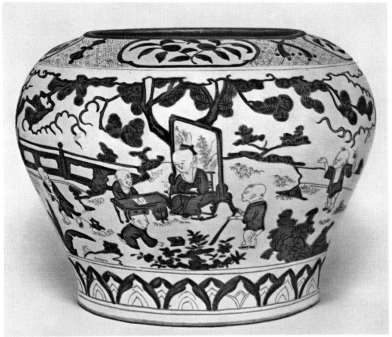

PLATE 130. Wine-jar of potiche form with short neck and wide mouth. Porcelain decorated in underglaze blue, the background of the design washed over with a beautiful tomato-red enamel. The main subject represents the Eight Immortals paying court to Shou Lao, God of Longevity, who is seated on a rock throne with an incense burner before him and his familiar, the crane. The scene is set in a rocky landscape with pine tree and mists. On the shoulder are ju-i shaped lappets enclosing lotus scrolls, and a narrow band of plain ju-i pattern; on the neck is a band of key-fret (cloud and thunder pattern); and above the base a border of stiff leaves. The base is unglazed and shows the massive construction of the vessel. The glaze inside is thick, but uneven, and the paste seen at the parting of the glaze has burnt a reddish colour. Early 16th century. H. 13″. *In the Victoria and Albert Museum.*

PLATE 148. Wine-jar, or potiche; porcelain painted in the dark Mohammedan blue of the Chia Ching period with a continuous garden landscape with children at lessons and at play. The foot-rim shows a slightly red discoloration; and the base, which is glazed, is marked in blue with the *nien hao* of Chia Ching in six characters. Though time has been unkind to the upper part of this vase it remains a splendid example of Chia Ching blue and white. H. 11.75″. *In the possession of Mr. S. D. Winkworth.*

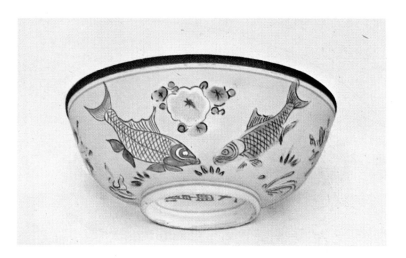

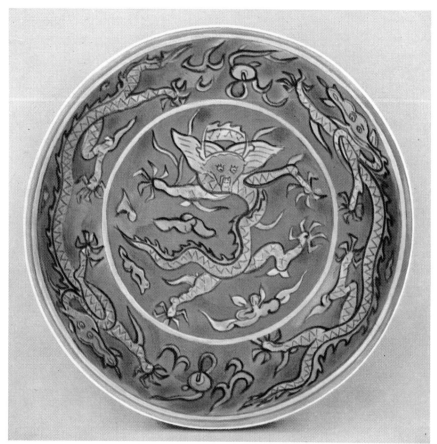

PLATE 132. Fig. 1. Shallow wine cup with convex bottom. Fine porcelain painted in enamel colours. Inside is a medallion with rock and waves. Outside, two pairs of fishes in water-weeds painted in turquoise-green, red, and yellow. Under the base is the mark of the Chia Ching period in blue (1522–66). The *Po wu yao lan* (a late Ming work) makes a special mention of shallow wine cups—with everted rim and convex interior, decorated in colours with fish— as one of the specialities of the Chia Ching period. A pattern of waves punctuated by conical rocks (apparently in allusion to the rocky islands of the Taoist Paradise) is a favourite border design on Ming wares. It has been called the "rock of ages pattern." 16th century. D. 3". *In the possession of Mr. George Eumorfopoulos.* Fig. 2. Saucer dish with everted rim. Porcelain with mottled underglaze blue ground and reserved designs, of Imperial five-clawed dragons pursuing pearls, outlined and shaded in red and enamelled with yellow. In the centre is a full-face dragon (*mien lung*), and on the sides within and without two side-face dragons; there are clouds and flames in the spaces. The designs have a double outline, one in blue under the glaze, and the other in red over the glaze. White glaze under the base, and mark of the Wan Li period in blue in six characters within a double ring. Late 16th century. D. 5". *In the possession of Mr. H. J. Oppenheim.*

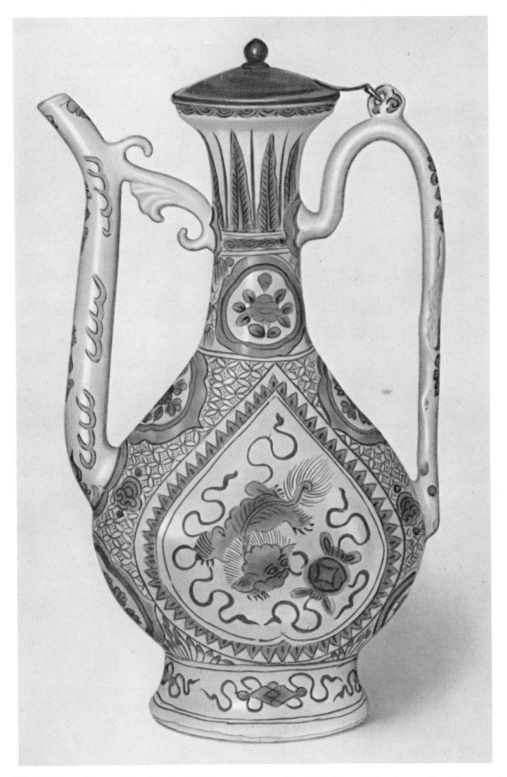

PLATE 134. Ewer (*hu p'ing*) with flattened pear-shaped body, tall slender neck with spreading mouth, low foot, long handle with eyelet for attaching the lid, and long spout braced to the neck with a palm scroll; silver lid. Porcelain enamelled with turquoise-green, leaf green, and tomato red. On the back and front is a heart-shaped panel lightly moulded in relief, and painted with a Buddhist lion sporting with a ball of brocade; on the sides, a red plum-blossom diaper interrupted by four quatrefoil panels of flowers and four *ju-i* ornaments. Similar panels on the neck, with pendent jewels and a border of stiff plantain leaves; symbols on the foot, spout, and handle. The turquoise-green, which is a feature of this piece, is an enamel peculiar to Ming porcelains. It was replaced in the next dynasty by a violet-blue enamel. Chia Ching period. H. 9.25". *In the possession of Mr. H. J. Oppenheim.*

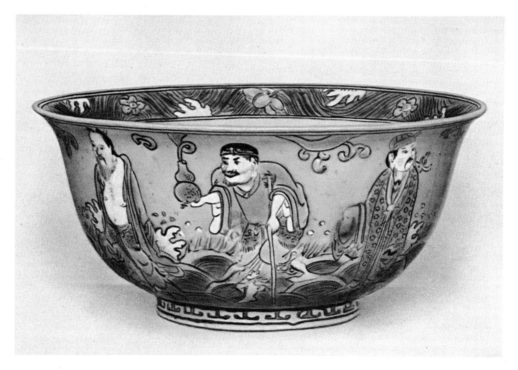

PLATE 138. Fig. 1. Wine cup of *ju-i* shape, with moulded base; the handle is in the form of a *ju-i* sceptre. Porcelain with yellow glaze outside and white within. The *ju-i* (as you wish) sceptre is supposed to bring about the fulfilment of wishes. Its head is usually in the shape of a *ling-chih* fungus, which is itself an emblem of long life. So that there is double reason why this propitious form should have been so popular with the Chinese craftsman. Two positions are illustrated to show the form of the cup. 16th century. H. 1.4″. *In the possession of The Honble. Mrs. Walter Levy.* Fig. 2. Bowl with curved sides and everted rim. Porcelain painted in enamel colours on the biscuit. Inside is Shou Lao, God of Longevity, and his stork; border of wave and plum-blossom pattern. Outside are the Eight Immortals crossing the sea on their way to the Taoist Paradise. The designs are in green, aubergine. and white in a yellow ground. The figures in view are Lü Tung-pin with his sword slung on his back; Li T'ieh-kuai with crutch and gourd from which magic exhalation is rising; and the portly Chung-li Ch'üan with bare abdomen. Mark of the Chia Ching period (1522–66). D. 7.75″. *In the possession of Mr. George Eumorfopoulos.*

been removed to form the design so that on firing the latter stands out as a bold relief on the exposed biscuit. In the white glazed pieces the slip may be etched away in a similar fashion so that the body shows below the transparent glaze in parts and the white slip elsewhere forms the design.

Though black and white, or brown and white, decorations are the usual embellishments of the Tz'ŭ Chou ware, they are not the only ones. Painted designs in red and green upon a white ground are also found on ware resembling that of Tz'ŭ Chou, and they constitute one of the few manifestations of polychrome decoration in the Sung dynasty.

Allied to the Tz'ŭ Chou ware, but probably executed at some other centre, are specimens with a reddish stoneware body and with painted or incised designs covered with a transparent blue or green glaze. The technique is so like that employed at Tz'ŭ Chou that these wares have been included in the Tz'ŭ Chou family.

In the Ming dynasty the ware was similar and it is difficult to distinguish between Sung and Ming specimens, except perhaps in the type of design and the freedom with which it is executed. The post-Ming examples show considerable falling off in artistic qualities.

The wide range of technique employed at this centre and other allied factories is well displayed in Plates LXXVIII to XCII

Our next group of wares, though a comparatively new one in the experience of collectors, is perhaps the choicest of all the Sung porcelains. Very little has been written about them hitherto, and specimens have been hard to come by until recently; even now they are difficult to obtain. The opening of tombs in Honan has brought to light a certain number of buried specimens, and these have whetted the collector's appetite for more.

The ware goes by the name of *ying ch'ing yao* which signifies a porcelain with a shadowy or misty blue glaze. The body is highly translucent in thinly potted examples and has a white sugary appearance. In other specimens the body, though made of similar porcelain, is much thicker and does not transmit light. The colour of the glaze varies from a white with a suspicion of blue in it to a pronounced light blue. The frontispiece to this album represents a choice example, and Plates XCIII to XCVII display other specimens.

When this ware first came to this country many years ago it was reported to have been found in Corea. The more recent specimens have been derived from Honan tombs. This latter origin is interesting because some colour is given thereby to the surmise[1] that these specimens may represent a type of Ju ware.

Ju yao has always been spoken of in Chinese ceramic literature as one of the most famous productions of the Sung potters. Made at Ju Chou in Honan it ranks only second to the celebrated Ch'ai ware of which no authenticated specimen is known to exist. On these two types of porcelain the full battery of extravagant description and praise has been turned by the Chinese writers, and the literature teems with encomiums of them. " Blue as the sky after rain, clear as a mirror, thin as paper, resonant as a musical stone of jade," and phrases of this order are the tribute paid by the ancient connoisseurs. We are told that a similar type of ware was made in the districts of T'ang, Têng, and Yao, on the north of the Yellow River, and there is no doubt that the minor Honan factories were employed on producing porcelain similar in character to that of Ju Chou. Further, a writer in 1125 speaks of certain Corean wares as being like the " new wares of Ju Chou." These statements support the view that the recent specimens found both in Honan and Corea may be of the Ju type, though it would be rash to ascribe any of them definitely to the potters of the famous Ju factory in the absence of kiln-site evidence. In support of the theory that this ware is of the Ju type it may confidently be stated that the porcelain of which it is made is of finer quality and more delicately potted than any other of the Sung wares; the incised designs which appear on some of the specimens are of a high order, and the general appearance of the best examples accords in large measure to the literary descriptions of Ju yao.

In marked contrast to the delicate potting of these porcelains is the heavy stoneware represented by the Chien yao, which is held in high esteem both in Japan and among Western collectors. The centre at which it was manufactured is Chien-yang in the province of Fukien. The body is heavy and black, and turns a rusty colour where exposed to the fire. The glaze is a lustrous black flecked

[1] The argument briefly set out here has recently been explored at length by Mr. G. Eumorfopoulos in a paper read before an Oriental Ceramic Society which is being published in its *Transactions*.

with golden brown; the terms " hare's fur " or " partridge markings " are given to these brown splashes from their similarity to the mottling of the tegument of these animals. The glaze is thick and terminates in heavy rolls or large drops short of the foot of the vessels, which almost invariably take the form of bowls. These bowls were used in the tea contests and tea ceremonies that had a great vogue in China in the past and still have in Japan to the present day.

The same kind of glaze was used at other factory centres upon a lighter coloured body; many examples can be found which appear to have been potted at Tz'ŭ Chou, and no doubt many of the Honan factories made similar glazes.

The golden brown markings take several forms, being widely spaced or more closely aggregated; while in some cases the whole surface of the glaze may be red-brown. In other instances the black glaze may have silvery drops on it resembling oil spots, and this effect is prized in Japan.

There is a third type[1] of *temmoku* bowl of which examples may be seen on Plates CII and CIII. The body is yellowish in colour, and the designs drawn in the glaze are of a fairly elaborate nature, birds, insects, and floral figuring being executed in a glaze of different composition from that surrounding the design.

The name *temmoku* (*t'ien mu*, or Eye of Heaven) was first given to a bowl, probably of Fukien origin, brought to Japan during the Sung period by a Zen priest from the Zen temple on the *T'ien mu shan* (Eye of Heaven mountain) in the north-west of Chekiang. In later times the generic name of *temmoku* came to be applied to the whole category of wares of this type.

In the foregoing brief review of the wares made at the main centres of production during the Sung dynasty, we have drawn attention to the development of a finer type of body than that used in earlier periods. It is conceivable that the felspathic glazes then employed, requiring as they do a higher temperature for their manipulation and development, led to the further porcelainisation of the body and prepared the way for the still finer bodies employed in the Ming and later periods. If this be generally true, it must be remarked that the *ying ch'ing* ware exhibits a body which, in some examples,

[1] The ware is reported to have been made in the region of Chi-an Fu in Kiangsi.

15

is as fine as any subsequently achieved by the Chinese potter, and that a good white porcelain was already made in the T'ang period.

The glaze effects of the Sung potter show a marked advance on those of his predecessors and exhibit a considerable mastery of technique. But it is probably in his artistic sense that the Sung potter chiefly excelled. Both in the simple shapes he used and in the designs he executed there is a subtlety which is generally lacking in the art of his successor. The shapes may be heavily fashioned, they may be simplicity itself, but it is rare indeed to find an example of Sung workmanship that does not make some appeal to our senses.

The drawing on the vessels whether executed by an incising tool, or by relief ornament or by bold washes of glaze colours, is invariably distinguished in character. It was the result of a relatively few strokes, as a rule, and the design is always in keeping with the vessel on which it is portrayed. With the growth of knowledge, elaboration of technique was exhibited later, and science to-day may be able to repeat the glaze effects of Sung times; but where the modern craftsman will fail is in the reproduction of the Sung drawing, unless considerable advances are made in artistic feeling in modern ceramic work.

The ideals of the Sung dynasty, whether in artistic expression or in philosophic thought, have always held a high place in Chinese estimation; so far as Sung art is concerned, the West has accepted that view and will continue to do so.

With the coming of the Mings, the old factories, which had supplied the ceramic needs of the Sung and Yüan dynasties, receded into the background, and Ching-tê Chên rose into pre-eminence.

Ching-tê Chên, in northern Kiangsi, is the home of porcelain proper. It was probably the source of the white porcelain found in the 9th-century ruins of Samarra, on the Tigris; and in the Sung period it produced a white ware which carried on the traditions of the Ting.

Changing fashion in the Ming period decreed that the famous monochromes of the celadon class should give place to white porcelain decorated with pictorial designs in coloured glazes, in overglaze enamels and in underglaze blue; and the only monochrome which appears with frequency among Ming porcelains is the pure white.

By far the largest Ming group is composed of the blue and white

porcelain. It ranges in quality from the daintily fashioned palace pieces to the rough wares exported by land and sea to Western Asia and Europe ; and it is not less varied in the shades of the blue with which it is painted. The colouring matter is derived from cobalt ; but the blue produced by the native supplies of this mineral, if not laboriously refined, had a dull grey or indigo tone, and the most famous Ming blue was imported from a Mohammedan country, doubtless Persia. It is, in fact, known as Mohammedan blue. The supply of this material was irregular, but we know that it arrived in the Hsüan Tê, Chêng Tê, and Chia Ching periods. During the remaining reigns apparently no new importation of it was made. In use it was blended with the native cobalt in proportions varying according to the quality of the ware desired.

The Hsüan Tê Mohammedan blue is extremely rare and even Chinese writers do not agree as to whether the prevailing shade was light or dark. But we have many examples of the Chia Ching blue which is of the dark violet tone seen on Plate CXLVIII. The more familiar Ming blues are usually tinged more or less with indigo; but even the least brilliant of the Ming blue and white porcelain is distinguished by a freshness and freedom of design ; and the skilful brushwork of the Ching-tê Chên decorators is seen to the best advantage in this ware. The actual designs are largely derived from the patterns on silk brocades, but we hear too of designs painted by the Court artists and sent to be copied at the Imperial factory.

Another underglaze colour, for which the reign of Hsüan Tê was specially celebrated, is the brilliant red derived from copper. This was used both as a glaze colour (i.e. in the glaze), or for painting individual designs under the glaze. Both types are illustrated on Plate CVIII. The successful development of this colour seems to have puzzled the potters after the Hsüan Tê and Ch'êng Hua periods, and we are told that they virtually abandoned it for a long time in the 16th century in favour of an overglaze red enamel.

The Ming polychromes, which include some of the most striking and decorative wares of the period, fall into two main groups—those with lead-silicate glazes or enamels applied direct to the biscuit, or body of the porcelain, and those with enamels painted on the white glaze. The former class is sometimes called " three colour " (san ts'ai) porcelain, the trio of colours being selected from the following—dark violet-blue, turquoise, aubergine (a purplish brown

17

or brownish purple), yellow, green, and an impure white. But it should be added that the number of colours used was not always strictly confined to three. Some of the earliest Ming polychromes are decorated with this colour-scheme, and the designs are generally outlined by threads of clay after the manner of the cloisonné enamel on metal. Sometimes, too, the designs are carved or pierced in openwork or framed by incised or pencilled outlines. The three-colour ware with incised outlines is often found with the Chêng Tê mark, and that with outlines pencilled in brown with the Chia Ching, and occasionally with the Ch'êng Hua, mark. All these classes of polychrome are illustrated on Plates CX, CXVI, CXX, etc.; and all of them, except the last, are frequently found in pottery as well as porcelain. The large group of porcelains with pencilled designs covered with soft enamels applied direct to the biscuit, though including a certain number of Ming specimens, belongs in the main to the succeeding dynasty.

The other principal group of polychrome, that decorated with soft enamels painted on the white glaze, has the generic name of *wu ts'ai*, or five-colour ware, though here again the colours are not strictly limited to the number implied. They include green of several shades, yellow, tomato red, aubergine-purple, a composite black (formed by a wash of transparent green or aubergine over a dry brown pigment), and a turquoise green. This last is the usual Ming substitute for a blue enamel; but if a true blue colour was desired, it was supplied by the ordinary cobalt-blue under the glaze. The Ming yellow is generally brownish or of amber tint; the red, though thin, is opaque and tends to become iridescent.

The Ming potters were partial to openwork (*ling lung*) decoration which we find on a large scale on the early wine-jars and barrel-shaped seats. But the perfection of the pierced ornament is seen on the delicate little bowls, made at the end of the Ming period (see Plate CVII, Fig. 1), with sides pierced in fret patterns of unimagined fineness. This is the *kuei kung* (or devil's work) of Chinese writers, and it assuredly needed an almost supernatural skill to accomplish it. Combined with the *ling lung* work we often find daintily modelled reliefs, figures, and other designs, in unglazed biscuit. They are sometimes of microscopic fineness, at other times of moderate size and standing out in full relief. The biscuit in these porcelains was often overlaid with oil gilding applied on a

red medium. Another decoration, remotely related to these biscuit designs, is traced in white slip on a coloured, or under a colourless, glaze. Plates CXIV and CXXXIII show good examples of this type.

The Ming monochromes, which as already stated are relatively rare, include celadon green, brown-black, and a variety of blues, besides the lead-silicate glazes and enamels which are used on the three- and five-colour ware, viz. green, aubergine, turquoise, and yellow.

The porcelain made in the early Ming reigns is naturally very rare and precious to-day, especially that proclaimed by its fine execution to be Imperial ware. None is more highly prized than the finer types made in the Hsüan Tê and Ch'êng Hua periods, the two classic reigns of the dynasty. The former of these reigns was noted for its " blue and white " and underglaze red ; and the latter for its underglaze red, and enamelled wares. A fair number of the larger and more stoutly constructed of the 15th-century porcelains is still to be seen ; but very few of them are in perfect condition. Such pieces were not preserved from their early youth in silk-lined boxes. They have had to stand the usage of many centuries and to pay the forfeit of their longevity. The 16th century is more fully represented in our collections, which include many fine specimens of three-colour ware with engraved designs and " blue and white " of the Chêng Tê period, together with a great variety of Chia Ching porcelains. Both these reigns have a high reputation among Chinese connoisseurs. The surviving Wan Li wares are comparatively numerous, and, in general, display less refinement in material and manufacture. This is partly explained by the fact that the mines at Ma-ts'ang, which had supplied the best porcelain clay to Ching-tê Chên, were worked out by this time.

Apart from Ching-tê Chên, a fine white porcelain was made at Tê-hua in Fukien in the last half of the Ming dynasty. The Fukien ware is distinguished by a soft-looking, luscious glaze of great transparency, which blends very closely with the body material. In general it is milk white, or cream white, with a pinkish tinge in some cases ; and the texture of the glaze has been aptly compared with blancmange. It is the *blanc de chine* of old French writers ; but as its manufacture continues on the old lines to this day, it is very difficult—in many cases impossible—to distinguish the Ming productions from those of later periods.

19

Figure modelling was a speciality of the Fukien potters, and some good examples of this work are shown on Plates CIV to CVI, but it would be unwise to guarantee that they are all of Ming date.

In addition to the porcelains of which most of the Ming specimens in this album consist, there was a vast quantity of pottery and stoneware made in the many factories scattered up and down the eighteen provinces of China. Much of this is classed as " tile ware," and indeed it includes roof tiles and architectural pottery which are often distinguished by finely modelled ornament and rich glazes. But the tile factories and miscellaneous potteries also produced many noble vases, fish bowls, figures, and groups, in which the three-colour glazes were applied to a pottery base with strikingly beautiful effect; and one of the most attractive of the late Ming types are vases with a stoneware body and soft-looking turquoise, green, and aubergine glazes, such as those represented by Plates CXXVII and CXXIX. The provenance of these handsome vases has not been definitely ascertained.

Such then is the story, in briefest outline, of the development of Ceramic Art in China up to the early part of the 17th century. After that date potting technique may have been further elaborated and certain new glazes invented, but the art of the Chinese potter never reached a higher plane than in the best of the early periods. Indeed the later potters often devoted their skill to the reproduction of the older types. It may be that part of this tendency was due to the proverbial Chinese veneration of the past; but in any case these imitative efforts were not conspicuously successful. The simple beauty and the freshness of the earlier wares are their chief distinction, and they do not suffer from the fussiness which is often noticeable in the work of the 18th-century potters. Most of our readers are familiar with the finer examples of 17th- and 18th-century porcelain, and they can form their judgment on the truth of our statement from the illustrations which follow.

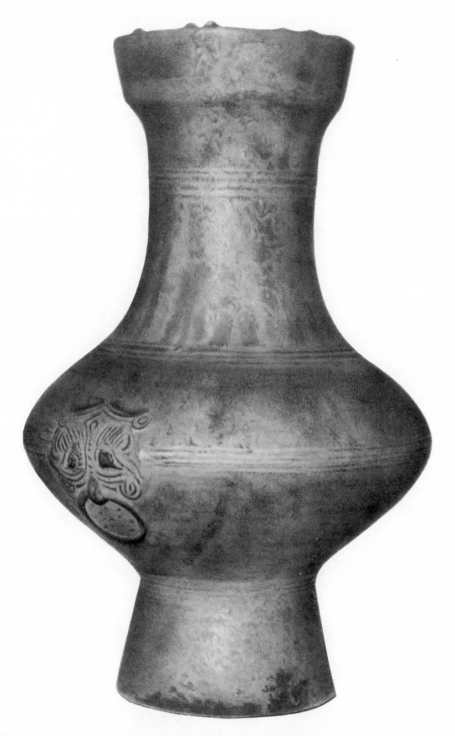

PLATE 1. Wine-jar with depressed globular body, high neck, and slightly expanded mouth; high foot, slightly spreading, and flat beneath. On the sides are two tiger-masks in applied relief with ring handles (in the style of a bronze) enclosing a pattern of raised dots. Otherwise the plain surface is relieved only by groups of horizontal wheel-made rings on the neck and body. Red pottery with leaf-green glaze encrusted with golden and silvery iridescence due to prolonged burial and consequent decomposition of the glaze. Drops of glaze have formed on the mouth-rim suggesting that it was fired upside down. Han dynasty. H. 17.5″. *In the possession of Mr. O. C. Raphael.*

PLATE 2. Ornamental brick of dark grey pottery with a stag's head moulded in high relief, and stamped ornaments consisting of (1) tiger-masks and rings, (2) a palm tree between two buildings, (3) a chariot, and (4) lozenge diaper. Borders of matting pattern. Found in the Kaifêng district, Honan. Han dynasty. H. 22″. *In the British Museum.*

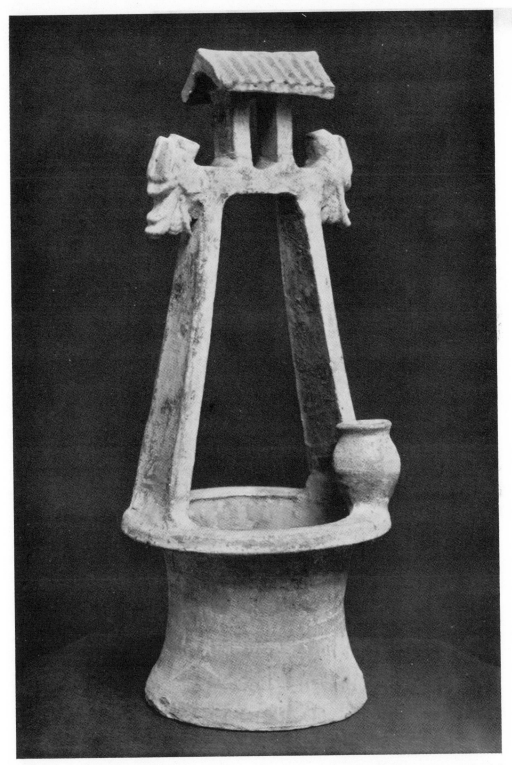

PLATE 3. Well-jar of buff pottery with green glaze now iridescent from age and burial. The jar is in the form of a well-head with an erection to hold a pulley wheel, sheltered by a penthouse with tiled roof: the ends of the cross-beam are ornamented with two well-modelled dragon heads; on the rim of the well a bucket is resting. The tomb furniture of the ancient Chinese included models of all kinds, not only of domestic objects but of farm buildings and implements. Some of these, such as the granary towers and well-heads, lent themselves more readily than others to ornamental representation. Han dynasty. H. 19.5". *In the possession of Mr. A. L. Hetherington.*

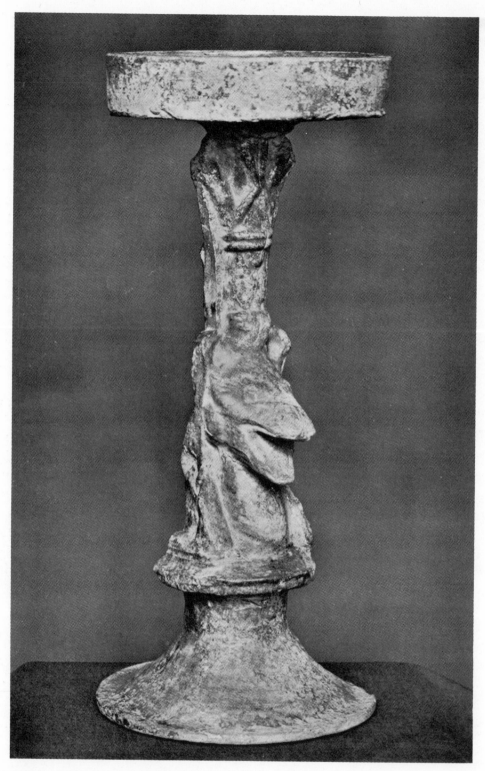

PLATE 4. "Pricket candlestick" with round tray supported by a tall stem of complicated modelling. The upper part suggests the trunk and shoulders of a figure with folded hands; and below this there is a small Buddha figure in relief. The lower part consists of a bear's head and neck resting on a rounded pedestal. The material is a reddish pottery with green glaze, much perished and iridescent. A candlestick of earthenware is mentioned among the furniture of an Imperial tomb of the later Han dynasty (25–220 A.D.) in a list quoted by De Groot, *Religious Systems of China*, Vol. II, p. 401. Han dynasty. H. 16". *In the possession of Mr. George Eumorfopoulos.*

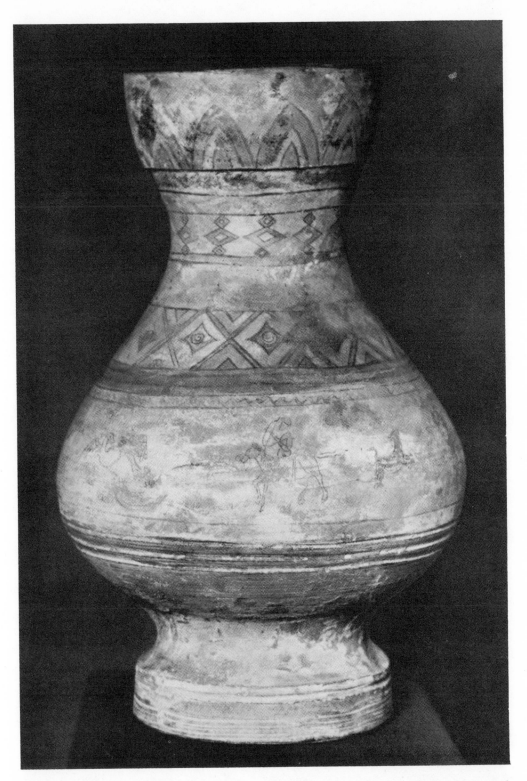

PLATE 5. Wine vase with baluster body, contracted neck and stem, and spreading mouth and foot: flat base. Red pottery with a wash of white slip on which designs have been painted in unfired blue, red, and black pigments. On the body is a broad belt painted with a sequence of hunted and hunting figures realistically drawn. They include two horsemen armed with bows, a demon figure, deer, tigers, hounds, and a flying crane; the contours of the ground and growing plants are also indicated. The remaining ornament consists of painted bands of formal pattern, and two groups of horizontal rings cut on the wheel. The drawings are partly obliterated by the deposit formed by burial. As an early example of brushwork this vase has considerable interest for the historian of Chinese painting; see *An Introduction to the Study of Chinese Painting* by Arthur Waley, p. 38. Probably fourth century. H. 13.7″. *In the British Museum.*

PLATE 6. Burial figure of a woman standing with hands folded within her sleeves. She wears a robe with V-shaped opening at the neck, and her hair is done in a bobbed queue at the back. Grey unglazed pottery with remains of white slip. The figure is much conventionalised, the lower part being little more than a pedestal and the back flattened, while the upper part is a skilful impressionist rendering of one of the typical retinue figures found in tombs. Probably Wei dynasty. H. 20.5". *In the possession of Mr. George Eumorfopoulos.*

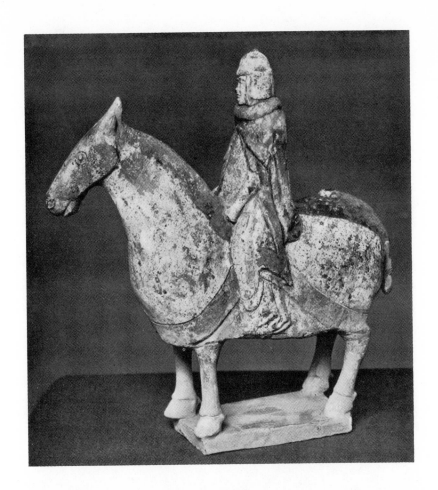

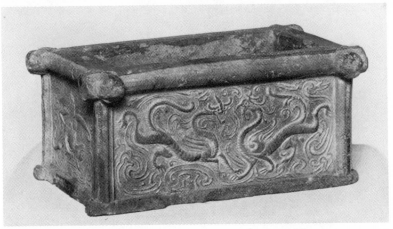

PLATE 7. Fig. 1. Burial figure of a horseman heavily cloaked and mounted on a caparisoned horse. Slaty grey, unglazed pottery with white slip dressing and traces of pigment. Though summarily executed, this guardian figure—for he is evidently one of the so-called "life guards" of the dead—has great dignity and style. Wei dynasty. H. 8.5″. *In the possession of Mr. George Eumorfopoulos.* Fig. 2. A rectangular "stand," open at the top and bottom. Grey, unglazed pottery with panels on each side moulded with vigorous designs in low relief. On one side, two confronted "hydras" or bird-headed dragons and cloud-scrolls, on the other, a winged dragon and tiger; on one end, one of the Lokapalas or Guardians of the Four Quarters of the Buddhist heaven; on the other, a figure of Yama, the Thibetan God of Hell. The precise use of this object is not clear; but it appears to have followed a wooden model, to judge from the "dovetailed" frame. The reliefs are full of life and movement. Third or fourth century. L. 8.75″. *In the possession of Mr. George Eumorfopoulos.*

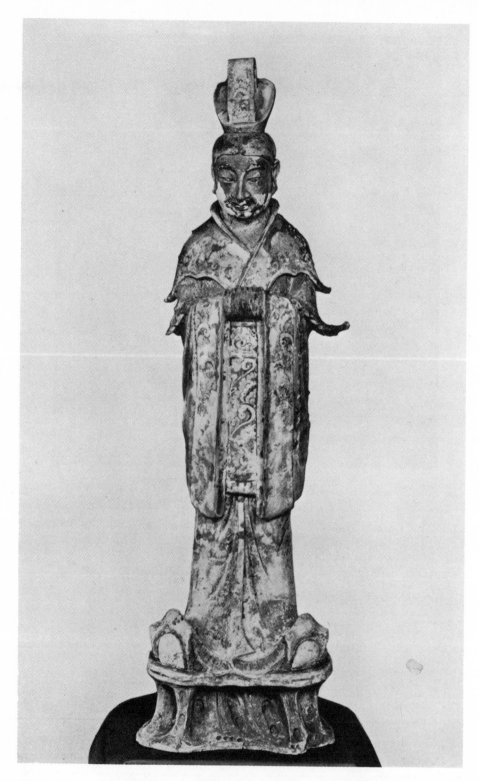

PLATE 8. Figure of a dignified personage in rich robes and elaborate headdress standing with folded hands on a rock-pedestal. Soft white pottery unglazed, but richly pigmented in black, red, and green. The robes are carefully modelled and decorated with brocade patterns in colour (much of which has worn away), and the ends of the skirt are frilled. Persons of the same ministerial aspect have been found in princely tombs. Who they represent, is a matter of debate. The latest contribution on the subject by M. Pelliot (*T'oung-pao*, March, 1923) leaves the question still open. If they are ministers, then, he thinks they must be ministers of a spiritual kingdom. T'ang dynasty. H. 41″. *In the possession of Mr. George Eumorfopoulos.*

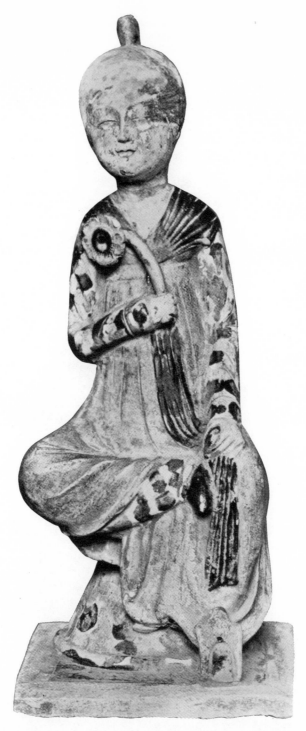

PLATE 9. Figure of a lady seated on a drum-shaped stool. She carries a lotus flower in her right hand and holds up the end of her scarf with her left; her right foot rests on the left knee. Hard white pottery with coloured glazes on the draperies; the scarf is brownish yellow, the under robe white spotted with yellow, and the main robe pale green. The head is unglazed, but the hair is coloured black. In the grave equipment female figures are usually represented standing with folded hands in an attitude of respect. The seated position of this figure would seem to indicate that it represents a lady of importance. This supposition is borne out by the care with which the figure is modelled; the drapery in particular has received minute attention. The shape of the stool with its contracted waist recalls a T'ang pottery vessel preserved in the Shoso-in at Nara. T'ang dynasty. H. 13.75". *In the possession of Mr. George Eumorfopoulos.*

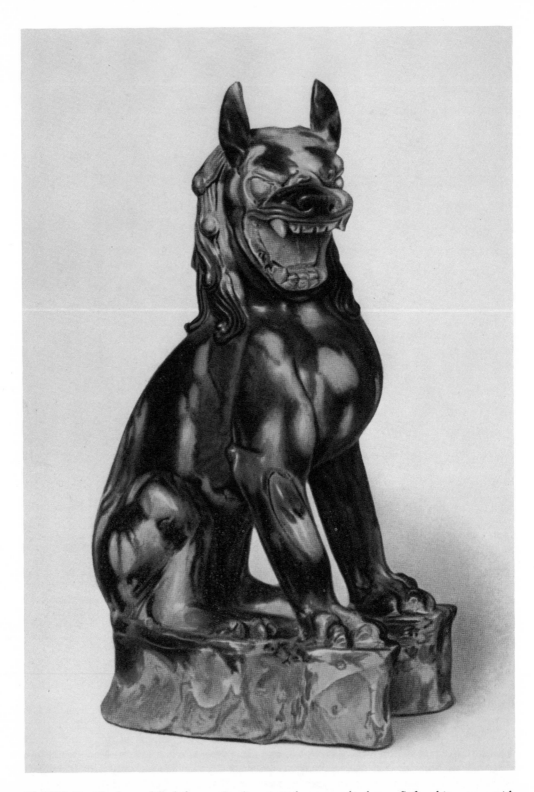

PLATE 11. Finely modelled figure of a lion seated on a rocky base. Soft white ware with a white glaze thickly splashed with green. The beast with its powerful frame and fierce threatening jaws is of the naturalistic type which preceded the familiar Buddhist lion, or dog of Fo (see Plate 126), whose form and features resemble those of the Pekingese spaniel. T'ang dynasty. H. 10.5″. *In the possession of Mr. H. J. Oppenheim.*

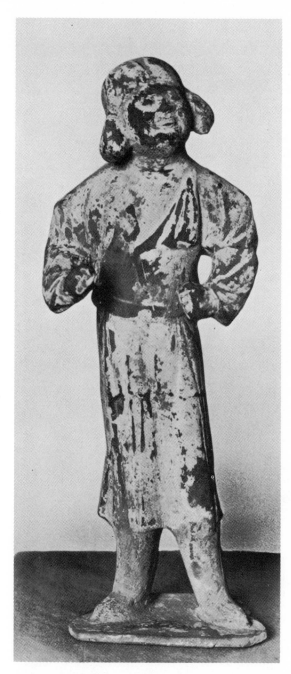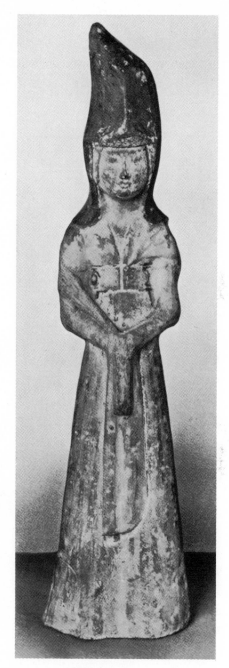

PLATE 12. Fig. 1. Figure of an actor, standing in an attitude of defiant contempt. He wears a long coat with open lapels at the neck and girdle; flat, polygonal base. Red ware with dressing of white slip which is much worn. A skilfully modelled figure full of "life-movement," and carefully finished in all the details of the costume. T'ang dynasty. H. 11.2". *In the British Museum.* Fig. 2. Figure of a lady standing, with folded hands covered by the ends of her sleeve and scarf. Long flowing robe with high waist-band and V-shaped opening at the neck; scarf thrown across the shoulders; high mitre-shaped headdress covered by a hood which falls over her ears and back. Soft white pottery with dressing of white slip, painted in unfired red and black pigments. The robe is striped with red from the waist downwards, and the hood is black. T'ang dynasty. H. 12". *In the British Museum.*

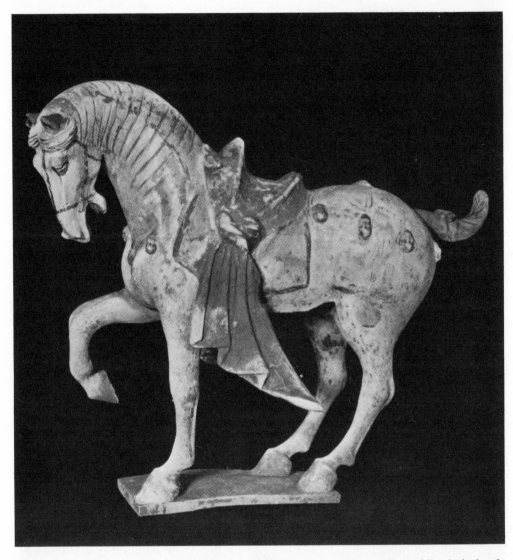

PLATE 14. Model of a horse in unglazed, soft white pottery. The saddle, saddle-cloth, hoofs, and rosette ornaments on the trappings are covered with unfired red pigment which has flaked off in places. The straps on head, collar, saddle, and girth are shown up with blue pigment, and the rosette ornaments are picked out with the same colour. The Bactrian horses, of which this is a fine model, were first imported into China during the second century before the Christian era, and by the T'ang dynasty were the possession of most of the Chinese notables. The T'ang tombs of importance usually contain models of these horses and examples are now familiar in this country. But the fine modelling in this instance and the life imparted to the movement of the animal are somewhat exceptional. T'ang dynasty. H. 16″. *In the possession of Mr. F. N. Schiller.*

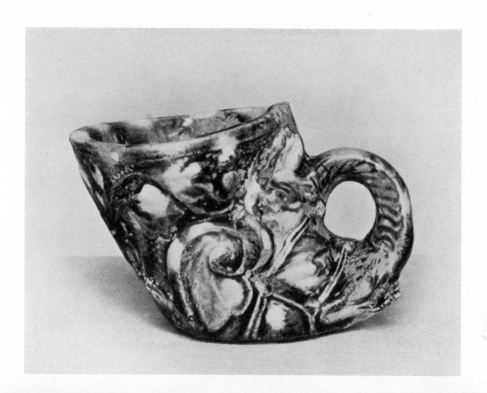

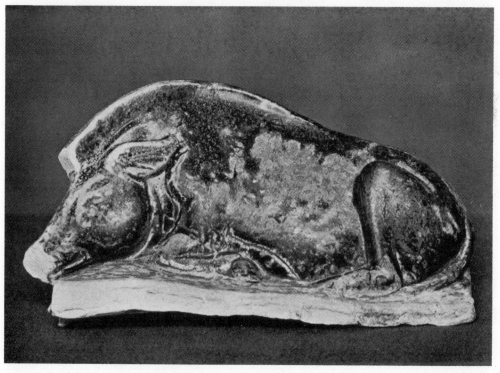

PLATE 16. Fig. 1. Cup in the shape of an elephant's head, trunk turned back to form the handle. The elephant motive disappears in the pure cup form of the sides and lip on which formal foliage is moulded in low relief. Hard porcellanous ware with glaze mottled with green and yellow. This piece, like Fig. 1 of Plate 23, is similar in conception to the Greek rhyton. T'ang dynasty. H. 2.5". *In the possession of Mr. George Eumorfopoulos.* Fig. 2. Figure of a boar reclining on an oblong base. White porcellanous ware with olive brown glaze. The ware appears to be of an early type, the glaze being similar to that of the so-called proto-porcelain. The modelling is admirable and the animal is full of life in repose. T'ang dynasty or earlier. L. 6". *In the possession of Mr. George Eumorfopoulos.*

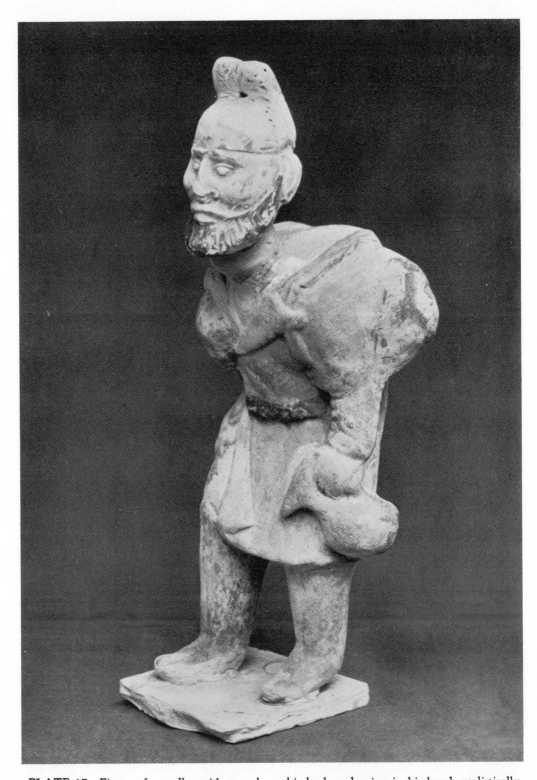

PLATE 17. Figure of a pedlar with a pack on his back and a jug in his hand, realistically modelled in soft white clay and painted with unfired black, red, and green pigments. Though the costume of this figure is Chinese, it will be remarked that the features of his face are foreign and rather Semitic. He may represent a Western Asiatic sojourner of whom there were considerable numbers in China at this time. T'ang dynasty. H. 10″. *In the possession of Mr. A. L. Hetherington.*

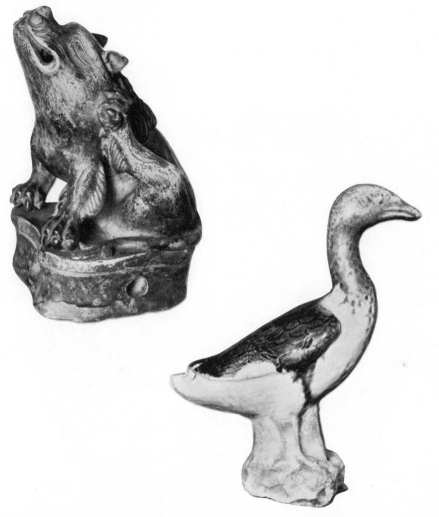

PLATE 18. Fig. 1. Model of a lion seated and scratching his head with left hind paw. Hard buff white ware with creamy white glaze tinted in parts with green and yellow. Low base with pierced sides. The contended expression of the beast enjoying a good scratch is admirable. Probably T'ang dynasty but possibly later. H. 8.6". *In the possession of Mr. C. Rutherston.* Fig. 2. Model of a duck. Soft white ware with creamy glaze splashed in parts with yellow and green. The feathers are indicated by engraved lines. Though somewhat impressionist in the modelling, the duck is very life-like in its pose. T'ang dynasty. H. 7.75". *In the possession of Mr. C. Rutherston.*

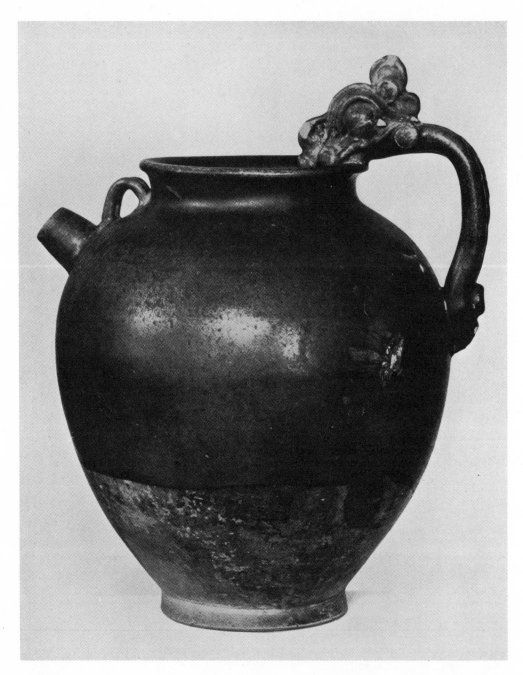

PLATE 19. Ewer with shapely oval body, short neck and wide mouth, and flat base; double handle with stud at the base and elaborate dragon head biting the rim; short, straight spout with loop above it. Hard grey ware with dark chocolate-brown glaze which stops some distance above the base. Apart from suggestions of Hellenistic influence, this piece is interesting as an example of the mastery of form achieved by the T'ang potter. T'ang dynasty. H. 10.5". *In the possession of Mr. George Eumorfopoulos.*

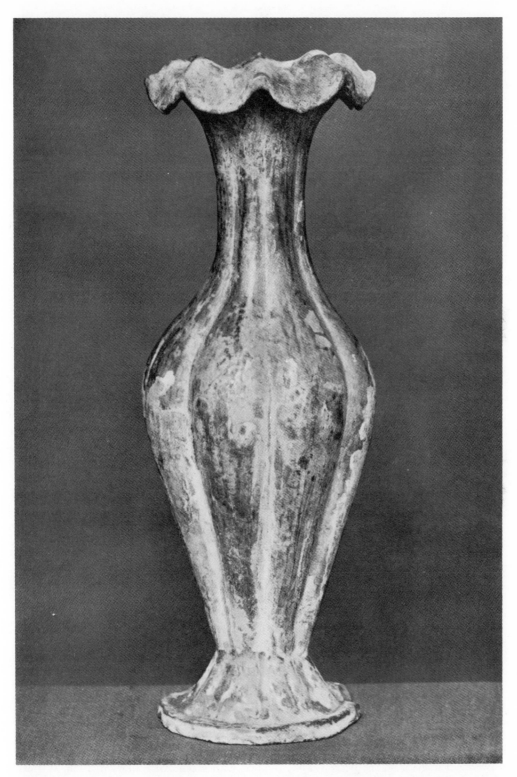

PLATE 21. Vase of slender baluster form, eight-lobed, with tall neck and spreading foot; the mouth expands and the lip is turned over in eight foliations. Hard porcellanous ware of reddish tone with dressing of white slip and iridescent green glaze, which has scaled off in places. The graceful lobed form and foliate mouth of this vase are borrowed from a Han bronze known as the *k'uei hua p'ing* or mallow flower vase. It must have taxed the skill of the T'ang potter to render this form of vase in clay. T'ang dynasty. H. 12.75". *In the possession of Mr. George Eumorfopoulos.*

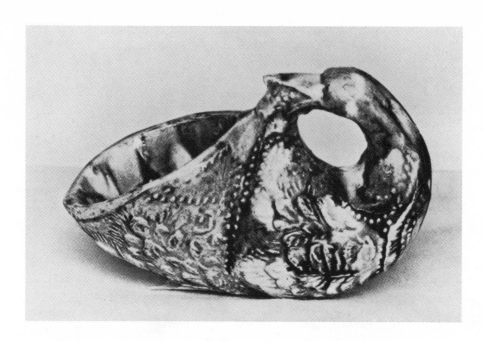

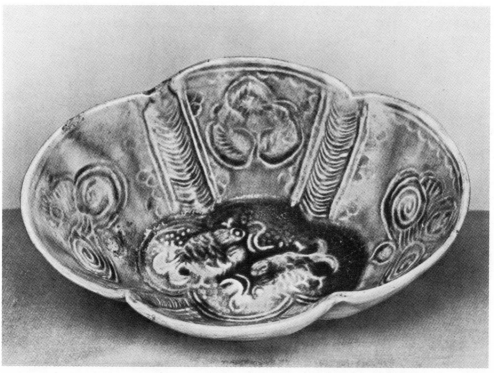

PLATE 23. Fig. 1. Cup moulded in the form of a duck. Buff-white porcellanous ware with coloured glaze. The head and neck are modelled after nature, and the body gradually passes into the form of a cup, in the manner of the Greek rhyton. The head is bent back to preen the back feathers; and the feathers are treated like overlapping leaves in clusters with dots between. The glaze on the neck is white mottled with green and yellow; the cup is green outside and mottled within. T'ang dynasty. L. 4.5". *In the possession of Mr. George Eumorfopoulos.* Fig. 2. Dish of quatrefoil shape with deep curving sides and small base. Soft white pottery moulded inside with two fishes on the bottom; trefoil ornament incised on the four lobes and hatched bands between. The glaze is coloured green and yellow. The same model is known in T'ang silver; and a white porcelain dish of the same form and design was found on an early site (eighth or ninth century) at Rhages in Persia. T'ang dynasty. L. 5.5". *In the possession of Mr. George Eumorfopoulos.*

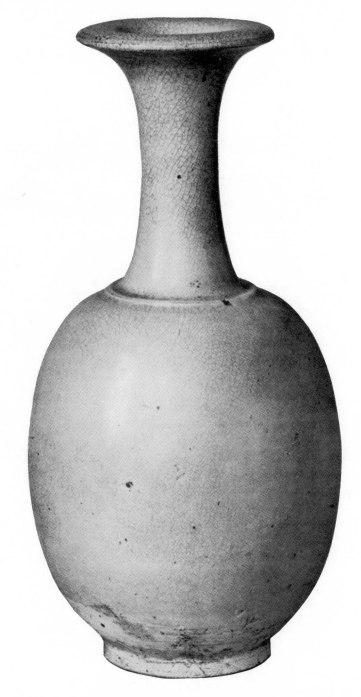

PLATE 25. Bottle with beautiful ovoid body, slender neck with spreading mouth, and flat base. Porcelain with thick finely crackled glaze, of faint bluish tint, which stops short of the base in a wavy line in typical T'ang fashion. Bottles of this elegant form are seen in T'ang sculpture and religious pictures in the hands of Bodhisattvas. Examples will be found in illustrations of the Lung-mên rock temples and of the pictures found by Sir Aurel Stein in Chinese Turkestan. T'ang dynasty. H. 8.9". *In the possession of the Misses Alexander.*

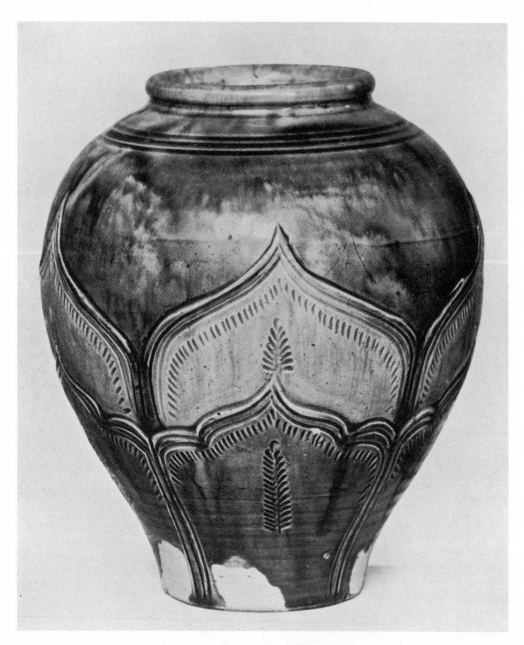

PLATE 27. Vase with ovoid body slightly contracted above the base, short neck and wide mouth with rolled rim. Hard buff ware with incised ornament and coloured glaze. On the body are two overlapping bands of formal leaves with triple outlines and hatched details; the lower band is green and the upper yellow, and the surface above is green; on the shoulder is a band of three wheel-made rings. The motive of the leaf ornament is probably derived from the lotus flower. T'ang dynasty. H. 7.5". *In the possession of Mr. George Eumorfopoulos.*

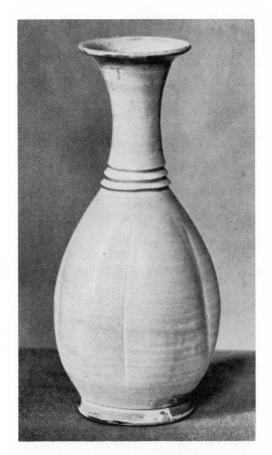
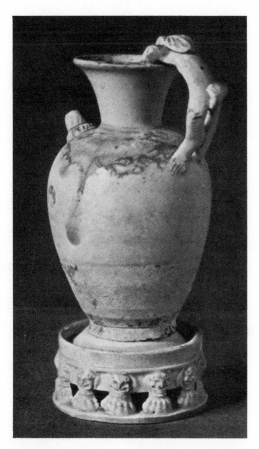

PLATE 29. Fig. 1. Bottle with slender neck, wide mouth, and pear-shaped body moulded in five lobes. Three wheel-made rings at the base of the neck. Porcelain with ivory white glaze which forms in places in brownish drops. The glaze on one side stops short of the base which is unglazed beneath. T'ang dynasty. H. 5.25". *In the possession of the Misses Alexander.* Fig. 2. Ewer with beautifully turned ovoid body and spreading neck; flat base with bevelled edge; short spout, and handle in form of an animal standing on the shoulder and looking into the mouth of the vase. White porcelain with ivory white glaze in which are brownish "tear drops" and stains; the glaze stops short of the base. With it is a circular stand of similar ware supported by a ring of demon busts. T'ang dynasty. H. 3.5". *In the possession of Mr. F. N. Schiller.*

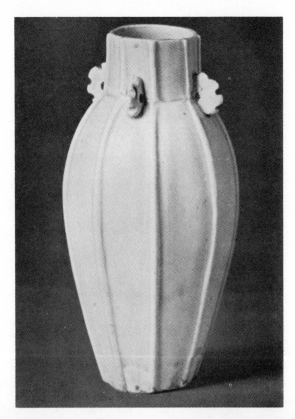

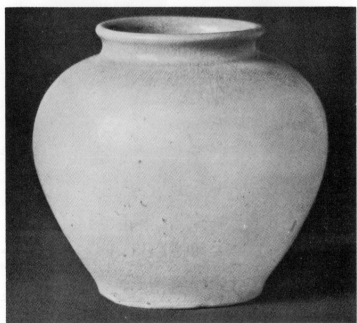

PLATE 30. Fig. 1. Vase with ovoid body and short straight neck. Eight ribs running ver-
tically down the sides give it an octagonal appearance; and there are four pierced wing-shaped
handles at the junction of the neck and body. White porcelain. The ivory white glaze, which
forms in brownish "tears" in the lower parts, stops short of the flat base. This vase and those
shown in Plate 29 have characteristics identical with those of the fragments of T'ang porcelain
found at Samarra (see p. 5 of Introduction); for this reason they have been ascribed to the
period. Previously this type of ware had been regarded as probably of Sung date. T'ang
dynasty. H. 5.25". *In the possession of Mr. F. N. Schiller.* Fig. 2. Jar with ovoid body,
short neck, and wide mouth; flat base with bevelled edge. Porcelain with warm ivory white
glaze, thick and faintly crazed. The finish of this simple jar and its beautiful lines are charac-
teristic of the T'ang potter's work. T'ang dynasty. H. 4.25". *In the possession of Mr. F.
N. Schiller.*

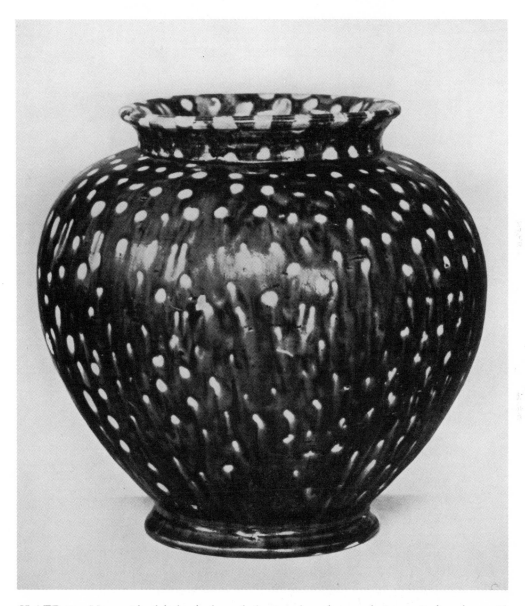

PLATE 31. Vase with globular body and short neck and everted rim; spreading foot with base slightly hollowed out and unglazed. The body is softish white pottery. The glaze, which extends to the foot-rim, consists of orange-brown splashes with white centres, dappled on a green ground. The inside of the vase is glazed yellow. The shape of the vase is beautiful, and the glaze has been applied with much skill. T'ang dynasty. H. 7.9″. *In the possession of Mr. George Eumorfopoulos.*

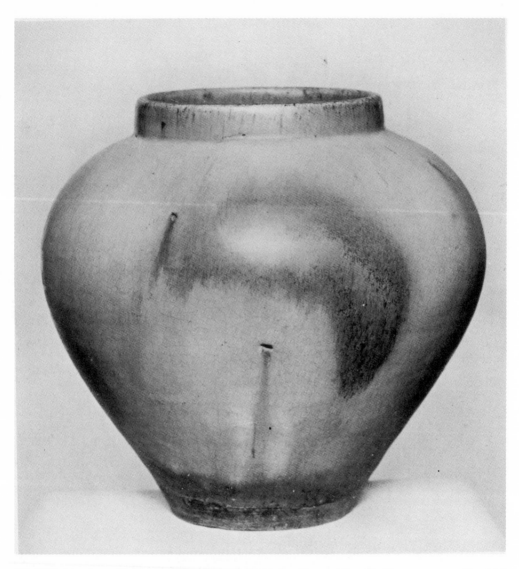

PLATE 32. Jar with ovoid body, short neck, and wide mouth. Buff stoneware with thick opalescent glaze of greenish grey, *clair de lune* colour with a purplish splash shading into green. The glaze is faintly crazed and stops short of the base where it has formed a thick line. On the mouth-rim the glaze is thin, and a brownish colour emerges. Chün ware. Sung or Yüan dynasty. H. 9.75". *In the possession of Mr. George Eumorfopoulos.*

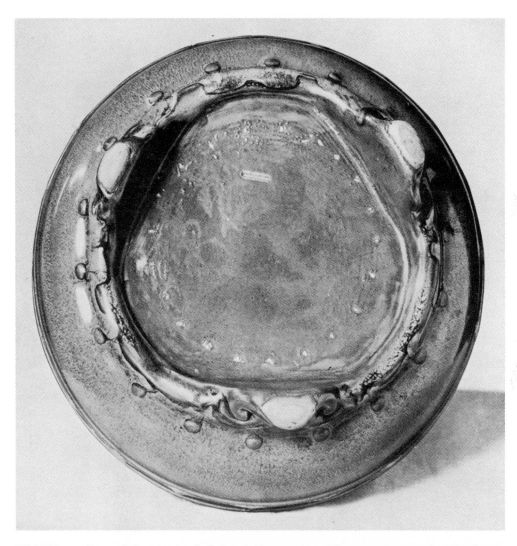

PLATE 34. Base of the circular bulb-bowl illustrated on Plate 33, showing the olive-brown glaze, the incised numeral *i* (one), the ring of "spur-marks," the biscuit under the feet, and the thick welt of glaze on the base-rim. The numerals, ranging from one to ten, are found on the flower-pots and bulb dishes of the "Imperial Chün," as the finest type of this ware has been called, and apparently indicate the size; number one size being the largest.

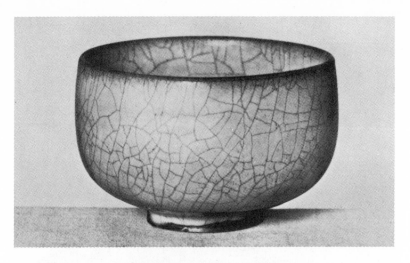

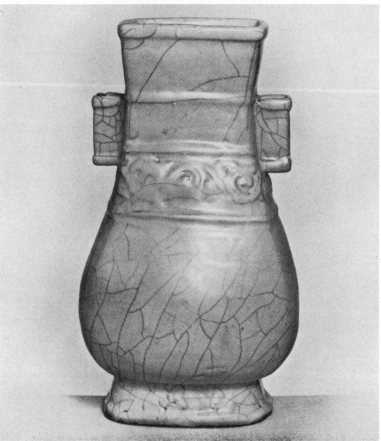

PLATE 36. Fig. 1. Tea bowl with crackled lavender-grey glaze, thick and smooth to the touch. The base-rim shows a greyish white porcellanous body which has browned on the surface in the firing; and there is a wash of glaze beneath the base. This type of ware is sometimes called Ko yao, which evidently in several respects resembled the Kuan yao or Imperial (official) ware made at Kai-fêng Fu in the early part of the Sung dynasty and at Hang Chou in the latter part. Kuan ware. Sung dynasty. D. 4.4". *In the possession of Mr. P. David.* Fig. 2. Four-sided vase of bronze form; body with pear-shaped outline; straight neck and low, hollowed foot; two tubular handles. The body exposed at the foot-rim is dark brown, and the glaze is pale blue-grey, thick and boldly crackled. Below the neck is a belt of foliage scroll in low relief enclosed by two ridged borders, and there is a plain raised band between the upper edges of the handles. The base is glazed. This specimen in technique resembles closely Fig. 1 above. Ko type. Sung dynasty. H. 10.25". *In the possession of Mr. George Eumorfopoulos.*

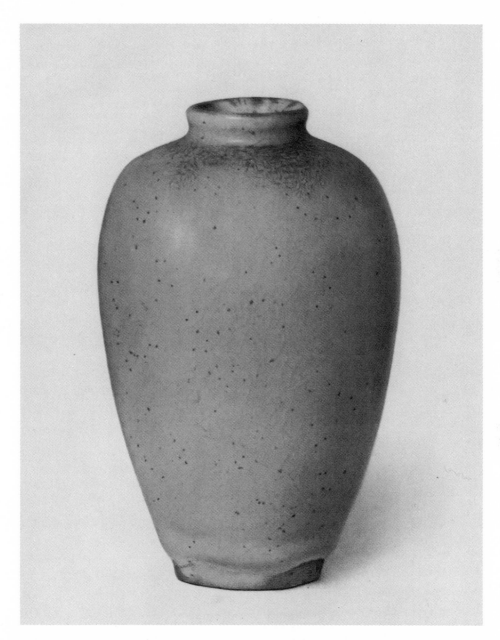

PLATE 39. Jar with ovoid body and short neck. Buff stoneware body with thick, lightly crackled opalescent glaze of pale lavender-blue colour with purplish suffusions on the shoulders. The "soft Chün," also called in China "Ma Chün" after a potter named Ma, is regarded by many Chinese authorities as a Ming production. To judge by the forms of known examples, its manufacture may well have ranged from the Sung to the end of the Ming periods. "Soft Chün." Yüan or early Ming dynasty. H. 4.5". *In the possession of the Misses Alexander.*

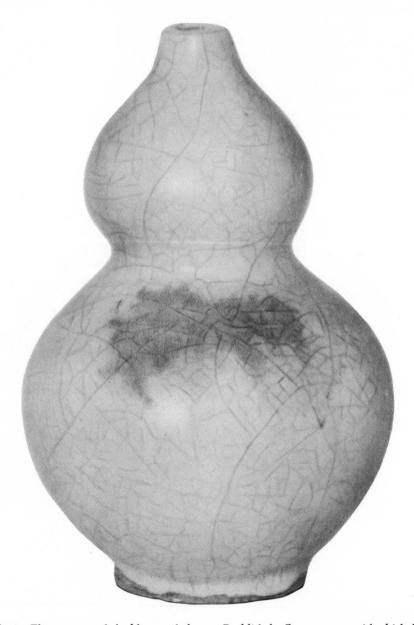

PLATE 40. Flower vase of double-gourd shape. Reddish buff stoneware with thick lustrous glaze of pale lavender tint lightly crackled and splashed in front with dull purple. The glaze has run in a thick welt round the edge of the foot-rim and the base is glazed. For a note on the "soft Chün" ware see preceding plate. The shape of this vase seems to point definitely to a Ming date. "Soft Chün." Ming dynasty. H. 7.4". *In the possession of Mr. P. David.*

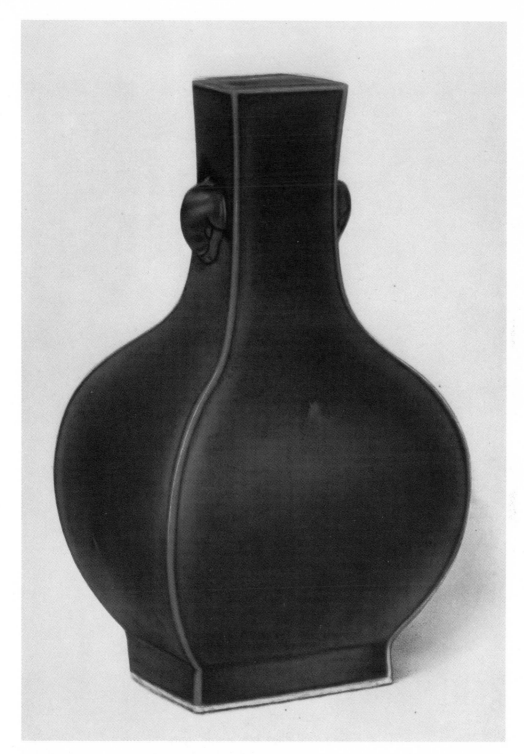

PLATE 42. Square vase of bottle shape with swelling body and neck almost straight; two handles in form of elephant heads. Porcelain with bubbly felspathic glaze of rich olive-green colour. The base is glazed, but the raw edge of the foot-rim shows a white porcelain which has burnt red in places. This vase, which is remarkable for its unusual glaze, is reputed to be Kuan ware, and, according to some critics, Kuan ware of the Sung dynasty. But the term Kuan in the sense of "imperial" is also applied to wares of the Ming period, and it is quite possible that this is an Imperial piece of the Ming dynasty, a supposition to which the nature of the base lends colour. H. 9.75″. *In the possession of Mr. F. N. Schiller.*

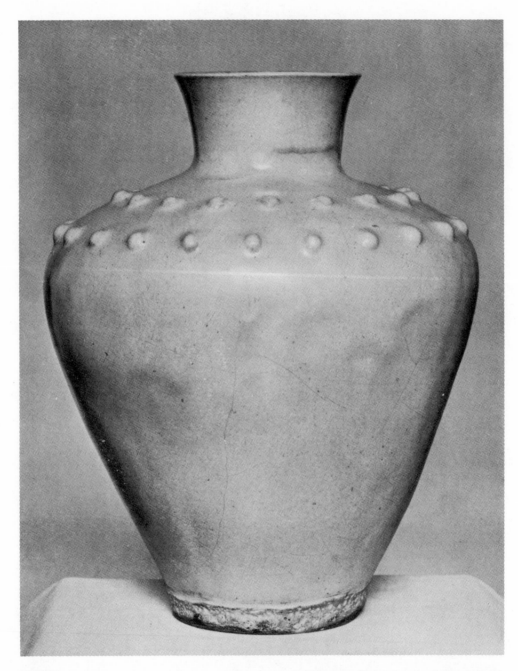

PLATE 43. Vase with ovoid body, and short neck slightly spreading towards the lip; on the shoulders are two bands of round bosses, derived from a bronze model. Hard buff ware with thick opaque *clair de lune* grey glaze, faintly crazed. The glaze has rather a dull paint-like lustre, and is not so vitreous as the Chün glaze which it imitates. Kwangtung ware. Ming dynasty. H. 12.5″. *In the possession of Mr. George Eumorfopoulos.*

PLATE 44. Basin of fine white porcellanous ware with ivory white glaze. The mouth-rim is unglazed and bound with copper. The outside is carved with a pattern of overlapping lotus petals in three rows, and there is a groove below the lip. Inside is a carved lotus design with flower, leaf, seed-pod, and tendrils in scroll form. A specimen of unusual size and quality. Ting ware. Sung dynasty. D. 12″. *In the possession of the Misses Alexander.*

PLATE 45. Bowl of conical form with small foot. Ivory white glaze with moulded design of flying phœnixes among flowers; border of key fret or thunder and cloud pattern (*lei wên*); a flower in the centre; bronze band on the lip. The ware is a fine white porcellanous material, translucent in the thinner parts, and the glaze has collected in well-defined "tear drops" on the back. This particular bowl was evidently highly prized at the Imperial Court of the Emperor Ch'ien Lung (1735–95) for on its base engraved through the glaze is an inscription of which the following is a rendering: "Amid accumulated pollen and massed flowers the two phœnixes droop their wings. The colour is confined to that prized by the Yin dynasty (i.e. white, which was the Imperial colour in that dynasty), simple and unadorned. It is not till we come down to the Chu dynasty of Hsüan (·tê) and Ch'êng (·hua), that we get elaborate painting and the employment of the five colours. Composed by the Emperor Ch'ien Lung in the spring of the cyclical year *ting-yu* (i.e. 1777 A.D.), and inscribed by his order." Pai Ting ware. Sung dynasty. D. 7". *In the possession of Mr. P. David.*

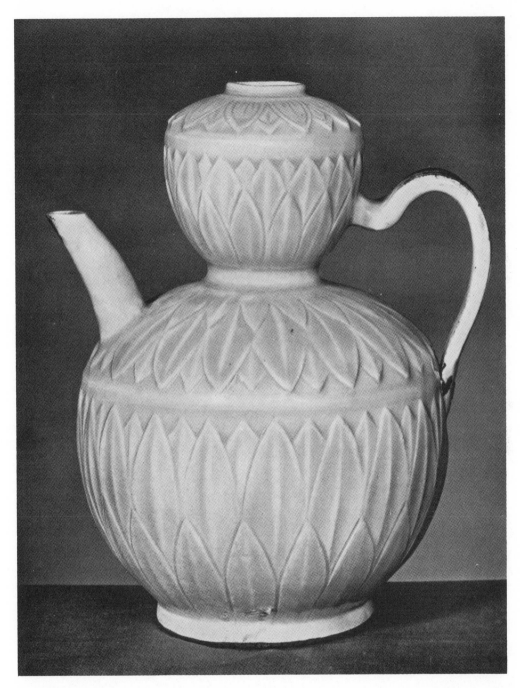

PLATE 46. Ewer of double-gourd form with plain spout and elegantly curved handle. White porcellanous ware carved above and below in a pattern of overlapping lotus petals. Ivory white glaze. In form and material an exquisite example of Sung ceramic art. Ting ware. Sung dynasty. H. 8″. *In the possession of Mr. George Eumorfopoulos.*

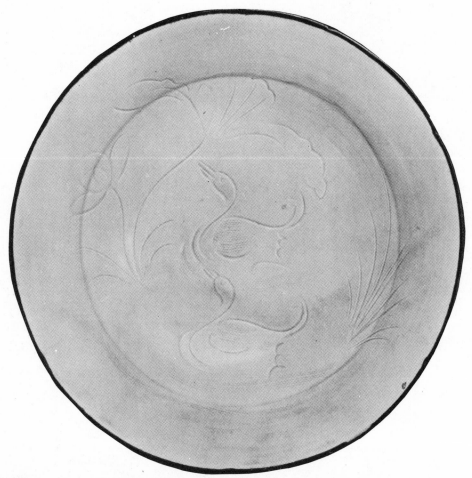

PLATE 47. Dish with shaped rim suggesting six foliations; fine white porcellanous ware with an orange-coloured translucence; ivory white glaze. The rim is unglazed and bound with copper. Decorated with a freely carved design of two mandarin ducks swimming in a lotus pond. A pair of mandarin ducks is an emblem of conjugal happiness. Ting ware. Sung dynasty. D. 10.1". *In the possession of the Misses Alexander.*

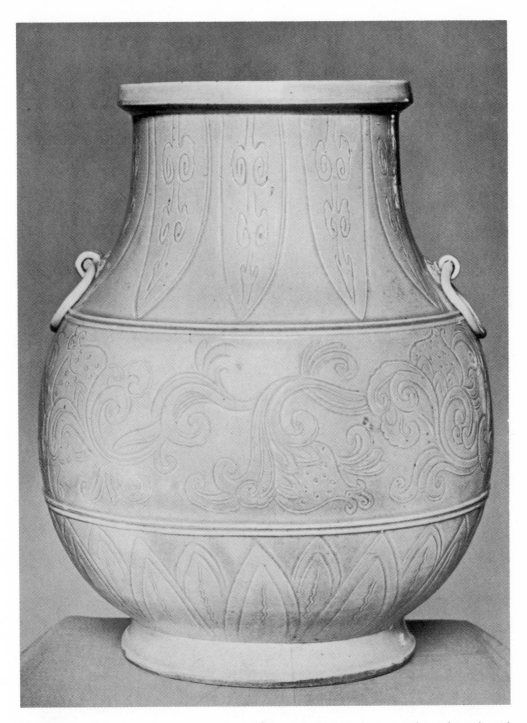

PLATE 48. Vase of bronze form with pear-shaped body, low foot, straight wide neck with flanged mouth-rim; two ring handles. White porcellanous ware with boldly engraved designs and warm ivory white glaze. On the body is a broad belt of lotus scrolls, bordered by wheel-made rings; on the neck are stiff plantain leaves etched with formal ornament; and above the base is a band of stiff overlapping leaves. Ting ware. Sung dynasty. H. 13.5". *In the posses-sion of Mr. George Eumorfopoulos.*

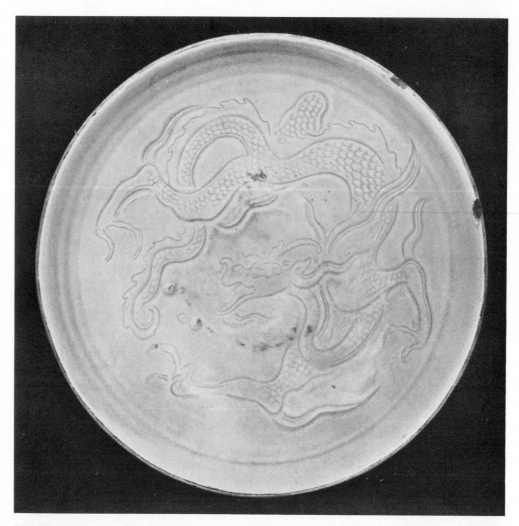

PLATE 49. Saucer dish of white porcellanous ware with ivory white glaze and a splendidly carved design of a three-clawed dragon pursuing a pearl. The edge of the rim is unglazed, and the base is glazed, showing the usual "tear drop" formation. The dish is more heavily built than is usual in the Ting ware to allow of the deeper type of carving. Ting ware. Sung dynasty. D. 11.25" *In the possession of the Misses Alexander.*

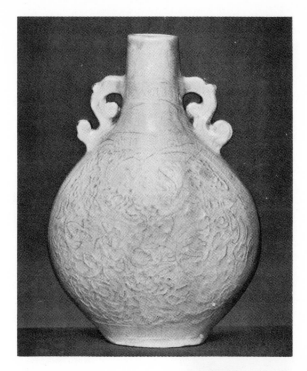

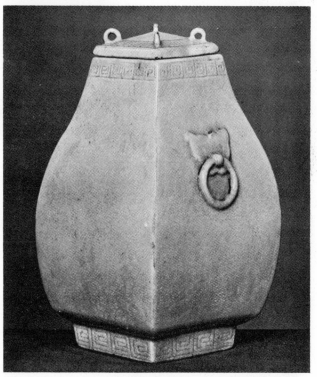

PLATE 50. Fig. 1. Bottle, pear-shaped, with flattened faces; narrow tapering neck and two scroll handles conventionalised from dragon forms. Buff-white ware moulded with what appear to be fungus scrolls and bats in low relief. Creamy glaze minutely crazed. The design of bats is symbolical of Happiness, and the *ling chih* fungus of Longevity; but the scroll ground is obscured by the glaze and its nature is not determined with certainty. Ting ware of the earthen variety (*t'u ting*). Ming dynasty. H. 7″. *In the possession of Mr. George Eumorfopoulos.* Fig. 2. Square vase with pear-shaped outline; short straight foot; clear-cut mouth with low cover. On the sides are two formal handles of tiger-mask and ring type, and on the cover are four loops. Buff-white stoneware with creamy glaze minutely crazed. Incised borders of key-fret—the Chinese *lei wên* or cloud and thunder pattern—on the lid, mouth, and foot-rim. The form of this vase, derived from a bronze, is typical of the Sung taste. Ting ware of the earthen variety (*t'u ting*). Sung dynasty. H. 6.75″. *In the possession of Mr. George Eumorfopoulos.*

57

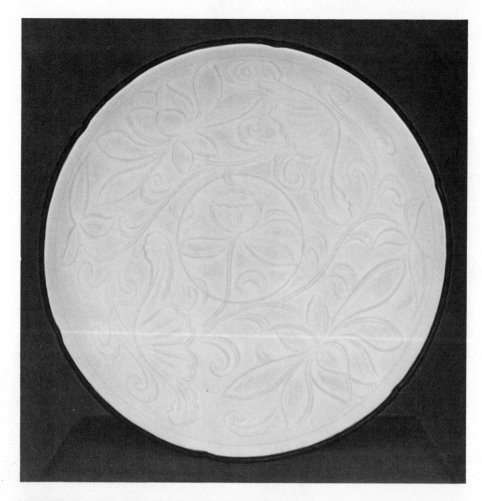

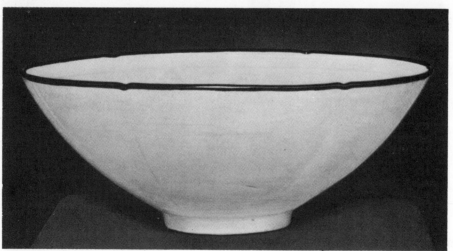

PLATE 51. Bowl with gently rounded sides and narrow, low base. The rim is shaped in six
foliations, and six compartments are faintly suggested on the exterior by engraved lines. Fine
white porcellanous ware with ivory white glaze showing "tear stains" under the base. The
mouth-rim is raw and bound with metal. Inside the bowl is a boldly carved lotus design with
a bud in the middle and flowers and foliage on the sides. Two views of the bowl are given
so that the general shape as well as the interior decoration can be realised. The quality of this
specimen is rather exceptional and shows the Ting ware at its best. Pai Ting ware. Sung
dynasty. D. 8.2". *In the possession of Mr. O. C. Raphael.*

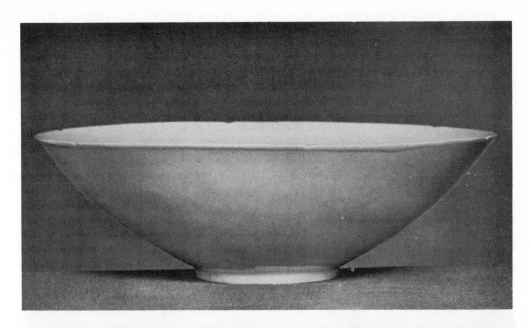

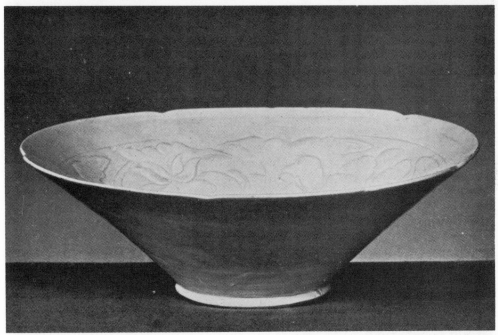

PLATE 52. Fig. 1. Bowl with wide mouth, gently curved sides, and narrow base with low foot-rim; the mouth-rim is nicked so as to suggest a foliate edge. Exquisitely fine egg-shell porcelain pared so thin on the sides as to seem to consist of glaze alone. Beneath the glaze is a design of Imperial five-clawed dragons and pearls, delicately traced in white slip and barely visible except as a transparency. In the centre inside is the Yung Lo mark in four archaic characters etched with a needle point. This bowl is a pair to the noted specimen in the Franks Collection in the British Museum; and it is a beautiful example of the *t'o-t'ai* (bodiless) por-celain which was one of the triumphs of the Imperial potters in the Yung Lo period (1403–24 A.D.). D. 8.25". *In the possession of Mr. George Eumorfopoulos.* Fig. 2. Bowl with wide mouth, straight sides, and narrow base. White porcellanous ware with ivory white glaze. The rim is nicked to suggest a foliate edge. Inside is a finely carved design of peonies and foliage. The base is glazed and the foot-rim, which is shallow, is raw at the edge. Ting ware. Sung dynasty. D. 7.25". *In the possession of Mr. George Eumorfopoulos.*

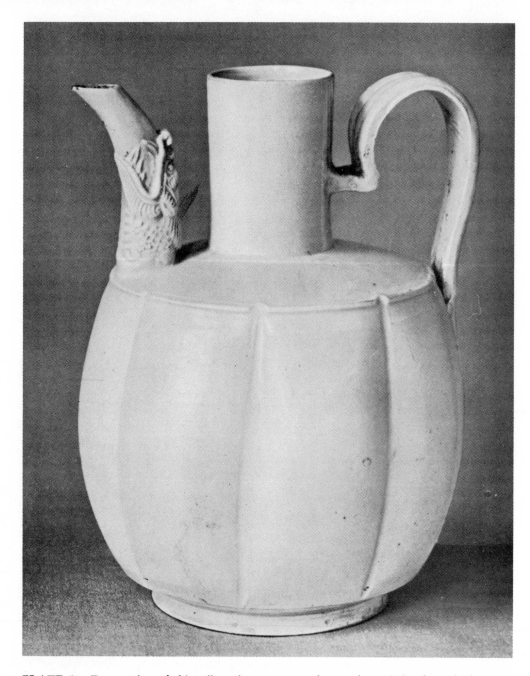

PLATE 53. Ewer with reeded handle and spout issuing from a dragon's head; the body which consists of white porcelain is shaped in eight lobes. The glaze which is of the Ting type is ivory-white and does not cover the base. This specimen may be as early as the T'ang dynasty. Sung dynasty or earlier. H. 7.5". *In the possession of the Misses Alexander.*

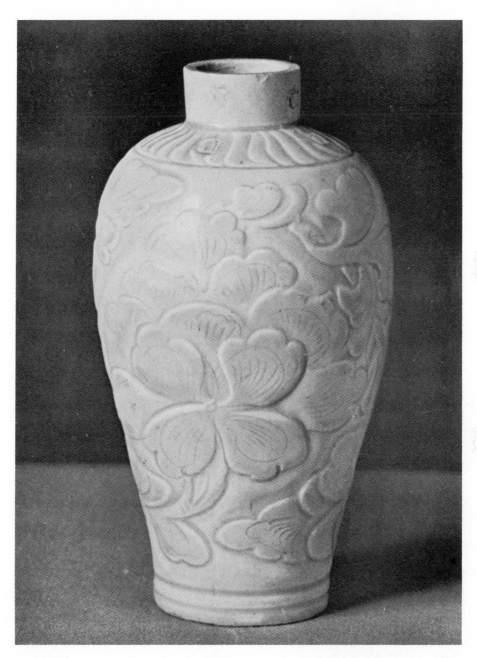

PLATE 54. Vase with ovoid body and short, straight neck. Porcelain with ivory-white glaze, the body beautifully carved in low relief with peony flowers and foliage. On the shoulder is a band of oblique petal pattern. The neck is incomplete and has had four loop handles. The base is deeply hollowed out, with narrow rim; it is glazed and shows marks of the sand on which it stood in the kiln. Ting type. Sung dynasty. H. 5.5″. *In the possession of Mr. F. N. Schiller.*

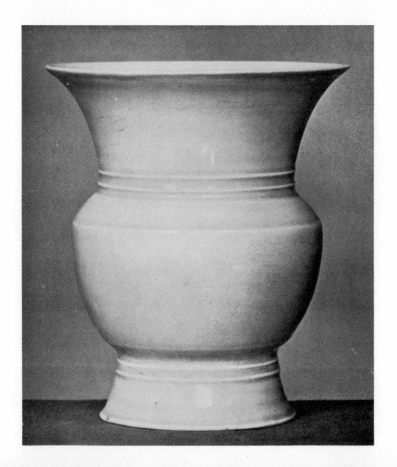

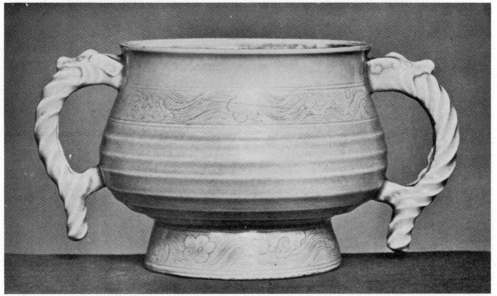

PLATE 55. Fig. 1. Vase of bronze beaker form with globular body truncated on the shoulder, high foot, and wide neck with flaring mouth; two wheel rings on the foot and at the base of the neck. White porcelain with ivory white glaze. This vase is distinguished by its finished potting and elegant form. It is of Ting type, and perhaps made at Ching-tê Chên. Sung dynasty. B. 5.75". *In the possession of Mr. George Eumorfopoulos.* Fig. 2. Incense burner with bowl-shaped body, high foot, and two twisted handles issuing from dragon heads. Buff-white porcellanous ware with incised designs and soft-looking creamy glaze. On the sides, a belt of wave and plum-blossom pattern, and below this a series of shallow horizontal flutes. The wave and plum-blossom design is repeated on the foot. This pattern is frequently mentioned among those of the porcelain supplied to the Imperial palace in the Ming dynasty. Ting type. Ming dynasty. H. 4.5". *In the possession of Mr. George Eumorfopoulos.*

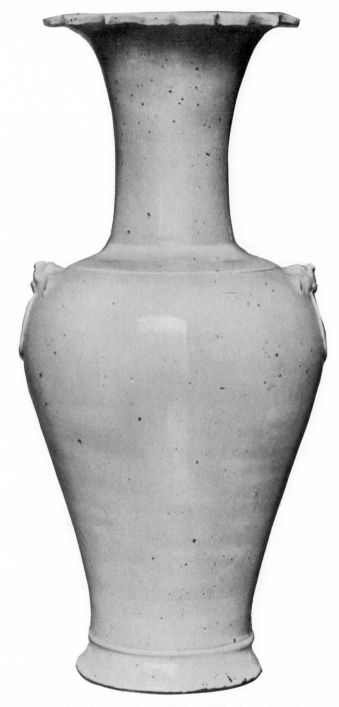

PLATE 56. Vase of beaker shape with slender ovoid body, tall neck, and spreading mouth with foliate lip; two lion mask handles with rings. Buff-white porcellanous ware with yellow-ish white glaze minutely crazed. Shallow foot glazed beneath. Ting type. ? Sung dynasty. H. 15.5″. *In the possession of Mr. George Eumorfopoulos.*

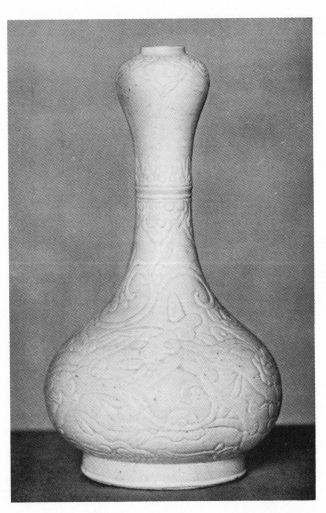

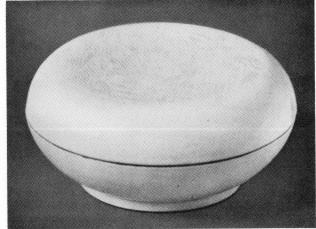

PLATE 57. Fig. 1. Bottle with slender neck ending in a bulb ("onion shape"); porcellanous ware with faint reddish translucency; creamy white glaze of Ting type, lightly crackled. Finely carved design of archaic dragons among *ling chih* fungus. On the neck, a double border of formal leaf design and *ju-i* pattern; and a *ju-i* pattern on the bulb. A beautifully finished piece probably made by one of the late Ming potters who specialised in imitations of Ting ware. The potting of the base and the nature of the crackled glaze support this at-tribution. H. 6.75". *In the possession of Mr. J. Baird.* Fig. 2. Round box with flattened cover. Beautiful cream-white "soft-paste" ware with lightly incised designs. On the cover is a five-clawed Imperial dragon rising from waves to grasp a pearl, and round the sides a wave pattern. This attractive type of ware was doubtless intended to recall the Sung Ting por-celain, and we know that skilful potters were engaged in making imitations of Ting ware at Ching-tê Chên in the latter half of the 16th century. It will, however, be remembered that similar cream-white wares of great beauty were made in the early reigns of the Manchu dynasty, and the differences between the Ming and Ch'ing imitations of the Sung ware will always be difficult to seize. Probably 16th century. D. 4". *In the possession of Mr. F. N. Schiller.*

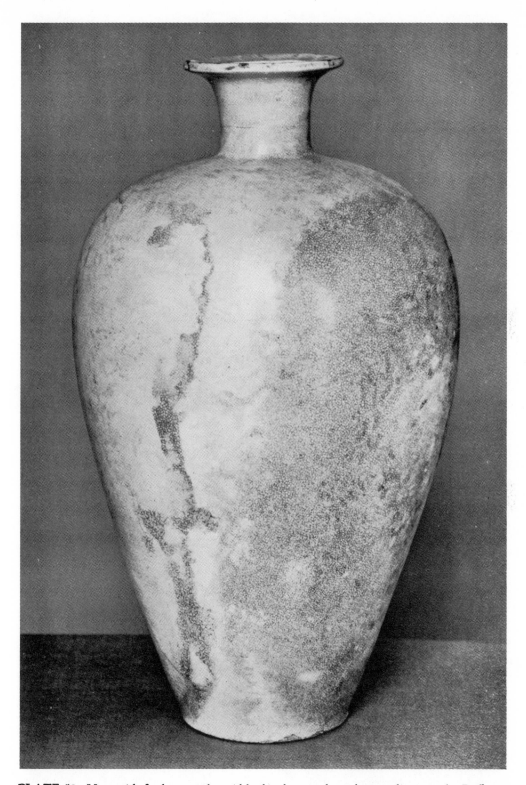

PLATE 58. Vase with finely turned ovoid body, short neck, and expanding mouth. Buff-grey stoneware with a coating of white slip and an almost transparent glaze minutely crackled and clouded with reddish stains due to burial. The base is unglazed. This type of ware has been found in the southern part of the province of Chihli, and is reputed to have been made at Kulühsien or Kichownan. Both towns are in the region of Ting-chou. Sung dynasty. H. 12.75". *In the possession of Mr. F. N. Schiller.*

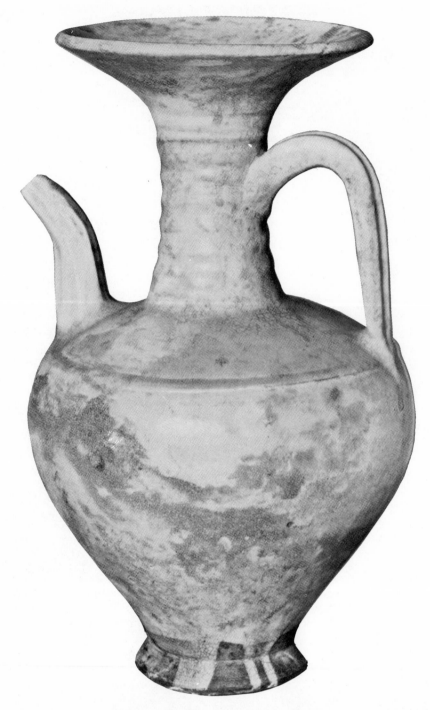

PLATE 59. Ewer with ovoid body tapering to a small base; slender neck spirally ribbed and wide flaring mouth; ribbed handle and carved spout. Buff-grey stoneware coated with white slip and covered with an almost transparent cream-white glaze which has crazed freely and absorbed brownish stains during burial. The glaze stops short of the base. A slightly raised band on the shoulder relieves the severity of the outline. The ribbed neck and widely cupped mouth are developments of a T'ang form. This type of ware is usually attributed to the Sung period; but there are features of this ewer—the ribbed neck and cup-shaped mouth—which are familiar on T'ang vases. Kulühsien or Kichownan ware. Sung dynasty or earlier. H. 11.5". *In the possession of Mr. O. C. Raphael.*

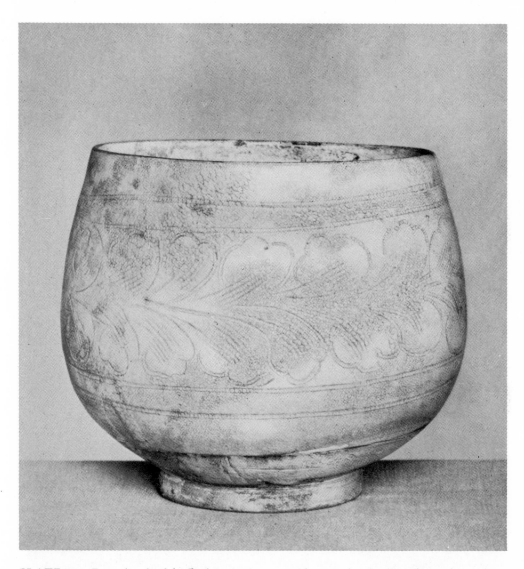

PLATE 60. Deep bowl of buff-white stoneware with a wash of white slip and an almost colourless glaze which forms with the slip a creamy white surface. The glaze, which stops short of the base, is minutely crazed. The bowl has evidently been buried, for through the crazing a reddish discoloration has penetrated. On the sides is a belt of incised palm scroll bordered by two plain rings above and below. The incised design is etched through the slip to the body, but is covered with the almost colourless glaze. Kulühsien or Kichownan ware. Sung dynasty. D. 5.5″. *In the possession of Mr. J. Baird.*

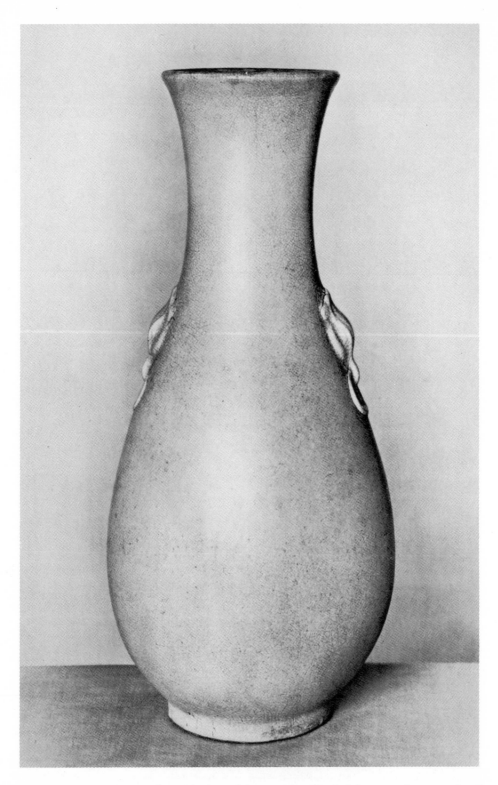

PLATE 61. Vase with pear-shaped body and long neck with slightly expanding mouth. On the sides there are two rudimentary handles in the form of elephant masks with rings. Buff porcellanous stoneware with finely crackled glaze of a warm ivory-white colour, clouded in places with brown. The base is glazed. This type of ware is difficult to date with accuracy, but represents the Ting tradition as carried on by the Ming potters in the various factories in the Kiangnan district, i.e. in Kiangsu and Anhwei. Kiangnan Ting. 15th century. H. 12.75". *In the possession of Mr. V. Wethered.*

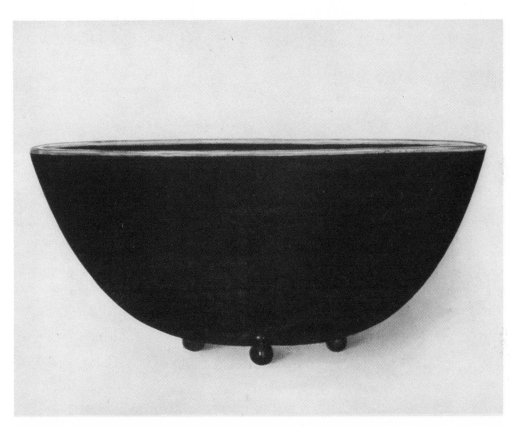

PLATE 62. Bowl with rounded sides and bottom, with three knob-feet. The unglazed mouth-rim is fitted with a silver band, and the body of the ware is not disclosed but rings with a clear note on percussion. The glaze is a brilliant black with a few brown markings of the "hare's fur" type near the mouth-rim and on the knob feet. The unusual nature of the feet, the fineness of the potting, and the even texture of the glaze differentiate this bowl from the familiar black wares of the Sung period to which it is reputed to belong. It is quite possible that it belongs to that rare type, black Ting, which Hsiang Yüan-p'ien (in his 16th-century album) evidently considered as scarce as black swans. D. 8.2″. *In the possession of Mr. F. N. Schiller.*

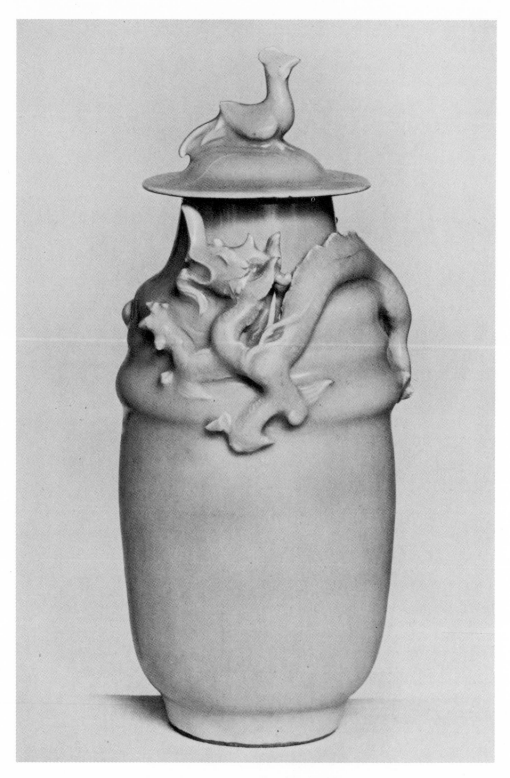

PLATE 63. Funeral jar with body of oblate oval form, straight neck, and dome-shaped cover surmounted by a bird. On the shoulders are three horizontal rounded ridges on which a dragon applied in full relief is pursuing a pearl. Greyish white porcellanous ware (burnt red on the raw edges) with soft dove-grey celadon glaze of great beauty. It is the "Kinuta" type (see p. 11). Other examples of this form are known. In some cases a tiger takes the place of the dragon on the shoulder; in others there are Buddhist figures in relief. It appears to be a refined version of the rather crude funeral jars which have been found in many tombs, tall slender objects with dragons or figures crudely applied on the upper part. Under the base is incised the character *ti* (earth). Lung-ch'üan ware. Sung dynasty. H. 10". *In the possession of Mr. George Eumorfopoulos.*

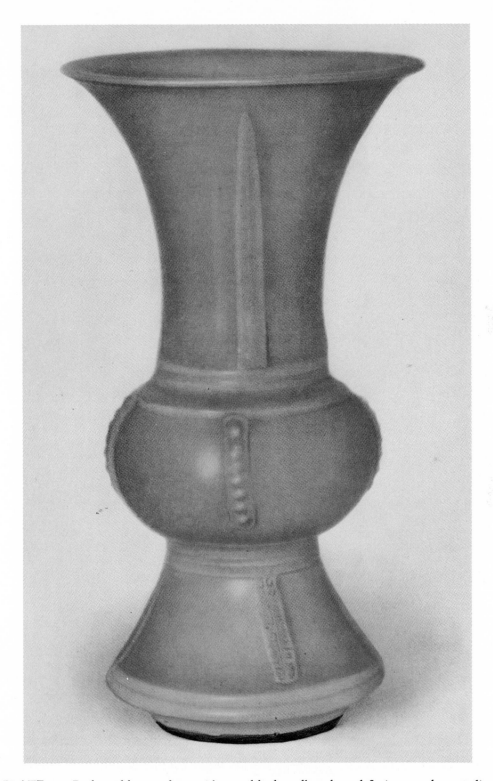

PLATE 64. Beaker of bronze form with round body, tall neck, and flaring mouth; spreading base with low foot-rim. Porcellanous ware, burnt red at the exposed edge of the foot-rim, with grey-green celadon glaze. On the bulb are four dentate ribs, and on the neck and base four pointed leaf designs in applied relief, stamped with key-fret pattern in the style of an ancient bronze. A fine example of the art of the school of potters founded by the younger Chang. Lung-ch'üan ware. Sung dynasty. H. 9.5″. *In the possession of Mr. P. David.*

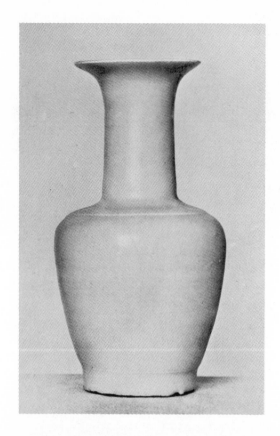

PLATE 65. Fig. 1. Vase, bottle-shaped, with ovoid body, straight neck, and spreading mouth. Greyish white porcellanous ware, burnt red at the exposed edge of the foot-rim, with a beautiful pale greenish gray celadon glaze. The faintly raised collar gives a finish to the simple elegance of this beautiful vase. Lung-ch'üan ware. Sung dynasty. H. 6.7″. *In the possession of Mr. P. David.* Fig. 2. Pigment box, round with flattened cover. Greyish porcelain with delicate sea-green celadon glaze of peculiar softness. On the cover is a carved lotus spray finely drawn, and on the edges wheel-rings appear through the glaze. The box is shallow and quite plain, with three round trays fixed inside; the base is small and concave and shows the marks of a ring of supports. The biscuit where visible at the edges and on the base is browned. Lung-ch'üan ware. Sung dynasty. D. 4.6″. *In the possession of Mr. H. J. Oppenheim.*

PLATE 66. Fig. 1. Bowl of conical form with small foot; fluted on the exterior in petal pattern. Soft greenish grey glaze finely crackled with irregular lines. The unglazed edge of the base-rim shows a buff-white ware which has browned on the surface in the kiln. The glaze has the dull lustre of marble. This bowl may be either a specimen of Ko yao (i.e. made by the school of potters founded by the elder brother Chang in the Lung-ch'üan district), or an example of the Tung Ch'ing ware (Eastern celadon) produced at one of the Honan factories, in the neighbourhood of Kaifêng. Sung dynasty. D. 6.7". *In the possession of Mr. P. David.* Fig. 2. Flower-pot of cylindrical form with three small feet. Greyish white porcellanous ware with three lotus designs in applied relief and a soft grey-green celadon glaze. The body has turned a rusty brown at the base-rim where exposed to the fire. Lung-ch'üan ware. Sung or Yüan dynasty. D. 5.8". *In the possession of Mr. P. David.*

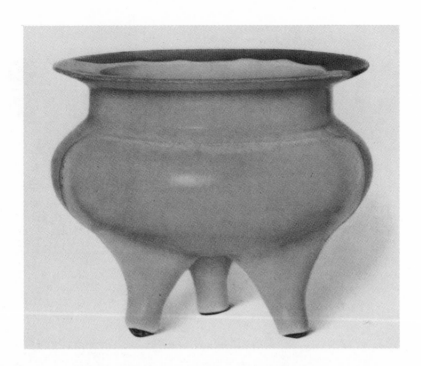

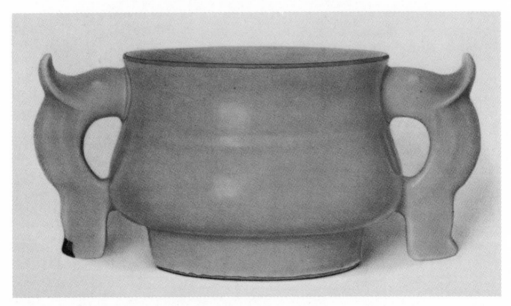

PLATE 67. Fig. 1. Tripod incense vase (*ting*) with three ribs on the sides and continued down the three legs. Greyish white porcellanous ware, thin and finely potted and coated with a lustrous grey celadon glaze of exquisite tone and texture. The ware has browned in the exposed parts under the feet. Like the incense vessel in Fig. 2 the glaze is of the colour and texture which goes by the name Kinuta; see p. 11. Lung-ch'üan ware. Sung dynasty. D. 5.75″. *In the possession of Mr. O. C. Raphael.* Fig. 2. Incense vase of bronze form, with deep bowl-shaped body, straight foot-rim, and two handles issuing from fish-dragon heads. A slightly raised band above the swell of the body breaks continuity in the outline. Greyish white porcelain with a pale greenish grey celadon glaze. The biscuit, where exposed on the mouth-rim, has burnt red, and similar red appears on the edge of the foot-rim. A vessel of refined form and indescribable delicacy of colour, belonging to the so-called Kinuta group. Lung-ch'üan ware. Sung dynasty. H. 3.75″. *In the possession of Mr. H. J. Oppenheim.*

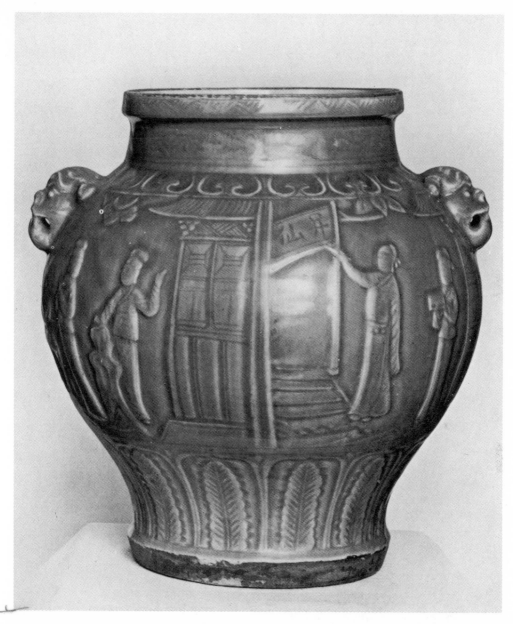

PLATE 68. Vase with wide ovoid body, short, straight neck, and wide mouth with flanged lip, and two handles in the form of dragon masks pierced for rings. Grey porcellanous ware with sea-green celadon glaze; the base formed by a saucer which has been dropped in and secured by the glaze. The ornament is carved in relief and etched. On the body is a broad belt with relief design of pavilions and groups of figures; one figure is pointing to a door-way over which is written *shêng hsien* (become a *hsien* or Immortal); on the other side Lü Tung-pin appears, on a cloud, to his votaries, and there is the legend *yo yang*. On the shoulder is a band of *ju-i* ornament, and above the base, false gadroons enclosing stiff leaves. On the neck a floral scroll is incised and a vandyke pattern on the mouth-rim. Doubtless the buildings represent the famous Yo-yang tower in Hunan; and the scene may be intended to represent a Taoist adept about to become a *hsien*, i.e., to enter on Immortality. Ch'u Chou ware. Ming dynasty. H. 14″. *In the possession of Mr. George Eumorfopoulos.*

PLATE 69. Dish, saucer-shaped, with flattened and everted rim; the outside is fluted. The inside has an incised wave pattern, and in the centre there is a four-clawed dragon pursuing a flaming pearl in applied relief under the glaze. The base is glazed, and the biscuit at the foot-rim has burnt red; there is no unglazed ring on the base. Lung-ch'üan ware. Sung or Yüan dynasty. D. 14.5″. *In the possession of Mr. F. N. Schiller.*

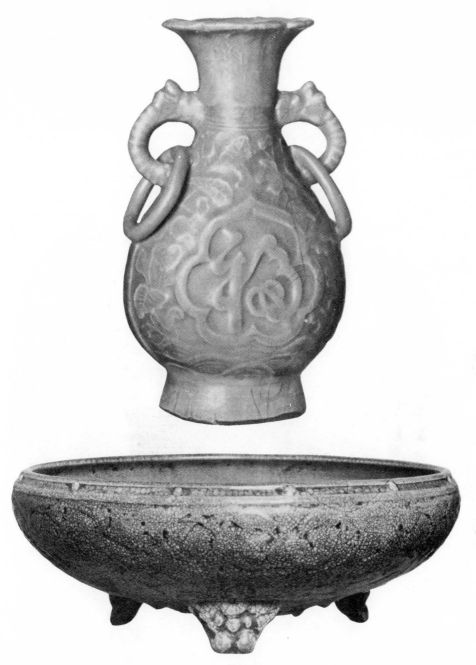

PLATE 70. Fig. 1. Vase of flattened, bottle form, with pear-shaped body and narrow neck with spreading quatrefoil mouth. Greyish porcellanous ware, burnt a rusty red at the foot-rim, with a soft grey-green celadon glaze with the dull lustre of a water-worn stone. Two handles on the neck suggesting an elephant head and trunk, with rings in full relief. On each side are moulded designs in low relief; a *ju-i* shaped panel enclosing the characters *shou* (longevity) and *fu* (happiness) enclosed by flowering sprays; below the character *shou* is a formal hill design (suggesting *shou shan,* "longevity of the hills"), and beneath the *fu* is a formal wave design (suggesting *fu hai,* "happiness boundless as the sea"). On the neck are a key fret band and stiff plantain leaves. The glaze resembles that found on Sung or Yüan specimens; but the decoration points to the probability of a Ming date. In the latter dynasty the Lung-ch'üan potters moved to another centre at Ch'u Chou. Ch'u Chou ware. **Ming dynasty.** H. 8″. *In the possession of Mr. H. B. Harris.* Fig. 2. Bulb-bowl of shallow bowl shape with three cloud-scroll feet: below the lip, which is slightly contracted, is a channelled band with rosette studs at regular intervals. Grey porcellanous ware, with watery grey-green celadon glaze minutely crackled. On the outside is a faintly carved floral scroll. The glaze has run in large drops round the edge of the base, which is raw and heavily browned. Inside, the glaze has accumulated towards the centre, which is bare and burnt a reddish brown. Ch'u Chou ware. 16th century. D. 16″. *In the possession of Mr. George Eumorfopoulos.*

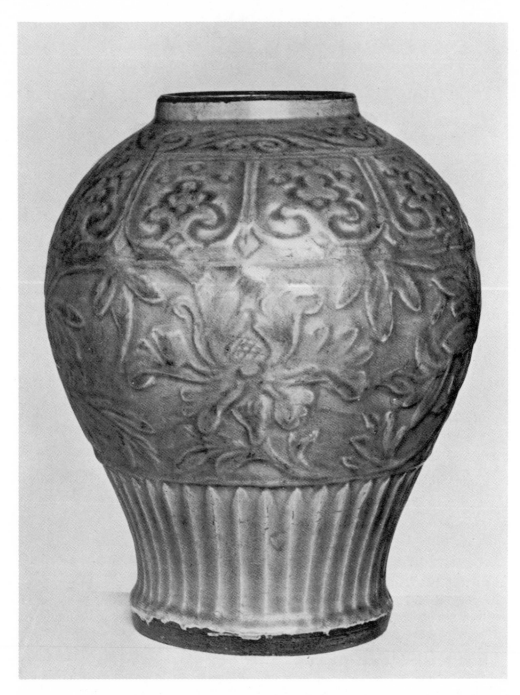

PLATE 71. Vase with ovoid body, short, straight neck, and wide mouth; the base formed by a saucer which has been dropped in and secured by the glaze. Grey porcellanous ware with sea-green celadon glaze. Carved ornament in horizontal bands; a broad belt of peony scroll in low relief, below which is a band of stiff, pointed leaves; on the shoulder, a band of false gadroons with conventional foliage, and above it a foliage scroll. Ch'u Chou ware. 15th century. H. 12". *In the possession of Mr. George Eumorfopoulos.*

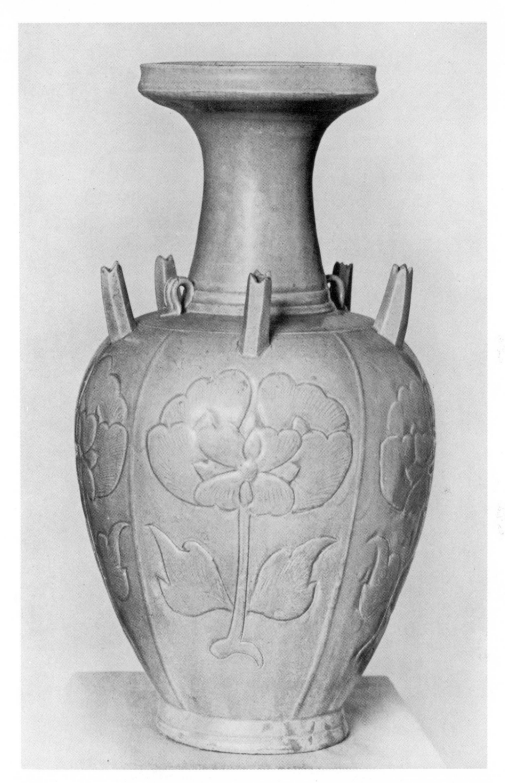

PLATE 73. Vase with ovoid body, tall, slender neck, and cup-shaped mouth. On the shoulder are two small loop-handles and five hexagonal tubes. These tubes do not communicate with the interior of the vase and may possibly have served to hold joss sticks. Greyish porcellanous stoneware with a delicate grey-green glaze, frosted in parts with a dull-yellowish deposit due to decay during burial or occurring during the firing. The sides are partitioned by ribs into five vertical panels, in each of which is a stiff peony spray carved in low relief with etched details; and above are faintly etched scrolls. Base glazed over, with a ring of sand-marks. Northern Chinese celadon. Sung dynasty. H. 13.7". *In the possession of Mr. O. C. Raphael.*

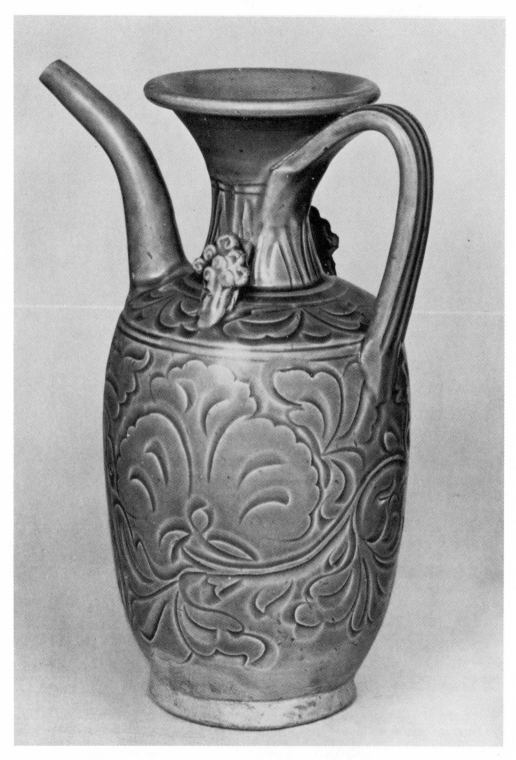

PLATE 74. Ewer with barrel-shaped body, and slender neck with flaring mouth; plain spout and ribbed handle, with two cloud-scroll ornaments projected from the shoulder. Grey stoneware with light brownish celadon glaze and boldly carved designs of foliage on the body and shoulder and stiff leaves on the neck. Northern Chinese celadon. Sung dynasty. H. 10″. *In the possession of the Misses Alexander.*

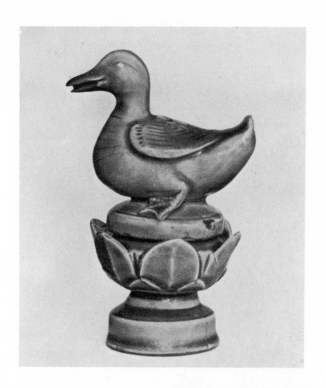

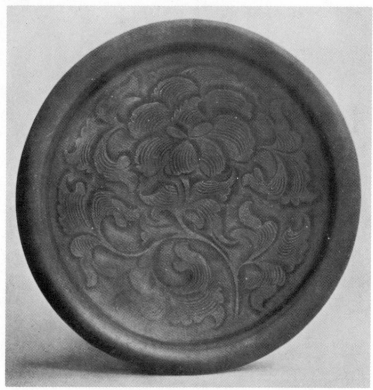

PLATE 75. Fig. 1. Incense vase in the form of a duck (which serves as the cover) on a lotus pedestal. Buff porcellanous ware with olive-green glaze. Northern Chinese celadon. Sung dynasty. H. 6•5″. *In the possession of Mr. J. Baird.* Fig. 2. Shallow bowl with narrow foot-rim and mouth-rim sharply curved outwards. Grey stoneware which has turned dark brown where exposed to the fire. Brownish green celadon glaze over a boldly carved design of peony flowers and foliage. Northern Chinese celadon. Sung dynasty. D. 7.25″. *In the possession of Mr. A. L. Hetherington.*

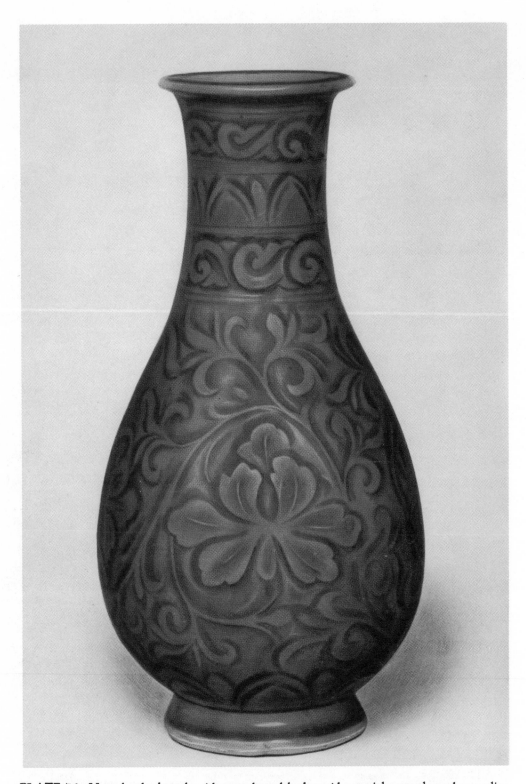

PLATE 76. Vase, bottle-shaped, with pear-shaped body, wide, straight mouth, and spreading lip; low, hollow foot. Buff-grey stoneware with finely carved designs and olive-green celadon glaze. The body is covered with a lotus scroll, and on the neck is a band of stiff leaves between two bands of foliage scroll. Northern Chinese celadon. Sung dynasty. H. 9.25". *In the possession of Mr. George Eumorfopoulos.*

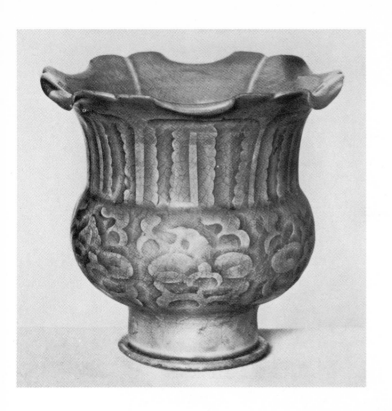

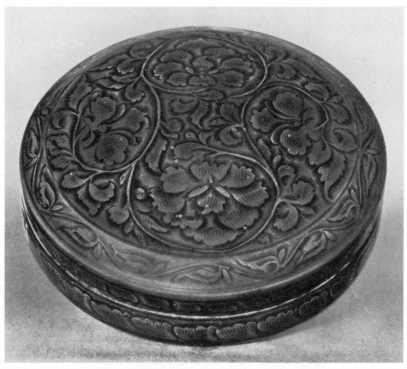

PLATE 77. Fig. 1. Vase with low globular body, wide neck, expanding at the rim, which is shaped in six foliations each folded in the middle. There are six ribs inside the neck. Buff porcellanous ware with carved ornament under a brownish green celadon glaze, lightly crackled. The design consists of six formal sprays of foliage vertically disposed on the body, and stiff plantain leaves on the neck. Northern Chinese celadon. Sung dynasty. H. 4.75″. *In the possession of Mr. S. D. Winkworth.* Fig. 2. Box, circular, with slightly rounded top; brownish stoneware with finely carved designs under a brownish green celadon glaze. On the cover are finely drawn peony scrolls and a foliage scroll border; borders of scalloped leaves on the sides. The glaze under the base and inside is decidedly brown, and recalls that found under the base of the numbered Chün flower-pots. Northern Chinese celadon. Sung dynasty. D. 6.9″. *In the possession of Mr. P. David.*

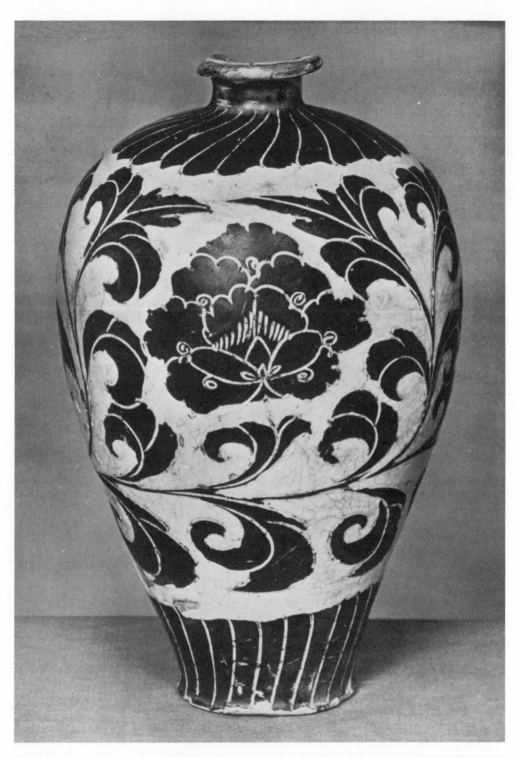

PLATE 78. Vase with ovoid body and short neck with spreading lip. Buff-grey stoneware with coating of white slip, on which floral designs are lightly incised and brushed over with black. The whole is covered with a transparent cream-white glaze giving a marble-like texture. On the sides is a bold lotus scroll, and above and below are bands of oblique petal pattern. This is a particularly fine example of Tz'ŭ Chou work when it was at its best. Tz'ŭ Chou ware. Sung dynasty. H. 12″. *In the possession of the Misses Alexander.*

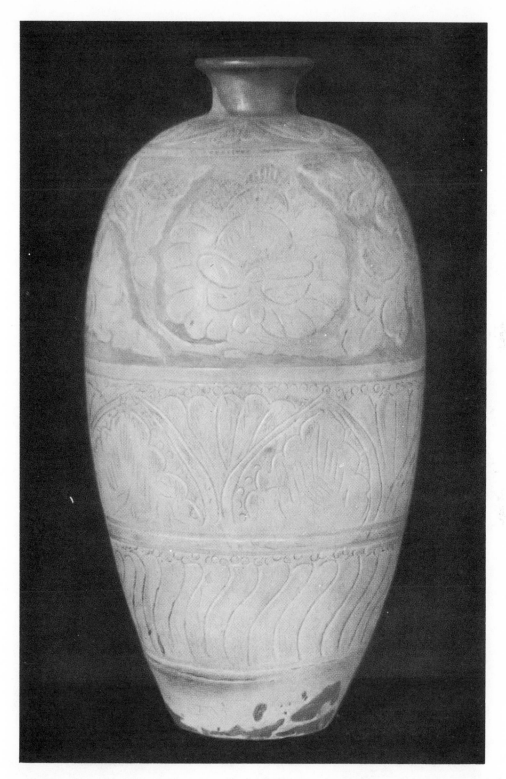

PLATE 79. Vase with slender ovoid body and small neck with spreading lip. Greyish stone-ware with coating of white slip through which the design is carved so as to expose the body. An almost transparent glaze, minutely crackled, covers the whole so that the design in cream-white shows up against a mouse-coloured ground. The ornament is in four belts: (1) a foliage band on the neck; (2) a broad belt of bold floral scroll next; (3) overlapping leaf design in a ground sprinkled with small circles; and (4) lowest, a band of oblique leaf pattern bordered by small circles. Tz'ŭ Chou ware. Sung dynasty. H. 14.6". *In the possession of Mr. C. Rutherston.*

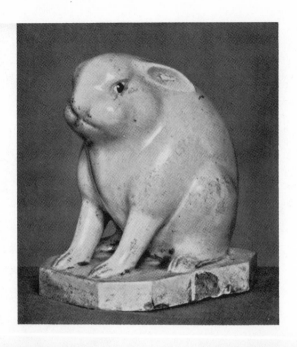

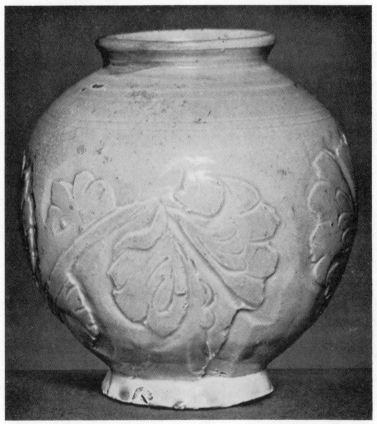

PLATE 80. Fig. 1. Figure of rabbit seated on a flat octagonal base. Buff stoneware with white slip dressing and a creamy white glaze; the eyes touched with black slip. A delightful model full of life and humour. Tz'ŭ Chou ware. Sung dynasty. H. 4″. *In the possession of Mr. George Eumorfopoulos*. Fig. 2. Vase with globular body, short neck with wide mouth, and low base. Greyish stoneware with white slip coating and transparent glaze of faintly creamy tone. On the sides is a boldly carved foliage scroll, and on the shoulder a few wheel rings. Tz'ŭ Chou ware. Sung dynasty. H. 5.5″. *In the possession of Mr. George Eumorfopoulos.*

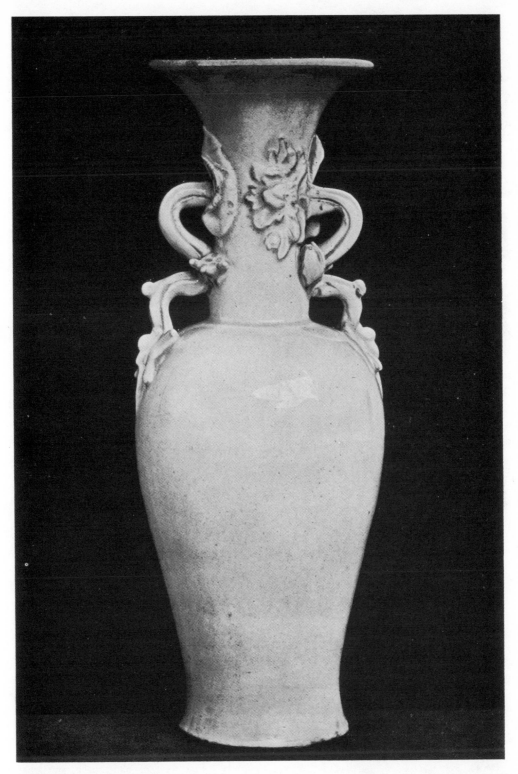

PLATE 81. Vase of beaker shape with swelling body; grey porcellanous stoneware of Tz'ŭ Chou type. Thick white, lustrous glaze which does not extend on to the base, though a smear of glaze appears underneath. The foot is hollowed out, and there is a widish foot-rim. The handles of the vase are in the form of lotus stalks, one bearing a leaf and the other a flower and bud. Tz'ŭ Chou type. Ming dynasty. H. 12″. *In the possession of Mr. F. N. Schiller.*

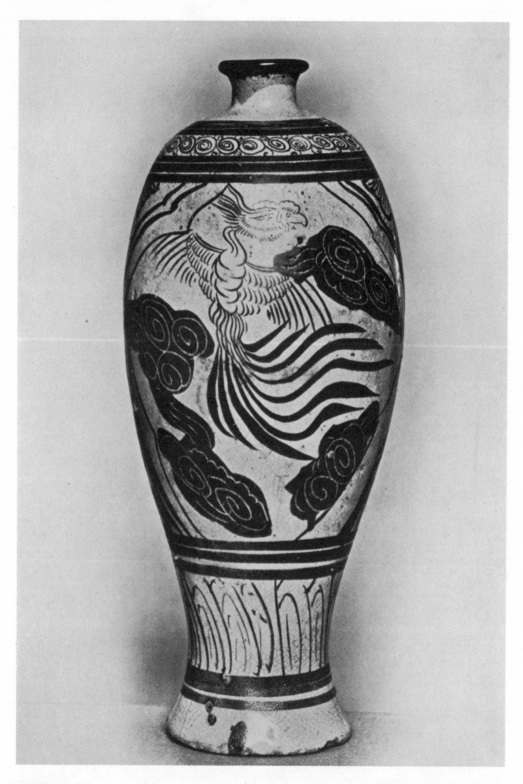

PLATE 82. Vase of slender ovoid form with slightly spreading foot, short neck, and small mouth. Buff-grey stoneware with coating of white slip and a colourless glaze of faintly yellowish tinge. The designs, painted in black with details etched through to the white, are arranged in horizontal bands. The main belt is divided into two large panels of mirror shape boldly painted with a phœnix in clouds; formal ornament between. On the shoulder is a curled scroll band between triple borders of black; and above the foot is a sketchy leaf pattern similarly bordered. Tz'ŭ Chou ware. Sung dynasty. H. 14.5". *In the possession of Mr. George Eumorfopoulos.*

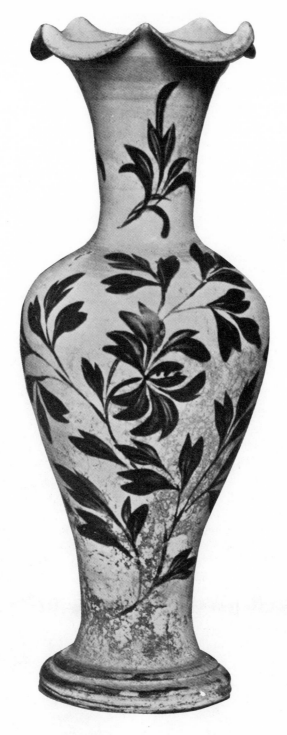

PLATE 84. Vase of beaker form with slender ovoid body, terraced foot, tall neck with wide mouth and folded foliate lip. Buff-grey stoneware with coating of white slip and a creamy white glaze. On the body is a lily design beautifully painted in brown. Foliage sprays on the neck. The foliate mouth throws back to the "mallow flower base" (see Plate 21). Tz'ŭ Chou ware. Sung dynasty. H. 14.75″. *In the possession of Mr. George Eumorfopoulos.*

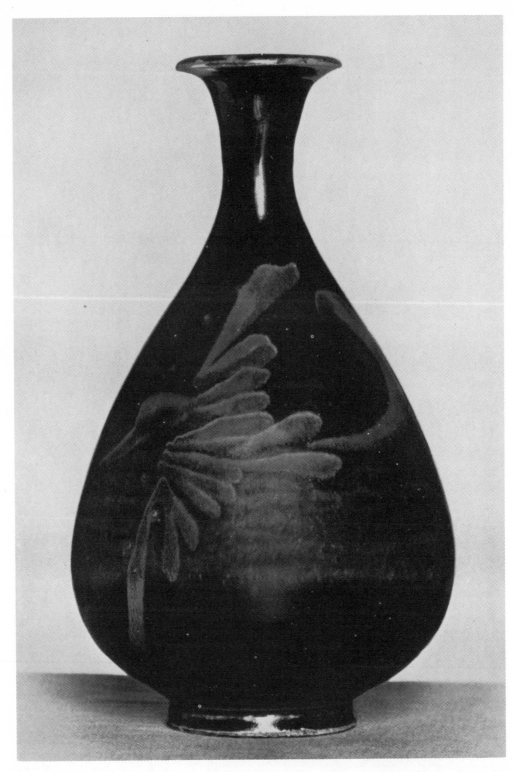

PLATE 86. Bottle-shaped vase of buff-grey stoneware, with rich brown-black glaze. On either side an impressionist sketch of a flying bird has been painted in a brown glaze of a different composition from the main glaze. Tz'ŭ Chou ware. Sung dynasty. H. 10.5″. *In the possession of Mr. J. Baird.*

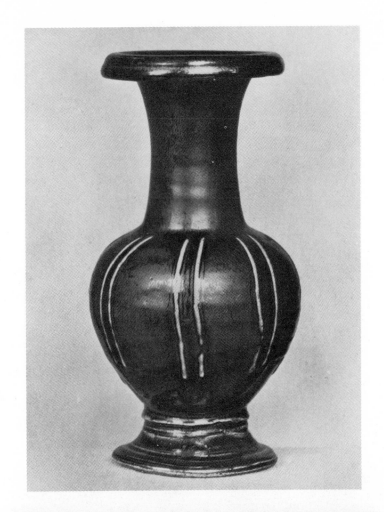

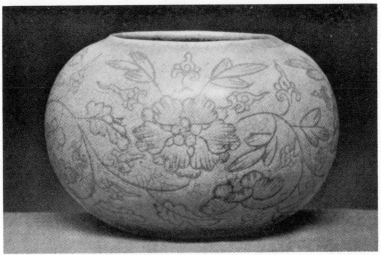

PLATE 87. Fig. 1. Vase with globular body, tall, slender neck with wide mouth-rim, and spreading foot. Buff ware with seven pairs of slightly raised ribs on the body and a black glaze which loses its colour on the raised edges, leaving them white. Tz'ŭ Chou type. Sung dynasty. H. 7.6″. *In the possession of Mr. George Eumorfopoulos.* Fig. 2. Buddhist alms bowl of depressed globular form with wide mouth. Greyish stoneware body; unglazed base and pared foot-rim. The body is washed over with white slip, through which the design, a peony scroll, has been engraved; the whole has then been covered with a transparent glaze which shows slight crackle. Tz'ŭ Chou ware. Ming dynasty. D. 4.5″. *In the possession of Mr. F. N. Schiller.*

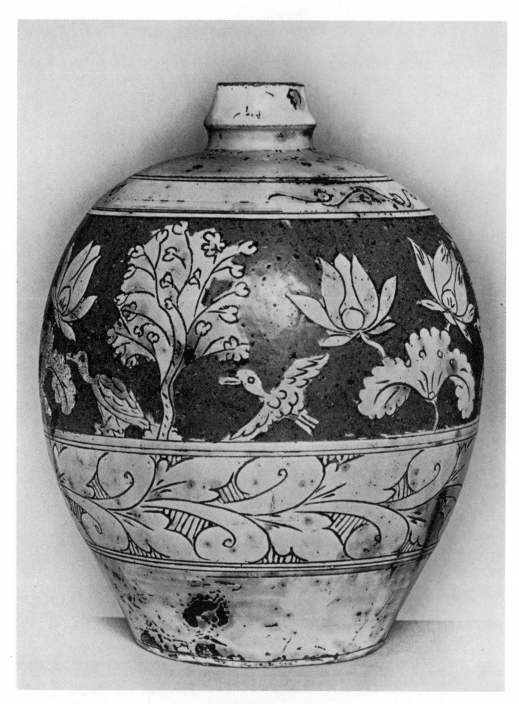

PLATE 88. Jar with ovoid body and short, narrow neck flanged below the mouth. Buff-grey stoneware coverd with white slip and transparent glaze of slightly yellowish tone. The designs are formed by the graffiato process. In the body is a broad band with lotuses, plants, and birds, standing up in white against a grey ground from which the slip has been cleaned; the incised outlines and details of the decoration are picked out with a black slip painted on. Below this is a narrower band with foliage scroll etched through the slip, and on the shoulders are sketchy scrolls similarly produced. The base is unglazed. Tz'ŭ Chou ware. Yüan dynasty. H. 10.5". *In the possession of Mr. George Eumorfopoulos.*

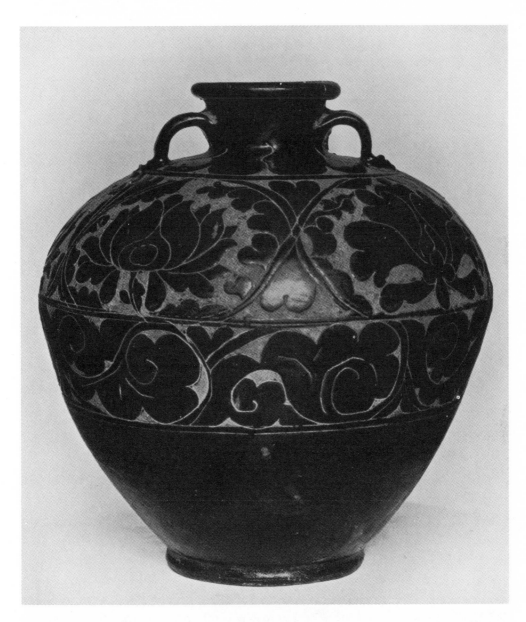

PLATE 89. Jar with wide ovoid body, short straight neck, and small mouth with two loop handles from the shoulder to the neck. Buff-grey stoneware with coating of thick, lustrous black glaze, and *champlevé* designs, consisting of a broad band with interlacing lotus scrolls, below which is a narrower band with foliage scrolls. The ground of the pattern is scraped clean of glaze, leaving the designs standing out in black against a greyish biscuit. The base is glazed. Tzʾŭ Chou ware. Yüan dynasty. H. 14.25″. *In the possession of Mr. George Eumorfopoulos.*

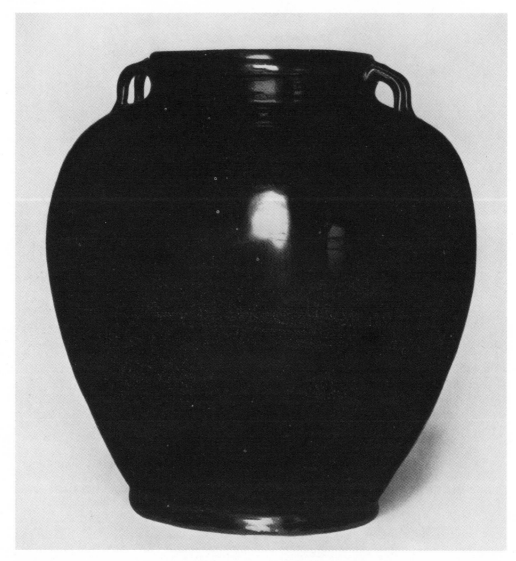

PLATE 90. Jar with ovoid body, short transversely corrugated neck, and wide mouth; two pairs of loop handles on the shoulder. Buff stoneware with thick black glaze of great richness and lustre. The glaze is thicker on the upper portion of the jar and looks as if the jar had been glazed (before firing) on the upper portion and then had been dipped in glaze to cover the lower portion, the foot-rim being subsequently wiped clean. Tz'ŭ Chou ware. 15th century. H. 10″. *In the possession of Mr. J. Baird.*

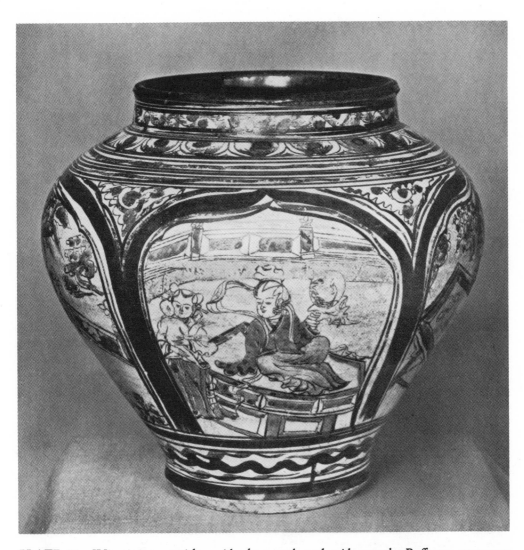

PLATE 91. Wine-jar, or potiche, with short neck and wide mouth. Buff-grey stoneware with dressing of white slip and four leaf-shaped panels framed in black and brown slips and painted with figure subjects (ladies and children) in green and red enamels. Formal borders above and below. Brown glaze inside. Tz'ŭ Chou ware. Ming dynasty. H. 12". *In the possession of the Misses Alexander.*

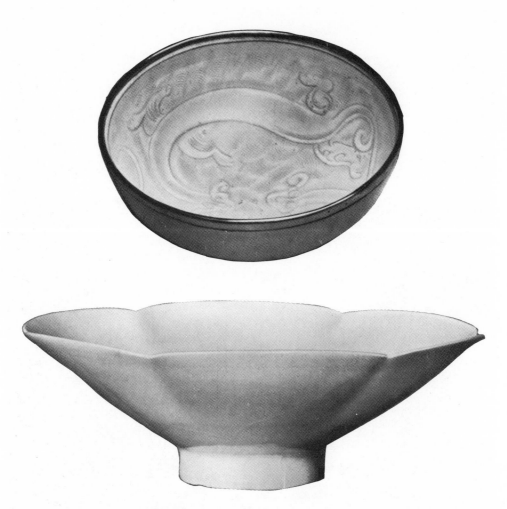

PLATE 93. Fig. 1. Small bowl or cup of very thinly potted and highly translucent porcelain with pale bluish glaze. Finely carved inside with two archaic dragons and waves. The mouth-rim is unglazed and bound with gold; the base is glazed and the foot-rim is trimmed almost to a sharp edge. Where the glaze has accumulated it shows a pronounced blue colour. Ju type. Sung dynasty. D. 4.2″. *In the possession of Mr. A. L. Hetherington.* Fig. 2. Shallow conical bowl with sides lightly moulded and mouth-rim cut in six foliations; narrow foot with sharp-edged rim. Porcelain of egg-shell thinness, and white glaze with a faint tinge of blue, and slight crazing. Under the base is a circular patch of unglazed biscuit which seems to be of a granular texture; it has burnt red-brown, and is fringed with a ring of kiln-sand. This dainty little egg-shell bowl is a masterpiece of potting. Ju type. Sung dynasty. D. 5.25″. *In the possession of Mr. H. J. Oppenheim.*

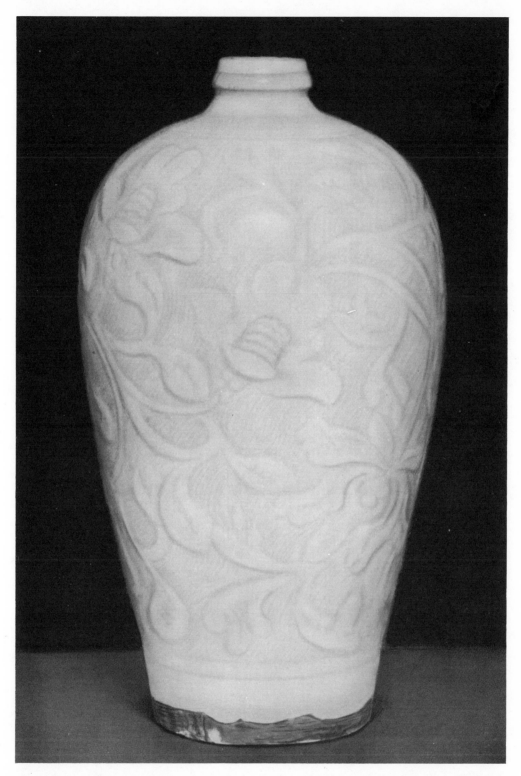

PLATE 94. Vase of ovoid form with small neck and narrow mouth flanged below the lip. Porcelain with carved designs and a pearly, bluish white (*ying ch'ing*) glaze. The design, a bold peony scroll, stands up in low relief, the ground being cut away and hatched with combed lines. The glaze stops short of the base, and the biscuit below is burnt a reddish tone. Ju type. Sung dynasty. H. 9.75". *In the possession of Mr. George Eumorfopoulos.*

PLATE 95. Bowl with sides divided on the interior into six compartments by slightly raised ribs. The porcelain, which is thinly potted and highly translucent, is covered with a light blue glaze. The bottom is engraved with two fishes in water, an emblem of conjugal felicity. The mouth-rim is unglazed. The foot-rim is low, and the base is covered with glaze. The bowl is shown in two positions to indicate the shape as well as the decoration. Ju type. Sung dynasty. D. 7.2″. *In the possession of Mr. A. L. Hetherington.*

PLATE 96. Vase with pear-shaped body, wide neck, and spreading mouth, and four pro-jecting ribs on the side and on the foot. Fine white porcelain, following closely a bronze model in form and ornament; white glaze with faintly bluish tone, which is more prominent where the glaze has run thickly. Moulded designs. On the body a ground of key-fret or "cloud and thunder" pattern (*lei wên*) over which are *k'uei* dragons, interrupted by the ribs; below this the body is reeded. On the foot, similar designs. On the neck, stiff leaves engraved with fret patterns, and below the lip a key-fret border. The foot is hollow and glazed inside, and the raw edge of the rim shows a fine white body. The style of this exquisite vase recalls some of the illustrations in the famous album of Hsiang Yüan-p'ien. Ju type. Sung dynasty. H. 5.75″. *In the possession of Mr. George Eumorfopoulos.*

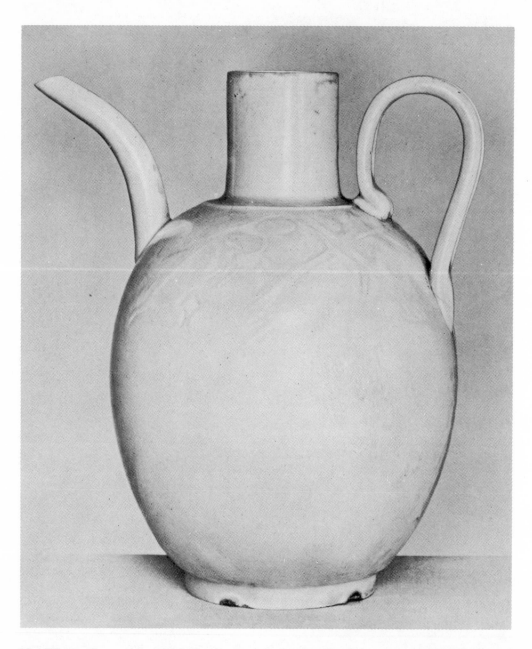

PLATE 97. Ewer with ovoid body, narrow cylindrical neck, plain spout, and handle formed
of two strands of clay. On the shoulder is a lightly carved foliage design. Highly translucent
porcelain with bluish white (*ying ch'ing*) glaze, which shows the blue colour only where the
glaze is of some thickness. There are five support marks on the foot-rim. Ju type. Sung
dynasty. H. 7.5". *In the possession of Mr. J. Baird.*

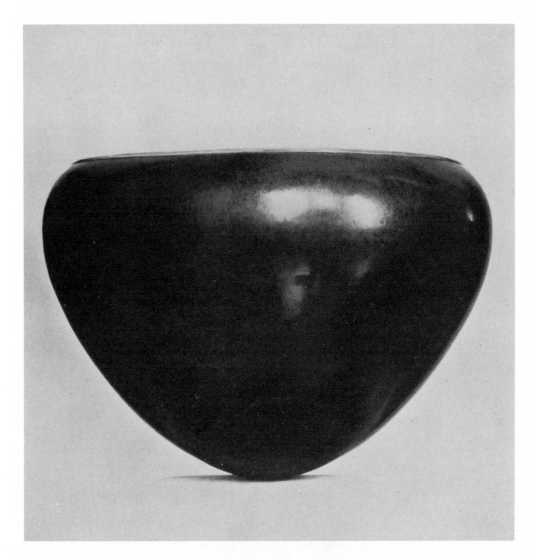

PLATE 98. Bowl of conical form with rounded sides and pointed base; slightly contracted at the mouth, which is mounted with a metal band. The flow of the glaze is from base to mouth, and the point of the base, where the covering is thin, discloses a body of light grey colour. The glaze inside and out is thick and of a dark olive-brown colour, streaked with brown-black. The form of this bowl is comparable with that illustrated on Plate 87, Fig. 2. Probably Honan ware. Sung dynasty. H. 7″. *In the possession of Mr. George Eumorfopoulos.*

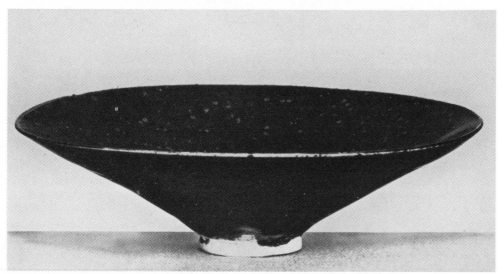

PLATE 99. Fig. 1. Vase with ovoid body shaped in six lobes, short neck and wide mouth. Buff ware with deep smooth reddish brown glaze, of the colour known to the Japanese as "*kaki*"; glazed base. At certain parts of the vessel the glaze shows a black underneath, indicating that the brown effect is superficial and caused by execss of ferric oxide coming out of the glaze on cooling and being deposited on the surface. Probably Honan ware. Sung dynasty. H. 3.75". *In the possession of Mr. George Eumorfopoulos.* Fig. 2. Shallow bowl with wide mouth, straight sides, and narrow foot. Light buff ware with rich black glaze spotted with red-brown. The glaze stops short of the foot, and has run thinly at the mouth-rim. The red-brown spots have the appearance of flecks of glaze of different composition spattered on to the main glaze. Honan ware. Sung dynasty. H. 7.5". *In the possession of Mr. George Eumorfopoulos.*

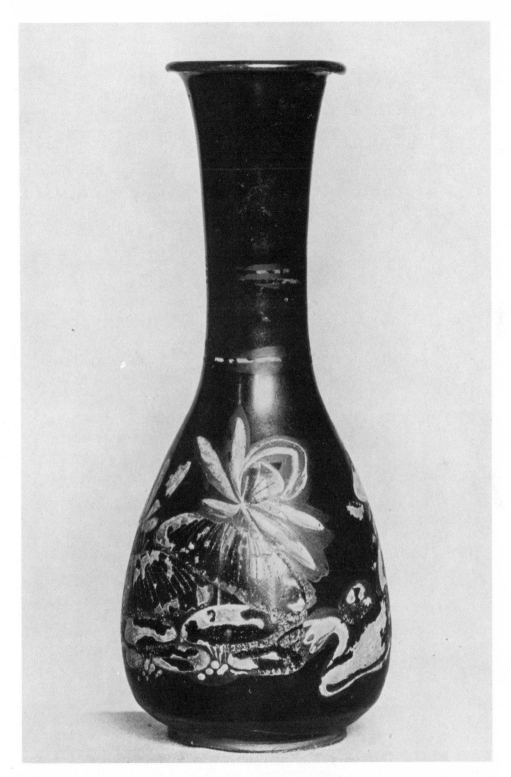

PLATE 101. Bottle with pear-shaped body and tall, slender neck with flat, spreading mouth-rim. Buff ware with black glaze, and a free design of ducks and lotus plants painted in white and black slips. This is a most unusual technique on Chinese wares, though it is closely paralleled on some early Persian—so-called Gabri—wares. Probably Honan ware. Sung dynasty. H. 8.75". *In the possession of Mr. George Eumorfopoulos.*

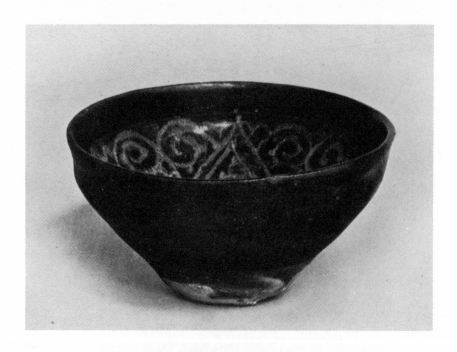

PLATE 102. Fig. 1. Tea-bowl with mouth lightly channelled on the exterior. Buff stone-
ware with brown-black temmoku glaze, decorated on the interior with geometric designs in
greyish yellow. Reported to have been made in Chi-an Fu in Kiangsi (see p. 15.) Sung
dynasty. D. 4.75″. *In the possession of Mr. F. N. Schiller.* Fig. 2. Tea-bowl of conical
form, the rim slightly compressed at the mouth. Buff stoneware with black temmoku glaze
reaching the foot; with a stencilled leaf design inside in greyish yellow. Another specimen
said to have been made in Chi-an Fu. Sung dynasty. D. 5.75″. *In the possession of Mr.
F. N. Schiller.*

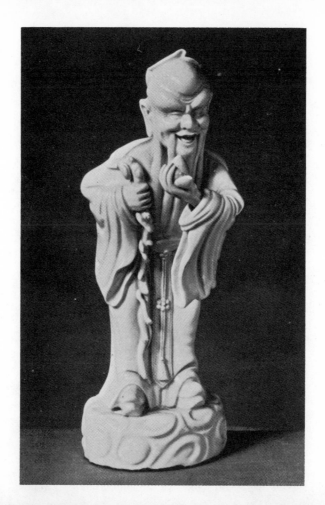

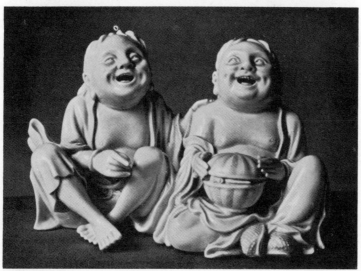

PLATE 104. Fig. 1. Figure of an old man bearded and slightly bent, holding a knotted staff in his right hand and peach in his left, and standing on a circular cloud-scroll base. Buff-white stoneware with creamy white glaze minutely crazed. The ware is of beautiful quality and finely modelled. The subject is probably Tung-fang So, the "boy" who stole the peaches from the Tree of Life in the garden of Hsi Wang Mu and so obtained a fabulous longevity. Ting type. Perhaps Ming dynasty. H. 10″. *In the possession of Mr. George Eumorfopoulos.* Fig. 2. Group of the *Ho ho êrh hsien.* Twin Genii of Union and Harmony (Han-shan and Shih-tê), seated and looking up with laughing faces. Han-shan holds his "box of blessings." Fine white Fukien porcelain, skilfully modelled, with ivory white glaze. Tê-hua ware. ? 17th century. H. 3.75″. *In the possession of Mr. George Eumorfopoulos.*

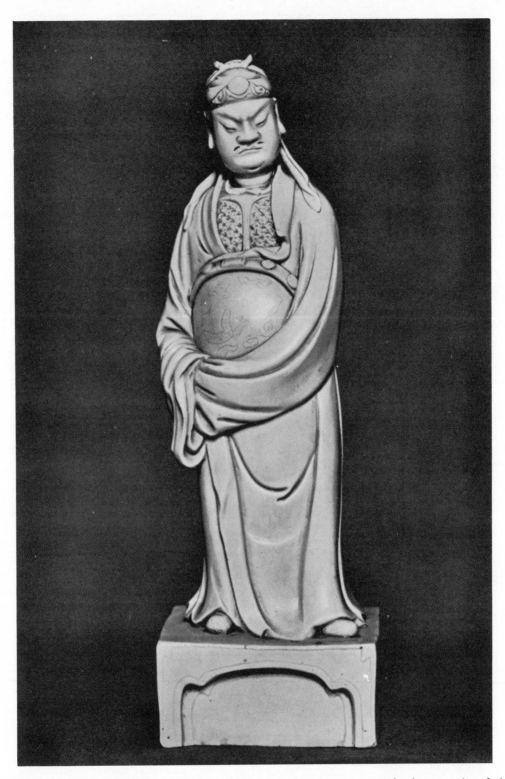

PLATE 105. Figure of Kuan Ti, God of War, standing on a rectangular base—a dignified martial figure with helmet, and breastplate appearing beneath his robes. There are holes on the lips and chin for moustache and beard; and there is a faintly incised brocade design on parts of the robe. Fine white Fukien porcelain with ivory-white glaze. For the story of Kuan Ti, see Plate 131. Tê-hua ware. Late Ming. H. 13.5". *In the possession of Mr. George Eumorfopoulos.*

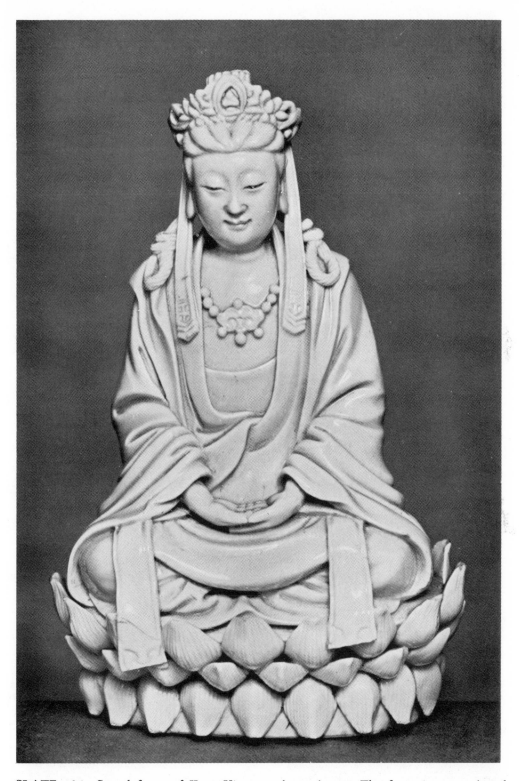

PLATE 106. Seated figure of Kuan Yin on a lotus throne. The figure is crowned and draped in flowing robes opened at the bosom and showing a jewelled necklace. White Fukien porcelain of fine quality with cream-white glaze. On the back is an incised inscription which is almost obliterated by abrasion of the glaze. Kuan Yin (one who hears cries) is commonly known as the Goddess of Mercy, and receives more attention than any other Buddhist object of worship in China. The resemblances between Kuan Yin in the East and the Madonna in the West are obvious, especially when, as Kuan Yin the Maternal, she holds a child in her arms. Tê-hua ware. ? 17th century. H. 7″. *In the possession of Mr. George Eumorfopoulos.*

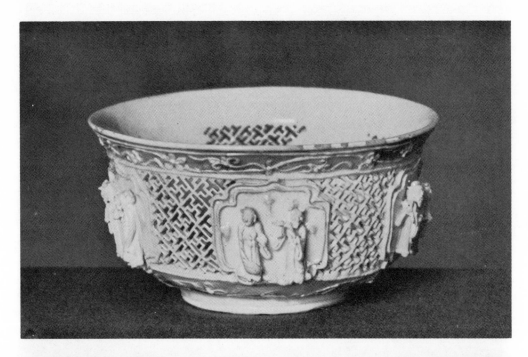

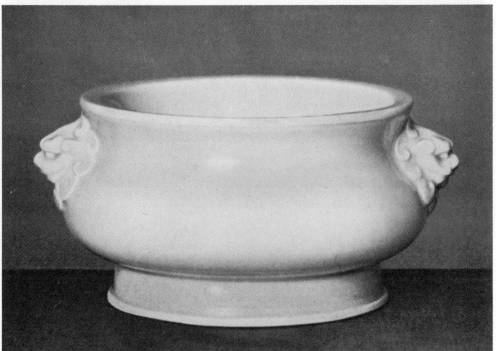

PLATE 107. Fig. 1. Perfume bowl with sides delicately pierced in swastika fret pattern interrupted by four panels with figures of the Eight Immortals in pairs, modelled in full relief in unglazed biscuit; the panels are edged with threads of unglazed clay and the borders are floral scrolls in white slip on a ground of blue glaze. This elaborate pierced work was significantly called *kuei kung* or devil's work. About 1600. D. 3.8". *In the possession of Mr. P. David.* Fig. 2. Incense bowl with a pair of well-moulded lion handles. Fine white Fukien porcelain with milk-white glaze. Mark stamped in a rectangular panel, *Ta Ming Ch'êng Hua nien chih.* The bowl can hardly be as early as the 15th century (as the mark would indicate); but it is an exceptionally choice specimen of the ware showing the simple beauty achieved by the Fukien potters. D. 6". *In the possession of Mr. P. David.*

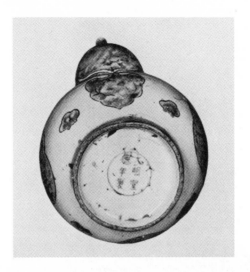

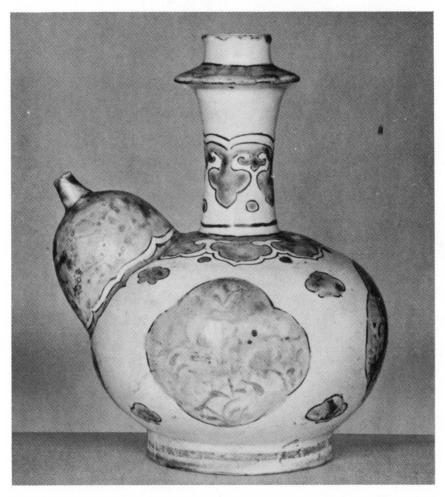

PLATE 109. Pipe-shaped bottle with globular body, slender neck with flange below the mouth, and mammiform spout. Fine-grained porcelain with solid glaze, painted with designs in red outline, filled in with brilliant turquoise-blue enamel, over which there is gilt orna-mentation now much worn. The designs consist of mirror-shaped medallions, large and small, and borders of *ju-i* pattern. The paste where it appears in patches under the base is burnt reddish, and the Hsüan Tê mark in six characters is written in under-glaze blue within a ring, as seen in the upper illustration. Bottles of this form were adapted as narghili bowls in Persia and India after the introduction of tobacco smoking—an event which took place in China in 1530; but several of these bottles are of a date antecedent to the use of tobacco, and their form suggests that they were originally feeding bottles. 15th century. H. 7.5". *In the possession of Mr. T. H. Green.*

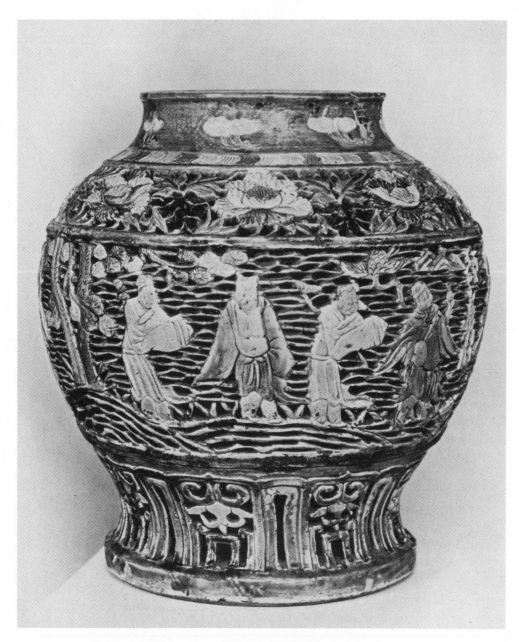

PLATE 111. Wine jar with wide ovoid body, short contracted neck with wide mouth, and slightly spreading base. On the sides is a reticulated outer casing. Porcelain with designs carved in openwork and washed in with coloured glazes—aubergine, yellow, and white in a dull turquoise ground. On the sides the Eight Immortals are paying court to Shou Lao, God of Longevity (*pa hsien pêng shou*), in the usual landscape setting. On the shoulder is a band of peony scroll, and above the base are false gadroons. On the neck are *ju-i* cloud-scrolls outlined in threads of clay. Unglazed base. 15th century. H. 13.75″. *In the possession of Mr. George Eumorfopoulos.*

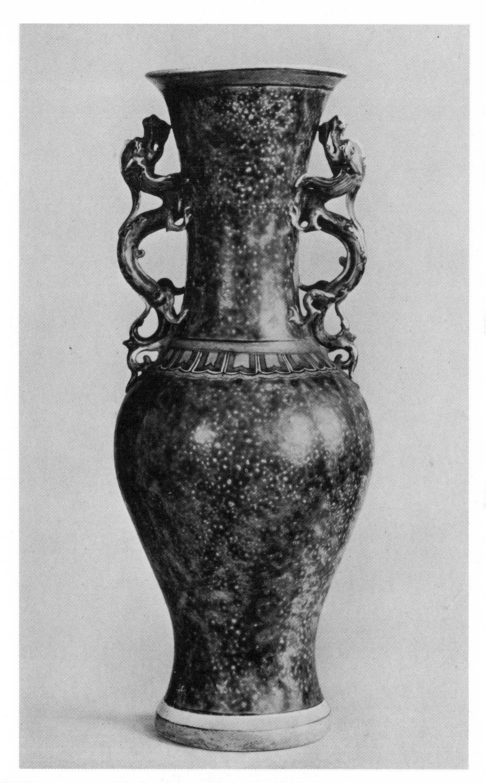

PLATE 113. Vase of beaker shape with baluster body, high neck, and spreading mouth, with two handles in the form of archaic dragons. Porcelain, with mottled turquoise glaze on the body and neck. On the shoulder, a collar painted with stiff gadroon pattern in yellow, bordered with under-glaze blue. The handles are coloured with yellow and green and under-glaze blue. Plain borders edged with brown. Massive base. 15th century. H. 22.5". *In the possession of Mr. R. H. Benson.*

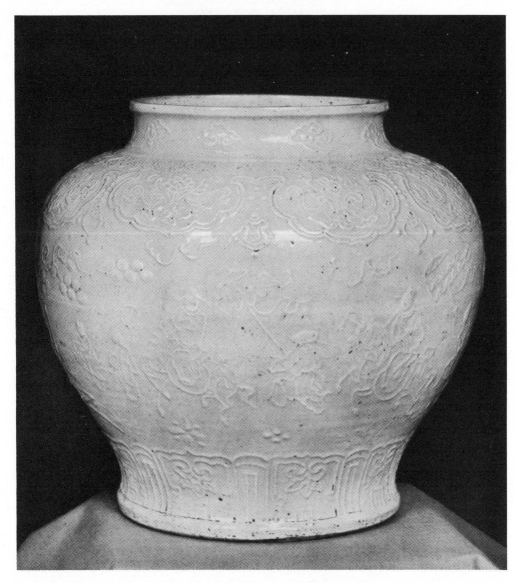

PLATE 114. Wine jar with wide ovoid body, short contracted neck, and wide mouth, and slightly spreading base. Porcelain, with designs outlined in threads of clay and covered with a white glaze. On the body are two horsemen, umbrella bearers, and attendants in the usual landscape setting. On the shoulder are *ju-i* shaped lappets with lotus designs, and pendent jewels between. On the neck are *ju-i* cloud scrolls, and above the base false gadroons. This type of vase, fairly often seen with coloured glazes, is extremely rare in pure white. The porcelain seen on the unglazed base is of fine texture but slightly browned; the glaze is solid and opaque and pin-holed in places. 15th century. H. 12.5″. *In the possession of Mr. George Eumorfopoulos.*

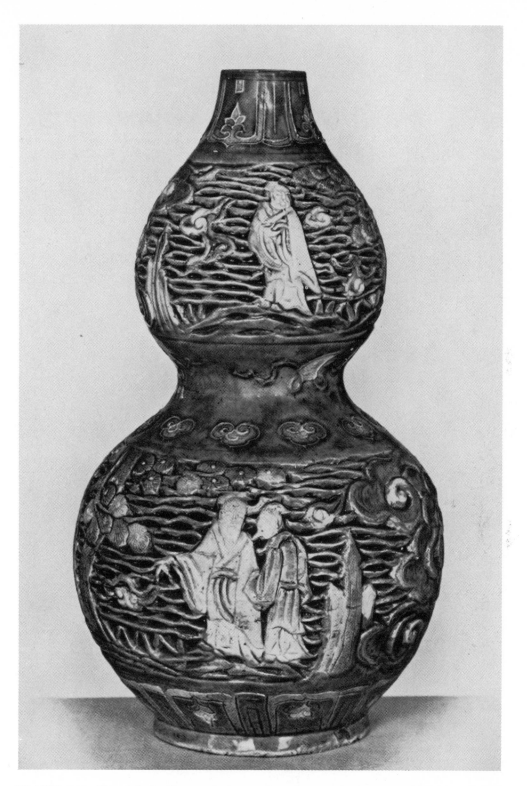

PLATE 116. Vase of double-gourd shape. Porcelain, with designs, which are variously carved, reticulated, incised, and outlined with threads of clay, washed in with coloured glazes—aubergine, pale yellow, and white—in a turquoise-blue ground. On both bulbs the main ornament consists of figures in landscape setting with pine trees, rocks, and clouds against an openwork background. On the lower bulb two figures are approaching a group engaged in checkers, and on the upper are a sage and attendant carrying a lute. The subsidiary designs are borders of false gadroons at the mouth and above the base, and symbols and propitious clouds (ju-i shaped) on the waist. The designs evidently illustrate two of the Four Liberal Accomplishments, viz. Music and Checkers. Possibly there was a companion vase on which the other two—Literature and Painting—were represented. 15th century. H. 14". *In the possession of Messrs. G., R. and C. Benson.*

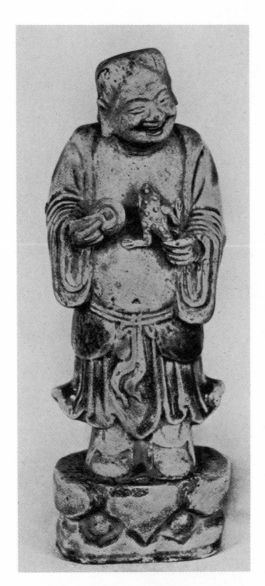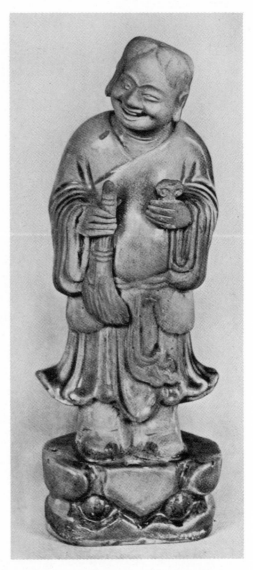

PLATE 118. A pair of figures, one representing Liu Han holding a "cash" or coin, and a three-legged toad, the other Shih-tê with a brush and a *ling chih* fungus. Porcelain with coloured glazes; the robes and rocky bases are turquoise, and there is a patch of aubergine at the back. The flesh parts, legs, and attributes are in unglazed biscuit. Both figures are Taoist Genii. Shih-tê (Japanese, Jitoku) is one of the Twin Genii of Union and Harmony (*ho ho êrh hsien*); and Liu Han and his toad are denizens of the moon. The *ling chih* fungus is one of the life-prolonging plants, and appears frequently in decoration as a symbol of longevity as will already have been observed. 16th century. H. 8″. *In the possession of Mr. Anthony de Rothschild.*

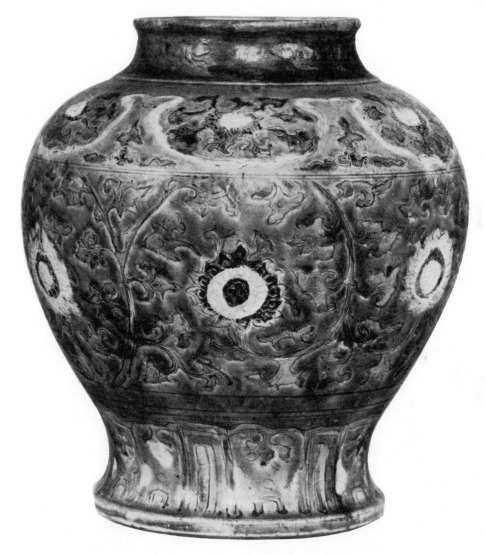

PLATE 120. Wine vase with wide ovoid body; short contracted neck and wide mouth; and slightly spreading base. Porcelain with incised designs washed in with coloured glazes—aubergine, yellow, and white in a turquoise ground. On the body is a bold lotus scroll; on the shoulder, *ju-i* shaped lappets enclosing lotus designs, with clouds between. On the neck are propitious *ju-i* clouds; and above the base, false gadroons. Chêng Tê period (1506–21). H. 10.75″. *In the possession of Mr. George Eumorfopoulos.*

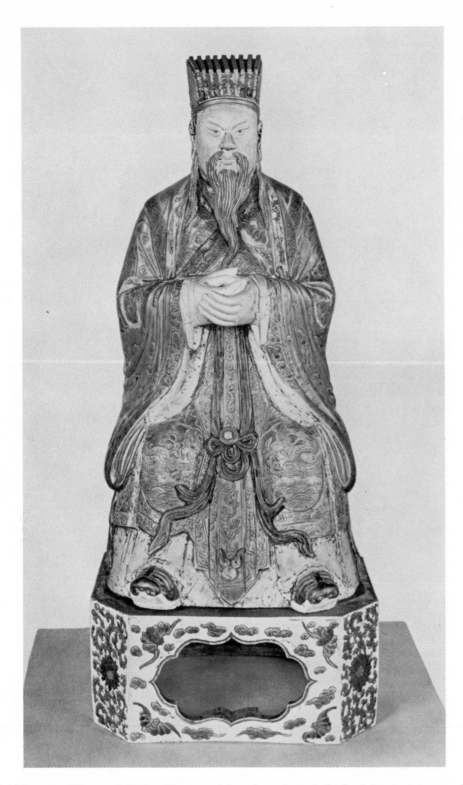

PLATE 122. Figure of *Wên ch'ang ti chün,* the principal God of Literature, seated in robes of state. Porcelain decorated with washes of coloured glazes over incised designs. Portions of the figure, including the flesh parts and the under robe, are in unglazed biscuit with traces of a red pigment which has been the medium for gilding. The over robe is richly brocaded with five-clawed dragons, cloud designs, and wave borders coloured green in a rich yellow ground, and there are touches of aubergine on the beard, belt, and boots. The octagonal stand is enamelled on the biscuit in green, yellow, and aubergine with brown outlines, the ornament consisting of bats and clouds in front and peony scrolls at the corners; the edges of the openwork are washed with yellow, Wên Ch'ang, whose habitation is the Great Bear, is reputed to have undergone many incarnations in the persons of distinguished literary men. 16th century. H. 30″. *In the possession of Mr. Anthony de Rothschild.*

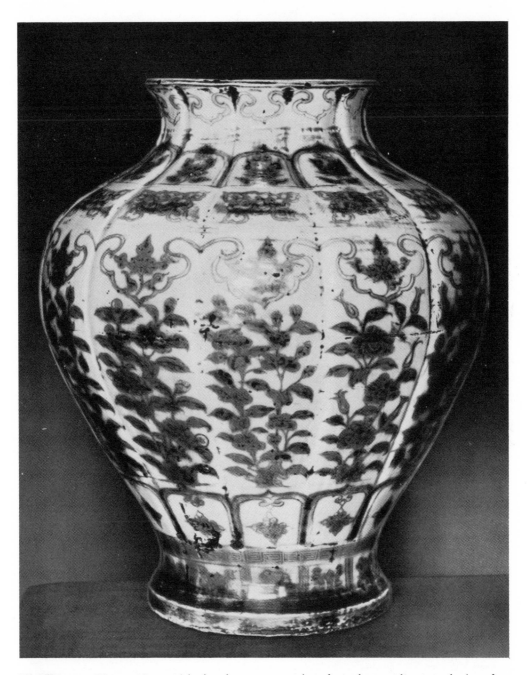

PLATE 124. Vase with ovoid body, short contracted neck, and expanding mouth; low foot slightly spreading. The body is shaped in twelve shallow lobes. Porcelain painted in under-glaze red which has run and is slightly hazy. On the lobes are growing plants, and above them *ju-i* shaped lappets enclosing formal lotus flowers. On the shoulder, designs of similar kind, and a border of *ju-i* pattern on the neck. Chêng Tê period (1506–21). H. 19″. *In the possession of Mr. George Eumorfopoulos.*

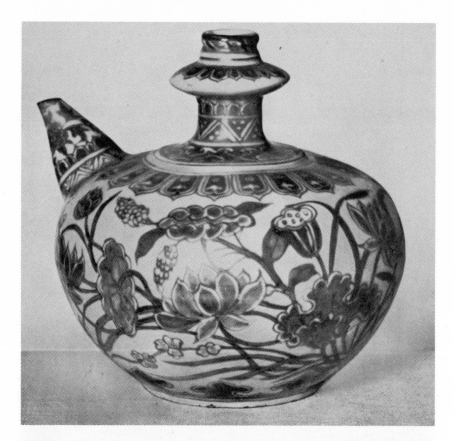

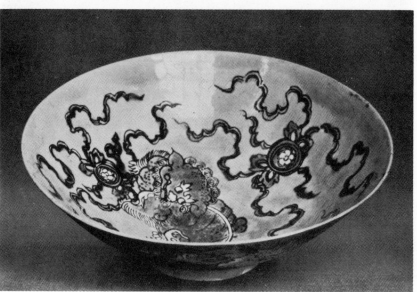

PLATE 126. Fig. 1. Pipe-shaped bottle with globular body, small neck, and pointed spout. Fine porcelain painted in a soft underglaze red of rather pallid tone, with a finely drawn design of lotus plants in flower, leaf, and bud; formal border patterns. The base is unglazed and discloses a fine-grained biscuit burnt reddish brown. The copper-red glaze shows incomplete mastery of the firing technique, and indicates the extent to which the potters had lost the art at this period. Though subsequently adapted as narghili for smoking purposes, it appears that objects of this shape were first used as ewers or even as feeding bottles. Tobacco, however, was not introduced into China until 1530. Chêng Tê period (1506–22). H. 6″. *In the possession of Mr. S. D. Winkworth.* Fig. 2. Shallow bowl with wide mouth and small foot. Porcelain painted in enamels on the biscuit with a design of Buddhist lions and brocade balls with streamers in green, aubergine, and white in a yellow ground. The Buddhist lion, or dog of Fo, is the guardian of temples and of Buddhist divinities. He is commonly represented in form and manner resembling a playful Pekingese spaniel, sporting with a ball of silk brocade, which was originally the sacred Buddhist jewel of the law. Chia Ching period (1522–66). D. 7″. *In the possession of Mr. George Eumorfopoulos.*

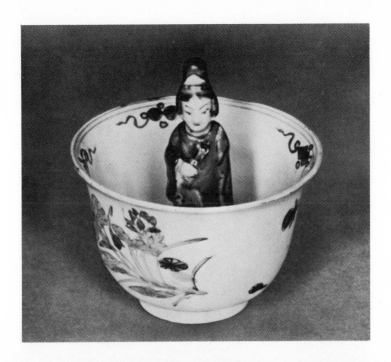

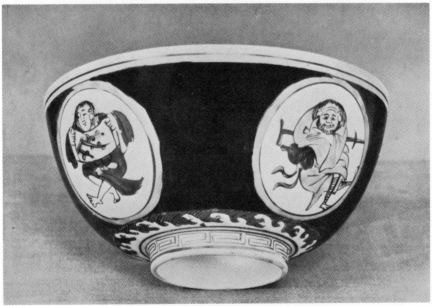

PLATE 128. Fig. 1. Tantalus-cup, bowl-shaped, with a figure inside. Porcelain painted in underglaze blue and red enamel. On the bowl are clumps of lotus and chrysanthemum in blue and red; and symbols round the lip of the bowl inside. The figure has a blue headdress and red coat. The quality of the porcelain and the colours suggest an early 16th-century date. Tantalus-cups, like the Western puzzle jug, could only be used with safety by those who knew their secret. Otherwise the liquid ran out of some unexpected hole to the discomfiture of the user. The figure contains a tube shaped like an inverted **U** of which one end communicates with a hole at the foot of the figure inside the cup, and the other end leads through the bottom of the cup. The cup can thus be filled safely to the level of the top of the **U** bend of the tube. If filled beyond that point the water runs out on the syphon principle. D. 3.5″. *In the possession of Mr. T. H. Green.* Fig. 2. Bowl with rounded sides and slightly convex bottom. Porcelain painted in enamel colours. On the outside, a broad band of tomato red broken by four medallions with figures, two of which are seen in the illustration; one holds a picture scroll with prunus design, and the other is the Beggar Immortal, Li T'ieh-kuai, with his iron crutch and gourd; the panels are edged with green, and there is a wave pattern below and a key-fret on the base. This kind of bowl, with convex centre (*man hsin*), is typical of the Chia Ching period (1522–66). The mark under the base reads *fu kuei chia ch'i,* i.e. fine vessel for the rich and honourable. D. 4.75″. *In the possession of Mr. George Eumorfopoulos.*

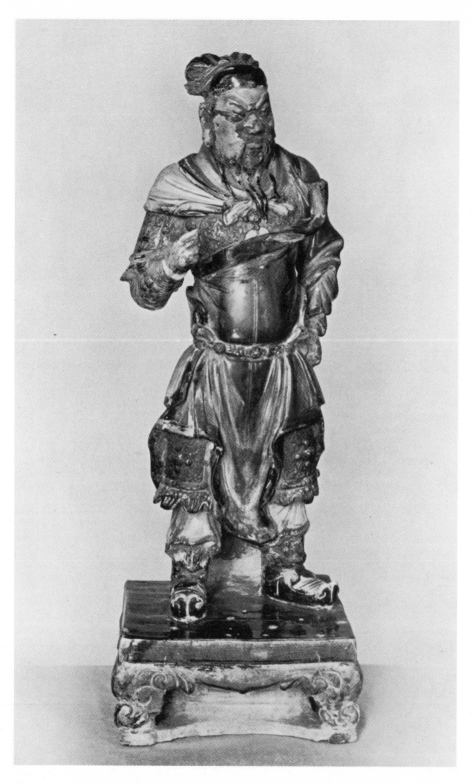

PLATE 131. Figure of Kuan-yü, with drapery over his armour, standing on a square base with four scroll feet. Buff pottery with coloured glazes. The robes green and the scarf white, both bordered with aubergine; the armour yellow; black on the beard, boots, and headdress. The flesh parts are in unglazed biscuit, on which there are traces of gilding. The stand is glazed green and yellow. Kuan-yü, a military hero of the Three Kingdoms (221–265 A.D.), was canonised in the 12th century, and eventually elevated to the position of God of War in 1594, under the title of Kuan Ti. 16th century. H. 31″. *In the possession of Messrs. G., R. and C. Benson.*

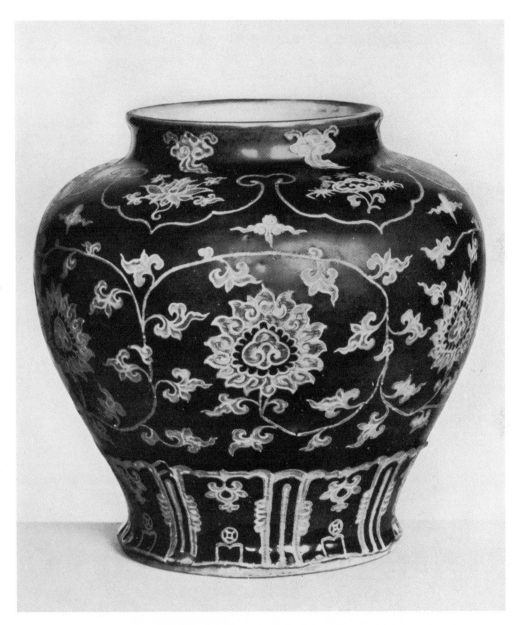

PLATE 133. Wine-jar of potiche form with low neck and wide mouth. Porcelain with deep blue glaze on the exterior, painted in white slip. A lotus scroll on the sides with a border of false gadroons below, enclosing stiff flowers and cash symbols. On the shoulders, a band of *ju-i* shaped lappets, enclosing lotus and *ling chih* fungus sprays; cloud scrolls on the neck. 16th century. H. 12.5″. *In the possession of Messrs. G., R. and C. Benson.*

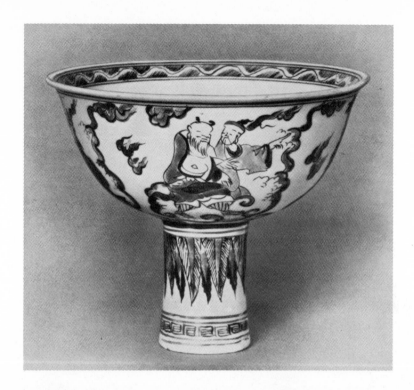

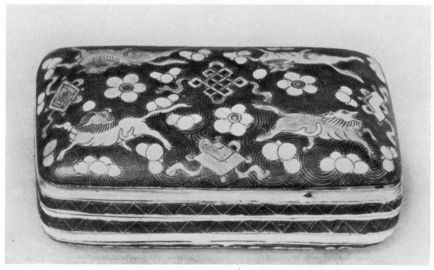

PLATE 135. Fig. 1. Stem-cup (pa pei), bowl-shaped, with everted rim and straight narrow shank. Porcelain enamelled in tomato red, green, aubergine, and yellow. Inside, a medallion with petal border, enclosing a figure of Lü Tung-pin (one of the Eight Immortals) in clouds, with branches of pine, bamboo, and prunus (emblems of longevity) in the spaces; red wave border at the lip. Outside, four groups of the Eight Immortals in pairs floating on clouds; stiff leaves and key-fret border on the stem. Chia Ching period (1522–66). H. 4.6″. *In the possession of Mr. H. J. Oppenheim.* Fig. 2. Box of oblong, rectangular form with rounded corners. Porcelain enamelled on the biscuit with yellow, aubergine, and greenish white in a deep green ground. On the top of the lid are four fantastic animals charging over green water, which is represented by spiral waves strewn with white plum blossoms and coloured symbols; on the sides, a groove and border of green matting pattern. The sides of the box are decorated to match with green matting border and symbols and plum blossoms on green waves. Base unglazed; the interior smeared with a thin greenish white. The symbols belong to the group known as the *pa chi hsiang*—the Eight Buddhist Emblems which comprise the wheel, shell trumpet, state umbrella, canopy, lotus flower, vase, pair of fish, and the angular knot. The "wave and plum-blossom pattern" is named in the lists of porcelain supplied to the Imperial Palace in the 16th century, but it is a pattern which retained its popularity for long after the Ming period. Wan Li period (1573–1619). L. 6.9″. *In the possession of Mr. H. J. Oppenheim.*

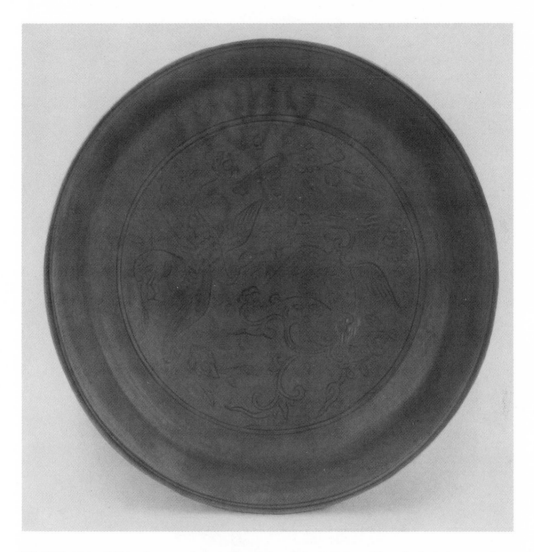

PLATE 136. Dish, of saucer-shape. Porcelain of fine grain with etched designs under a rich blue glaze. Inside is a large medallion with phœnix and crane in scrolls of peony and lotus. Outside, two phœnixes and two cranes in similar scroll work. The blue glaze appears to be strewn with minute points as though the grains of colour were not entirely dissolved. The same kind of effect, but in a more obvious fashion, is produced by the "powder blue" of the K'ang Hsi period. The finely traced designs under the glaze are a variety of the *an hua* or secret decoration. The phœnix, emblem of the Empress, is usually represented as flying through peony scrolls or "fairy flowers"; the crane, emblem of longevity, is usually associated with the lotus. Here the two birds and their special flowers are combined. Incised mark of the Chia Ching period. D. 15″. *In the Victoria and Albert Museum.*

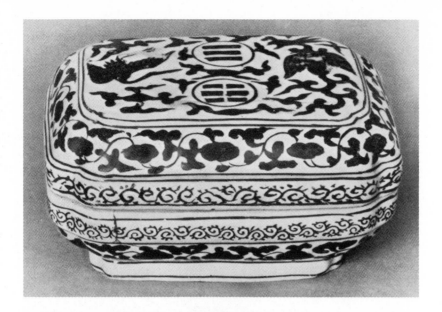

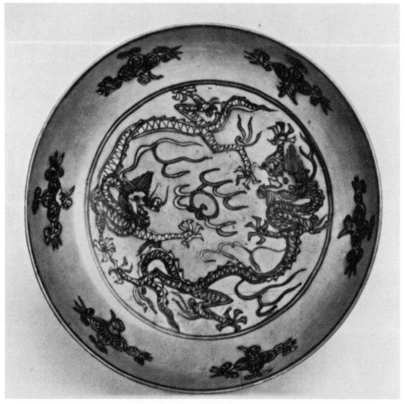

PLATE 137. Fig. 1. Box of rectangular form with indented angles. Porcelain painted in iron red. On the top of the cover, a phœnix and a stork in clouds, and two medallions of *pa kua* emblems; on the sides of the box and cover, a running *ling chih* fungus scroll and a formal scroll border. Mark in dark Mohammedan blue, *Ta Ming Chia Ching nien chih,* made in the Chia Ching period of the great Ming dynasty (1522–66). The *pa kua* or Eight Trigrams are supposed to explain the phenomena of nature, and to have been revealed to the Emperor Fu Hsi (2852–2738 B.C.) by a dragon horse in the Yellow River. The tri-grams consist of triple combinations of long and short lines. They are sometimes used to denote the points of the compass, and have been extensively employed for ages in systems of divination. L. 5.6″. *In the possession of Mr. H. J. Oppenheim.* Fig. 2. Saucer-dish of fine porcelain with designs outlined in brown on the biscuit and washed in with aubergine and white glazes in a yolk-of-egg yellow ground. In the centre, two five-clawed Imperial dragons in flames disputing a pearl. On the sides four *ling-chih* fungus designs. Outside, a band of running foliage scroll. Mark, in a double ring, *Ta Ming Wan Li nien chih,* made in the Wan Li period of the great Ming dynasty (1573–1619). D. 6.2″. *In the possession of Mr. H. B. Harris.*

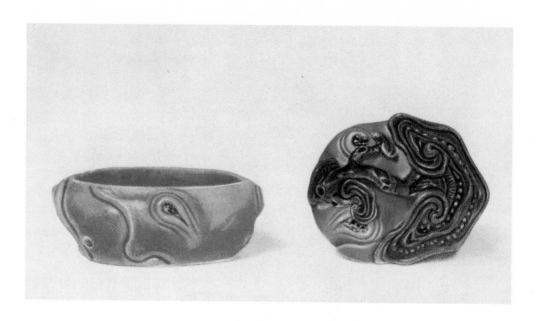

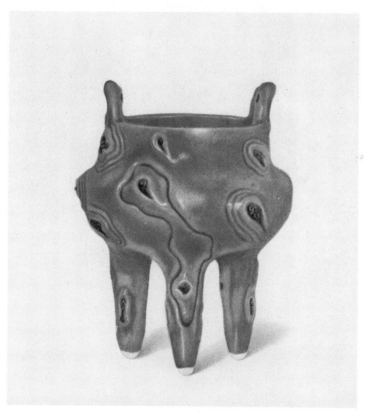

PLATE 139. Fig. 1. Incense box of fine porcelain with coloured glazes. The sides of the box are moulded to suggest a knotted tree-trunk; glazed yellow, the knots picked out with aubergine. The cover is in the form of a life-prolonging *ling-chih* fungus glazed aubergine purple. L. 2.5". *In the possession of Mr. F. N. Schiller.* Fig. 2. Tripod incense-burner of similar ware, the sides moulded in a similar design and glazed yellow with the knots picked out with aubergine. Parts of a dainty set of furniture for the writing-table, this and the box above are exquisitely finished objects, real gems of the potter's art. Pieces like these help us to realise the true character of the small Ming specimens illustrated in the 16th-century Chinese album of Hsiang Yüan-p'ien. H. (without handles) 3". *In the possession of Mr. H. J. Oppenheim.*

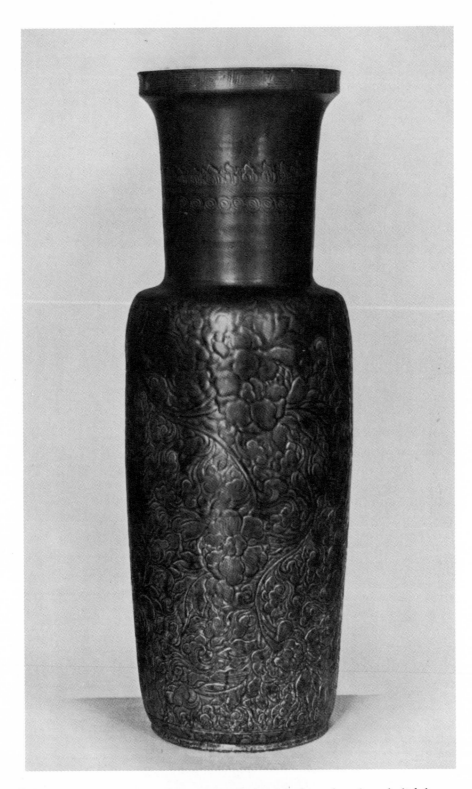

PLATE 140. Vase of rouleau form with cylindrical body and neck and slightly expanded mouth. Porcelain carved on the body with a beautiful peony scroll in low relief, beneath a dark aubergine violet glaze which varies in depth. On the neck are incised bands of stiff leaves and spirals; and on the lip is a key-fret or "cloud and thunder" pattern (*lei wên*). Late Ming. H. 23". *In the possession of Messrs. G., R. and C. Benson.*

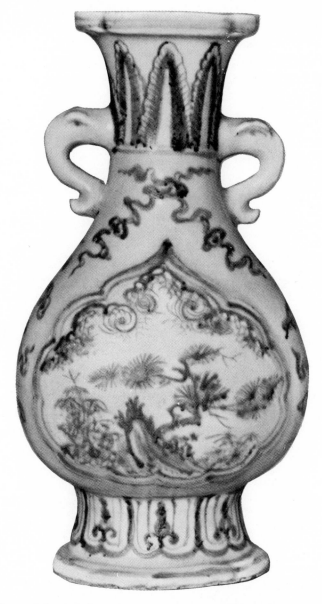

PLATE 141. Vase of bronze form with flattened pear-shaped body, high neck, slightly expanding at the mouth, spreading foot, and two elephant handles; the lip and the base-rim are of quatrefoil outline. Fine white porcelain with thick glaze of faintly greenish tint and dull lustre. Painted in underglaze blue of two tones, a light blue shaded with dark. On the front and back are two moulded leaf-shaped panels with rocks and symbolic plants and clouds; in one, an ancient pine and in the other a peach and *ling chih* fungus—all emblems of longevity. Above and beside the panels are *ju-i* cloud scrolls ("propitious clouds"); on the neck are stiff plantain leaves and on the stem false gadroons. The base is hollow and glazed inside, and there is grit on the raw edge of the foot-rim. 15th century. H. 8.5". *In the possession of Mr. Charles Russell.*

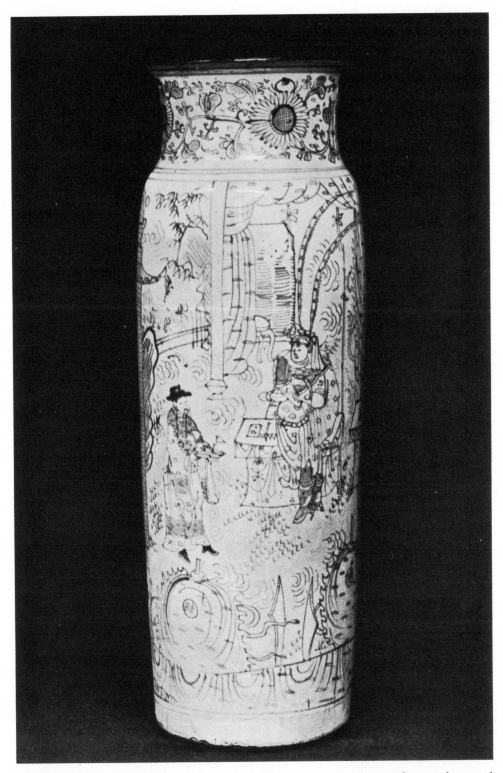

PLATE 142. Vase of cylindrical form with slightly contracted neck spreading at the mouth; unglazed base, nearly flat. Porcelain pencilled in a delicate shade of blue under the glaze. On the body, a court scene with a military chief receiving two civil dignitaries; an array of banners and pikes in the foreground. On the neck, a floral scroll with large chrysanthemum-like blossoms. The pencilled decoration is in an early style, associated with the 15th century. H. 16″. *In the possession of Mr. George Eumorfopoulos.*

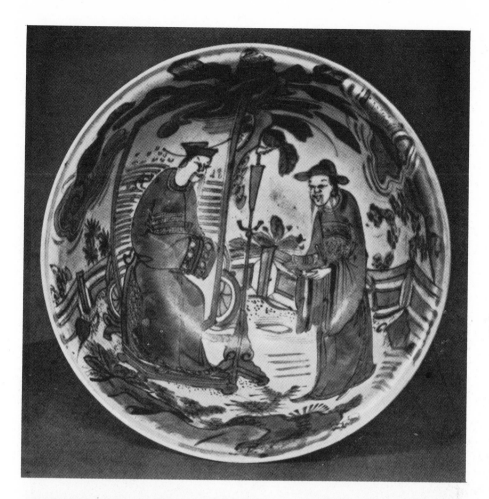

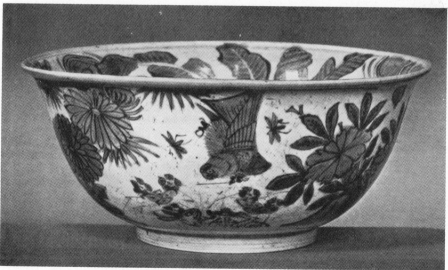

PLATE 143. Bowl with everted rim; porcelain finely painted in dark blue under the glaze. Inside is a garden landscape with fence, pictured screen, and a candle set on a tall stand, and two figures of dignitaries in conversation. Outside, as will be seen in the second illustration, is a garden with season flowers and an owl swooping down on a rabbit. Under the base is the mark of the Ch'êng Hua period (1465–87). D. 8.5". *In the possession of Mr. George Eumorfopoulos.*

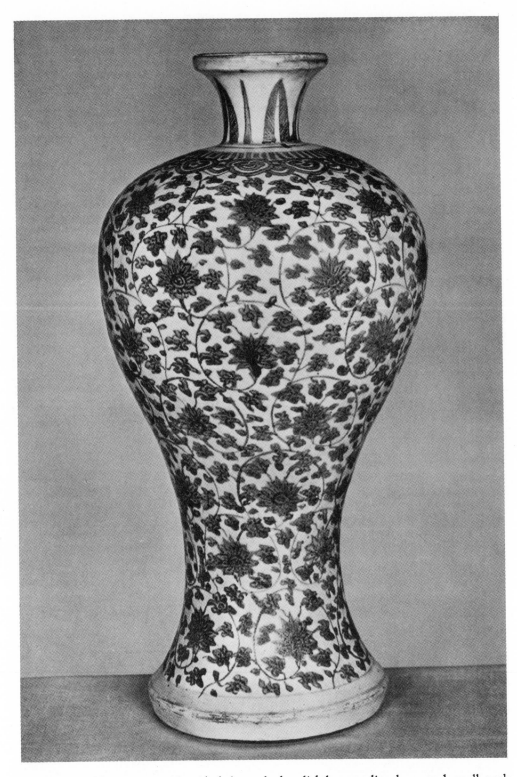

PLATE 144. Flower vase with wide baluster body, slightly spreading base, and small neck with expanding mouth. Porcelain of massive structure with finely painted lotus scroll in dark underglaze blue; *ju-i* border on the shoulder and stiff leaves on the neck. 15th century. H. 16.5″. *In the possession of Mr. T. H. Green.*

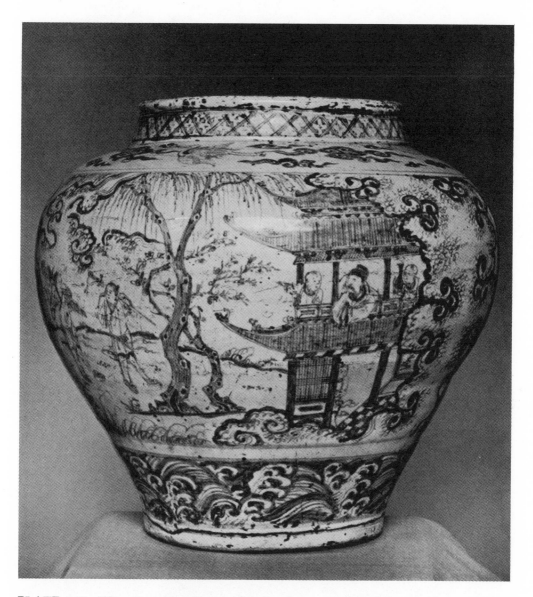

PLATE 145. Wine jar with wide ovoid body, short, straight neck and wide mouth; un-glazed base, almost flat. Porcelain painted in dark and light shades of blue under the glaze. On the body, a mountain landscape with trees, shrubs, and a pavilion half hidden in mist, in which a man and two boy attendants are watching the approach of mounted visitors with their attendants on foot. Band of stork and cloud pattern on the shoulder and a band of crested waves above the base; trellis pattern on the neck. About 1500. H. 13.5″. *In the possession of Mr. George Eumorfopoulos.*

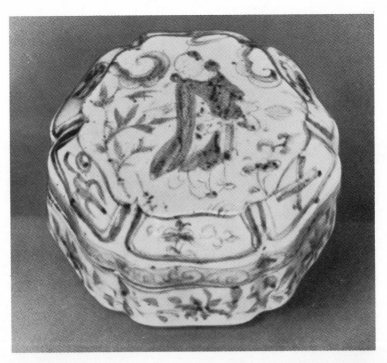

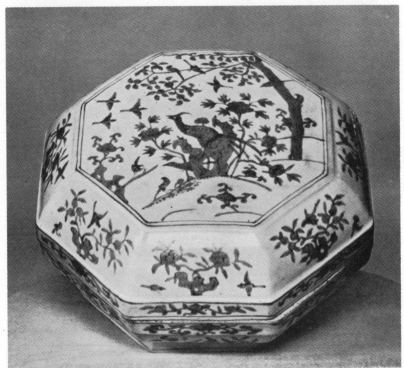

PLATE 146. Fig. 1. Box of six-foil form. Porcelain with glaze of slightly greyish cast, painted in underglaze blue of two tones, a light blue shaded with dark. On the top of the cover is a figure of the Immortal Ho Hsien Ku, the patroness of housewives, with her ladle, and a bamboo and *ling chih* fungus and clouds; on the sides are three emblems repeated—a pair of scrolls, a *ling chih* fungus and a pearl in flames—and a scroll border. On the sides of the box, floral designs, and false gadroons. The base is unglazed, and the glaze inside is washed on thin and has browned in places. The blue on the sides is hazy in outline, but clearer in the panel on the cover which is skilfully drawn. 15th century. D. 4.4". *In the possession of Mr. H. J. Oppenheim.* Fig. 2. Octagonal box with rounded cover. Porcelain painted in underglazed blue of good quality. On the top of the box a garden landscape and two pheasants or phœnixes on a rock receiving court from numerous small birds. On the side facets are flowering plants and scrolls. The subject is apparently a version of the "Hundred Birds paying court to the Phœnix." Under the base is the mark of the Chia Ching period (1522–66). D. 11.5". *In the possession of Mr. George Eumorfopoulos.*

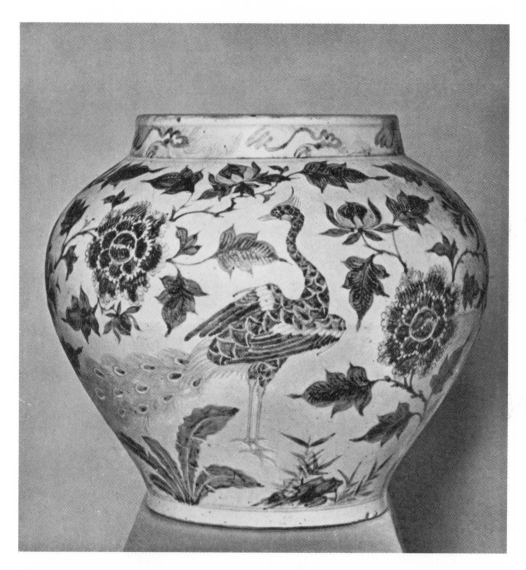

PLATE 147. Jar of potiche form with broad ovoid body, short neck, and wide mouth. Porcelain of fine grain with solid white glaze, painted in underglaze blue in two tones, a light tone shaded with dark. On the body are rocks, bamboos, palms, and *mu-tan* peonies in flower and bud, and a peacock and hen; on the neck is a wave border. Base unglazed. The design *kung chiao mu tan hua* (peacocks and peonies) is named in the lists of blue and white porcelain supplied to the Imperial Palace in the 16th century. It is also familiar on the "three-colour" vases of earlier date. About 1500. H. 11.75". *In the possession of Mr. Charles Russell.*

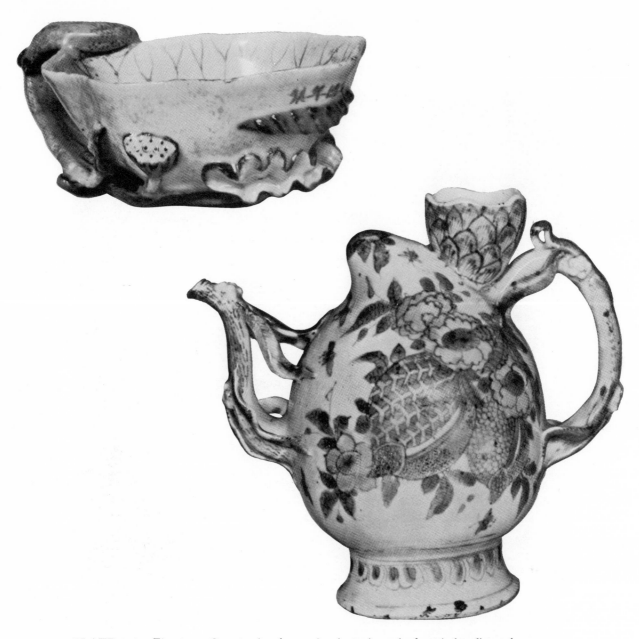

PLATE 149. Fig. 1. Cup in the shape of a large lotus leaf with handle and supports beneath in the form of stalks. buds, and smaller leaves. Porcelain with details in under-glaze blue and green enamel. The blue on the exterior of the leaf is mottled, and the stalks are a dark leaf green. Below the lip in front is the mark of the Hsüan Tê period (1426–35) in six characters. 15th century. L. 5.75″. *In the possession of Mr. George Eumorfopoulos.* Fig. 2. Wine-pot in the form of a peach with branches forming the handle and spout, and a filler on the top shaped like a many-petalled flower. Porcelain painted in underglaze blue with pomegranate designs with fruit and flowers. The peach, pomegranate, and finger citron are three fruits which symbolise the Three Abundances of years, children and happi-ness. The peach-shaped wine-pot occurs in Chinese porcelain of all periods. It is usual in the later specimens to find the hole for filling under the base, and this form was adapted in the well-known Rockingham teapots. 16th century. H. 7″. *In the possession of Mr. T. H. Green.*

PLATE 150. Dish with narrow flat rim. Porcelain with designs in underglaze blue strongly outlined and washed in with paler shades. In the centre is a medallion with a square enclosing a lozenge in which is a passage of Arabic writing enclosed by a ring and four *ju-i* ornaments; in the spaces are arabesque foliage scrolls. On the border are foliage scrolls interrupted by four cartouches of Arabic writing. Similar ornament on the back and the mark of the Chêng Tê period (1506–21). A number of Chêng Tê specimens are known with Arabic inscriptions; such pieces were doubtless made for the Mohammedan market, in China or abroad. Apparently this dish was used for the ceremonial washing of the hands before prayer. The inscription in the centre reads *Tahārat* (purification). The writing is Persian in character and points to the dish being made to order for the Persian market. D. 16.5″. *In the possession of Mr. George Eumorfopoulos.*

PLATE 151. Vase with high-shouldered, baluster body, and tall, slender neck with flaring mouth and edge of quatrefoil shape; the base is terraced and slightly spreading. On the neck are two crinkled loop handles to which are attached two rings. Porcelain with solid white glaze, painted in underglaze blue with belts of ornament. On the body, a broad band of lotus scrolls, stiff plantain leaves, foliage scroll, and formal patterns. *Ju-i* head pattern on the shoulder. On the neck, a fungus scroll, a foliage scroll, stiff floral ornaments, key-fret, and a cartouche inscribed *Chêng Tê nien chih*, made in the Chêng Tê period (1506–21). The base is flat and unglazed and discloses a fine-grained biscuit which has slighly browned. H. 17.9". In the possession of Mr. H. J. Oppenheim.

PLATE 152. Dish with slightly everted rim. Fine porcelain with well-painted design in a fine greyish blue. In the centre a landscape scene with a martial figure brandishing a pike and two small figures who may be demons. A gourd-vine scroll forms the border. Outside are lotus sprays supporting the Eight Buddhist Emblems (*pa chi hsiang*). Mark in a double ring, *Ta Ming Wan Li nien chih,* made in the Wan Li period of the great Ming dynasty (1573–1619). The subject appears to be a representation of Chung K'uei, the demon-queller, who corresponds in many ways to the more familiar Shoki of Japanese legend. Late 16th century. D. 11.8″. *In the possession of Mr. H. B. Harris.*